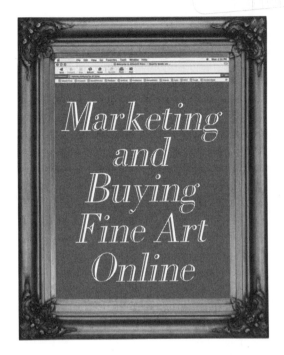

Marketing and Buying Fine Art Online

A GUIDE FOR ARTISTS AND COLLECTORS

Marques Vickers

ALLWORTH PRESS
NEW YORK

09 08 07 06 05 5 4 3 2 1

Published by Allworth Press
An imprint of Allworth Communications, Inc.
10 East 23rd Street, New York, NY 10010

Cover design by Derek Bacchus
Interior design by Joan O'Connor
Typography by Integra Software Services

ISBN: 1-58115-426-7

Library of Congress Cataloging-In-Publication Data

Vickers, Marques, 1957.
 Marketing and buying fine art online: a guide for artists and collectors/Marques Vickers.
 p. cm.
 Includes bibliographical references and index.
1. Art—Marketing. 2. Web sites—Design. 3. Internet marketing. I. Title.

N8600.V53 2005
706'.8'8—dc22

 2005013847

Printed in Canada

To my family support system, including Claudia, Mom, Dad, Lisa, Cathy, Charline, and Caroline Regina Coragliotti for editorial guidance

CONTENTS

PREFACE

Forget for a moment the traditional assumptions regarding the fine arts industry.

The stereotypical myths about artists, galleries, auction houses, and collecting are undergoing a substantial reexamination. The depths of this change have no precedent. A major technological innovation called the World Wide Web, cyberspace, or the Internet (whichever popular label you prefer) is connecting and opening communication channels to individuals, businesses, and institutions on a global scale . . . and the participants are taking comparative notes.

The rules are changing, as are the rule-makers. Age and experience remain valued skills in conducting business, but the understanding and employment of computer technology is creating an educational and cultural divide. An emerging generation of buyers, weaned on technology and the Internet, is creating its own adventurous and unique opportunities with this global platform.

The Internet has already influenced and transformed substantial patterns of cultural behavior in a condensed period of time. This technology has changed everything, from our collective sources of entertainment and leisure activities, to our most fundamental written communications (e-mail).

Patterns of conducting business have been forever modified and restructured to accommodate electronic commerce. The fine arts industry has been slower to change and evolve than many industries, yet it is not immune. Its unique path toward integration has not been universally embraced within all sectors. However, its ultimate acceptance is inevitable.

The industry-wide integration process will have its detours and circuitous routing but ultimately a more streamlined communication between producer (artist), reseller (gallery/auction house), and patron should evolve. The result will likely eliminate some of the middle strata currently clouding direct distribution. A smooth and functioning system will never sufficiently develop until artist, reseller, and buyer are on the same page of this process.

This book is an attempt to demystify many of the misconceptions and false assumptions about the art industry and the Internet, both intentionally and unintentionally created. The perception of fine art economics is that it often transcends the simple supply and demand curves of other industries, creating an unusual and complicated inner structure. For participants to assume that a medium such as the Internet will overhaul the inefficiencies and relationship-based nature of the industry is naïve. To assume likewise that the industry will remain unaffected is shortsighted.

From a broad perspective, all elements of the industry make the system function and each component can benefit from technological innovation. My admitted personal bias tends toward the creative artist. My commentary is drawn from direct personal experience, extensive readings, and trial and error, and contains some personal forecasts and hopeful speculation.

The art world is hurling headfirst into a new era of artistic free agency, more informed consumer comparative pricing, and expanded resource data (previously limited to curators and art historians). This evolutionary process of moving away from previously entrenched distribution patterns and assumptions is overdue and certain to facilitate progressive changes, opening up the landscape to a broader range of participants.

Some changes will be immediate, some may require years and even decades. Buckle up for an unpredictable headwind; the fun's just beginning.

part 1

THE ARTIST *Perspective*

A REVOLUTION *in Transition*

The Internet is changing the world of fine art. Change is unsettling.

This change has not been heralded by full-page color ads in art trade publications. The Internet's influence has not yet been fully embraced by the maze of galleries and resellers who comprise the traditional means of selling and distributing art. Artists themselves are perplexed, wondering how to exploit this new selling tool. Even potential art buyers seem overwhelmed by an avalanche of visual imagery and online promotional pitches intermingled with other less-than-savory online products, pitches, and pleas for money or other assistance.

Amid the current transitional chaos, the Internet is steadily changing the landscape of how the art world conducts its business. In 2004, the *Art Newspaper*, an international monthly publication and barometer of the industry, featured several profiles on the evolving nature of art reselling, including one headlined, "Do contemporary dealers still need galleries?"[1]

The substance of this article and numerous others in art trade publications is the increasing amount of business that is taking place online. In fact, a growing number of dealers are abandoning traditional, costly, onsite artist exhibitions and focusing instead on prestigious trade fairs and e-mail solicitations. This trend is emerging particularly in high-rent commercial urban centers. In effect, many art galleries are running virtual galleries whether they maintain a walk-in space or not.

The traditional physical art gallery as the industry has known it is struggling to maintain an existence amid an unfriendly business environment of escalating rents and rising expenses of promotion, staff, logistics, delivery, insurance, and security.

Conclusions Prompted by the Influence of the Internet

The conclusions for both artist and seller seem inevitable. A shift toward online sales, distribution, and promotion is essential to long-term survival. This shift in reality in the dealer community has not gone

unnoticed by the source of art creation, the artist community. What were once clearly defined roles of dealer and artist are blurring, and the catalyst for this shift is the wide-ranging communication capabilities of the World Wide Web.

Certain preconceptions and myths about buying art are being rapidly discredited, particularly the assumption that the ideal buyers will only purchase what they can actually see or be sold in person.

The basis of my observation is grounded by several factors including: 1) the breadth and variety of existing and emerging art-oriented Web sites, 2) the traceable indicators that the Internet has changed business operations, 3) the growing numbers of online users, and 4) the growing design sophistication of artist Web sites.

The Slow Ascent of the Internet's Influence

The Internet as a sales mechanism has not been an overnight success. In fact, the earliest efforts to make online selling an integral part of the art industry met with resounding silence. The prematurely released, blanketed advertising of the heady "dot-bomb" era between 1998 and 2000 promised and almost assured a radical realignment of how art was to be marketed in the twenty-first century. Advertiser enthusiasm was contagious, but when the venture capital funding this inflated self-promotion dried up, so too did the advertising exposure within art trade publications. Few of these heavy-hitting art Web sites survived the ensuing collapse of dot-com enterprises during the subsequent three years.

A hangover from unrealistic expectations was necessary. A more realistic picture regarding the commercial viability of the Internet is emerging. Today the illusion that instant wealth can be obtained by creating an online enterprise and taking it forward into public financing has been fatally punctured. Commercial Web sites share the same financial accountability as any other business enterprise. Revenue must exceed operating expenses and profit must sustain a business model. Corralling viewers at any cost (a prior dot-com philosophy) makes no more sense than opening up your inventory to free distribution or giving away your artwork in the remote hope of generating future sales.

Between the span of March 2000 and January 2002, when I initially began writing about the Internet as an art marketing outlet in *Art Calendar* magazine and several other publications, the failure rate for highly publicized commercial art Web sites was easily in symmetry with the steep decline of the NASDAQ stock exchange and other well-publicized dot-com busts.

This twenty-two-month period of excessive commerce hemorrhaging proved an unwelcome reality check. Following the pattern of traditional economic cycles in other business sectors, it was by no means unforeseeable.

The Aftermath of the Dot-Com (Dot-Bomb) Hangover

From January 2002 through the present time, the default rate of commercial art Web sites has stabilized. The numbers of art commerce Web sites even appear to be increasing (regretfully no present research outlet can substantiate an actual number of art Web sites).

What precisely has prompted this shift?

I believe a new, more modest stabilization and financial maturity has emerged consistent with other online business sectors.

When I drafted my initial writings in mid-2000 on selling artwork online, the outlook for the Internet as a selling medium was unrealistically exuberant and financially unaccountable. Heavily promoted dot-com art resellers, a hastily married coalition of art industry insiders, periphery observers, and industry-ignorant venture capitalists were spreading printed rhetoric and trade ads as rapidly as their operating funds were depleting.

Dot-com art resellers attempted to obtain instant credibility and a large base of sales revenue from an industry with minimal precedent for either component. The absence of long-term trading relationships and sustained industry exposure undermined the very credibility they were attempting to accelerate.

Instead, amid the hyperchaos of the spending and marketing frenzy, short-term partnerships, poorly structured business models, and ill-advised expectations reigned, resulting in the foreseeable collapse of most of the high profile Internet resellers. What was utterly overlooked within the art establishment was the emergence of a substantial and growing number of specialty art Web sites, marketing reasonably priced artwork and offering fresh exposure avenues for thousands of artists previously doomed to guaranteed obscurity.

The reason these surviving Web sites have escaped significant media notice is they have modest budgets, small staffs (often a single individual), and don't invest heavily in trade industry publication advertising. Editorial direction and coverage often has a direct correlation to advertising revenue.

These current smaller and focused reseller Web sites—along with the millions of individual artist sites—constitute the backbone of the fundamental shifts taking place within the art industry.

Other Significant Changes Hastened by the Internet

Aside from this online presence, has the Internet significantly changed the art world landscape in other ways? Yes. Specifically:

- More individuals (from all income brackets) are investing in fine art, creating the largest collector and art buyer base ever
- Marketing opportunities and the sales of art-related by-products, including licensed apparel, reproduction art, greeting cards, Giclées, and royalty-free photographs, continue to expand
- Artists actively and regularly promote themselves to both buyers and resellers via their individual Web sites, replacing traditional ineffective promotional tools
- Auction and dealer sales data are universally accessible and published on the Internet, expanding the scope and pool of available pricing research for informed buyers
- E-mail has become a standard, and in some cases primary, method of business communication
- Computer-generated artwork (while still in its infancy) is finding a niche online and integrating itself slowly as a marketable medium
- Online, cashless transactions and barter have become rapidly growing sales mediums for fine art and publication advertising
- Exhibition opportunities and public art commissions published online are drawing significantly more applications from the artist community

These factors represent a fundamental transformation taking shape in the contemporary art world. Revolutionary consequences may result. The balance-of-power relationship between artist and gallery is changing. Just as the demise of the motion picture studio system altered the business mechanics of movie making, the Internet may and likely will eventually transform the manner in which visual works of art are distributed and sold.

The Raw Numbers of an Expanding Medium

According to statistical data published by Nielsen Net ratings,[2] the Internet is maturing as a medium. The estimated Internet global universe has nearly 453 million users. Approximately 295 million are considered active users, an annual increase of approximately 10 percent.

Viewing statistics among active users included (per month):

- Twenty-nine online business/job related sessions averaging ten hours total
- Fifty-eight unique domains visited

- One thousand and twelve page views
- Thirty-four page views per surfing session
- Twenty-four hours of personal computer time

Each of these categories had increased annual growth figures. *Conclusion: Online viewers are investing significant time in the medium and averaging at least twenty minutes per session.*

How These Statistics Affect Artists

What this increase in viewership represents to a professional artist like me is this: Present and future exposure opportunities for my work can potentially reach millions of viewers *without* the exclusive patronage relationship of a third party, such as a commercial art gallery, reseller, art critic, and/or financial benefactor.

These industry insiders and organizations will always exist. Their niche is secure. Taste, style, and aesthetics are subjective interpretations, and most individuals who possess the resources to buy art prefer a second *qualified* opinion, if not a little hand holding, to reassure them of their purchasing preferences. But in the future, this particular sales model will be competing with others.

The opportunity and outlet for artists to display their work internationally (through cyberspace) is an unprecedented phenomenon. It has previously only existed for a privileged few artists. Likewise, the ability to digitally reproduce and affordably reprint painted or computer-designed images for resale is a new form of artist empowerment. Rather than being limited to an existing patronage and distribution system, artists now have the mechanism to create, cultivate, and develop their own public image, clientele, and sales outlets.

The focus for most of my comments is directed specifically toward image-oriented visual artists such as painters, photographers, and computer art designers. But the identical selling principles and opportunities apply to sculptors, crafters, artisans, writers, and any other potentially commercial discipline.

The Effect on Traditional Sellers of Art

The Internet may ultimately require more involvement in the distribution process by the visual creator, the artist. But will this innovation signal an end to the traditional means of selling art? This scenario seems very unlikely.

Internet-savvy gallery owners are already embracing the medium as a supplemental sales outlet. This acceptance does not mean galleries and resellers sell vast inventories of work exclusively online. Most gallery

owners confess that online sales are a minor sales outlet. However, the subtler influences of a gallery's Internet presence are easily overlooked. Online exposure frequently opens a visibility door that can provide important background information on the history, represented artists, available inventory, satisfied clients, and even physical location of the reseller.

Walk-in business to a gallery is often prequalified by buyers who have surveyed a gallery's Web site and arrived at certain impressions about the reseller based on its online presence. Buyers may not tell the owner that they originally browsed the gallery's Web site, but it's likely that the site will be used in follow-up stages to the purchasing process.

Some traditional galleries and resellers resent the Internet because they think it may ultimately reduce their influence in the sales and distribution process. It is a fear with limited merit since every industry is subject to the shifting of time and innovation. Business traditionally follows an evolutionary track: Survival of the fittest. Successful galleries will thrive because they are well managed and understand how to effectively service their client base. Poorly run galleries disappear because they cannot adapt and lack a clear vision of what they represent and who keeps them in business (namely their client base).

The Internet (as a sales medium) will not salvage a poorly run gallery any more than it can extend the credibility and sustainability of an artist who lacks marketing patronage.

The role of galleries, however, is due for a tune-up and potentially an overhaul. Simply stated, artists create artwork, gallery owners do not. Galleries remain retail outlets marking up merchandise for resale. On the issue of price, given the option of dealing directly with the creator or the middleman, most consumers would prefer the source if the retail markup is significant. The process, of course, is never quite as simple because the gulf between most visual artists and ultimate buyers is often wide. The buying public for most artists is generally difficult to access and navigate.

The Bargaining Position of Artists

Even if many artists are not commercially oriented, their bargaining position can change in the traditional selling arrangement as the Web continues to evolve. In the past and still presently, artists typically turn over 40–75 percent of the gross sales price to a dealer for the privilege of exhibiting their work in a gallery storefront or for access to the dealer's selling network.

As with any process, an artist acheives a stronger negotiating position with gallery owners and buyers as the artist's work, reputation, and recognition matures (and sells consistently). A principal role of an art gallery remains to drive up an artist's selling price as the art market recognizes an

emerging or commercially successful artist. This escalation, of course, enables a gallery to cover its substantial operating overhead and provide artists with a livable-income incentive to continue producing work.

The key to successful negotiation with a potential gallery (from the artist's vantage point) is based on the notion of an artist's perceived selling strength. Visual artists currently have several tangible means for establishing sales credibility based on 1) the caliber of previous exhibition outlets, 2) promotional write-ups and critical reviews in industry publications, 3) consistently earning prizes and awards in juried competitions, and 4) the roster of patrons and successful public, corporate, and museum commissions.

It is a reasonably open secret to both detached observers and insiders; the art business tends to be a compact and closed world. Numerous interests jockey, back scratch, and strategize for a concise and small number of coveted, prestigious positions and acclaim. The short list of those in favor and soon-to-be out of favor revolve in a continuum of musical chairs. Despite the inherent politics, fine art is created daily and in large quantities. Some works will endure; most will ultimately fade into oblivion, as do their creators.

Industry insider Anna Somers-Cocks has typified the art world as "a very small, rather secretive world that survives on much back scratching." She noted further, "so much in the art world is in fact ambiguous and corrupt in a petty sort of way."[3]

The industry as a whole is in the process of receiving an overdue airing out. The advancement of the Internet as a communications vehicle will be the engine responsible for this. For most visual artists, traditionally the beginning link in the distribution chain, this overhaul is both a welcome and overdue development.

Two Immediate Artist Strategies for Selling Online

The two most accessible and immediate assets an artist can and should be cultivating online are a Web site and an expanded selling network. This sales network should include Internet auction sites, affiliate partnerships, business and consumer exchanges, barter services, direct mail, licensing outlets, virtual art galleries, and portfolio listing services.

Businesses and creative professionals in all industries are discovering a key component to establishing credibility in today's market is a professional, easy-to-navigate Web site. Whereas innovations like the cellular phone or fax machine may have been a luxury or even novelty twenty years ago, today they are commonplace. As a business, absence from the Web is a serious strike against you. Consumers and potential resellers won't bother to ask you why not. They'll just assume it's not a priority and you're not serious about expanding your selling network. The art world

has been slow to accept this innovation, but the erroneous perception that an online presence is unnecessary is in full retreat as nearly all artists, galleries, and art organizations maintain a Web site.

Never in the course of economic history has an emerging trend like the Internet been burdened with such vaulted expectations. From its rocket growth over the past seven years—eliciting comparisons with the nineteenth-century Industrial Revolution—to the recent meltdown, rebirth, and flourishing of many dot-com enterprises and volatile technology stocks, the Internet has wildly exceeded its initially intended purpose as a universal research tool.

As a fine artist, if you're serious about exposing and selling your work to the largest potential market capability, you've never had a better ally than the Internet.

Within the artistic community, many artists have gone so far as to crown it the new and superior distribution channel to replace the traditional sales pipeline of galleries, brokers, showrooms, and assorted middlemen. This wishful concept has a nice ring to it—the artisan selling work direct to the buying public, empowering greater financial earnings. But is such an expectation realistic? Do most artists want to cross over into the full-time marketing of their work?

The answer varies among artists. Current financial realities insist that marketing expertise and art production are inseparable. The performance of Internet-sourced art sales has not equaled the levels of more standardized consumer products such as books, toys, or electronic equipment. Yet major opportunity trends are emerging. In the process of separating hype from substance, fresh client contacts and international exposure outlets—previously accessible to only a minority of artists—are becoming universally available.

The Internet Eliminates Territorial Sovereignty

The major marketing shift the Internet has eliminated is territorial sovereignty. Artists, galleries, and high-end outlets who have invested many years and substantial money in advertising to cultivate a geographical territory may have sound reasons to feel threatened by using only their traditional marketing approach. The Internet does not respect geography. An artist or gallery reseller can sell just as easily to its regional marketplace as halfway around the world.

This market shift has become the greatest distinction of Internet-based sales. A local art gallery or artist has the identical opportunity to expand its sales base. Rather than viewing the Internet as an intrusion into their limited slice of customer base, artists and galleries should understand that the Internet creates a substantially larger source to draw from. Ignorance

to the possible exploitation of the Internet as a sales medium results in lost sales opportunities. In the end, ignorance or avoidance of the medium may become an expensive luxury.

So how do artisans, galleries, and art-related institutions harness the potential of this global exposure and communications phenomenon? It begins with the simple physical presence of a Web site. As elemental as this sounds, it is only the start of a much more extensive process.

chapter 2

AN ARTIST'S *Web Site*

Should the design of a visual artist's Web site be different from a typical commercial Web site?

If creative output were simply a consumer commodity, then our work could be shrink-wrapped, Universal Product Code branded, and mass-marketed at grocery stores worldwide. Thankfully, art is as diverse and eclectic as its respective creators. It is also traditionally marketed very ineffectually. Why should an artist's Web site be generic if the artist's work is not?

Most art-oriented Web sites I have viewed (hundreds of thousands and growing) are a contradiction in intent. One might assume artists' Web sites would be colorful, insightful, creative, and even a little spicy like the contemporary work they produce. Instead, most are bland, thin in content, institutional in appearance, and offer viewers little encouragement to return.

In effect, most sites resemble a badly offset color brochure. It is little wonder most do not generate significant traffic, much less sales. Such a shoddy appearance is the equivalent of dragging collectors into a filthy, disheveled studio, wiping off a finished work layered in dust, and hoping they will purchase it solely because the artist will be the principal beneficiary of the transaction. Some incentive to buy!

Why Attractive Packaging Is Important

One of the important tools galleries and high-end sales outlets have provided in the sales process is attractive packaging. By maintaining a professional environment and a certain appearance, these outlets have succeeded in stimulating the buyer to pay generously for the work. This high-end retail system has also been a means of enabling art values to appreciate and artists to grow financially along with their reputations.

An artist's Web site should convey this attractive packaging, and an aesthetic design reinforces the caliber of the work. Unlike a retail gallery, an Internet presence is open twenty-four hours a day, seven days a week, year round. It is internationally accessible and should be viewed as a permanent

investment. The Internet itself is not disappearing any time soon, and I've read projections indicating that by the close of the decade, English may be the *second* most utilized language on the Internet behind Chinese. Adaptation is no longer a luxury.

A Web site representing a visual artist should be visually aesthetic. It is the artist's public face. Even if it is not e-commerce oriented nor set up to sell directly to the public, it should reflect an artist's sense of visual design and spatial coherence. Granted, artists are not necessarily computer gifted, much less technologically literate. E-mail is the furthest stretch for many among our ranks.

Contracting Out Concerns

If you're not comfortable designing your own site by learning the necessary software, recruit or hire someone (individual or service) proficient in the skill, but preferably a designer grounded in aesthetics.

The complaint against many art Web sites is they are forgettable, poorly thought out, and not cohesive. Because the Internet is still in its relative infancy, many artists, galleries, and art organizations erroneously view Web sites as an afterthought instead of a priority. The unappealing end result arises when disinterested third parties design the site. Generic template Web sites are as interesting to read as package labeling. Since most artists and art industry organizations have noticeably tighter spending budgets for design services than your average well-funded corporation, you may not be in a financial position to recruit a top-tiered Webmaster. Hiring design on a limited budget does not mean, however, that you have to console yourself with a flawed and amateurish finished product.

Before suggesting creative strategies to get a Web site up and running, I will mention a few that I would advise avoiding:

- A total hands-off approach
- Begging a friend to do the whole project as a favor
- Giving the designer sole possession of your Web site files
- Creating an online vision that is an absolute mystery to the viewer

Your Role in Creating the Design Concept

Whether you do the layout work yourself or work in conjunction with a hired designer, become directly involved with the project. A total hands-off approach is very risky because your Web site is your image, displayed to an international audience all day (and all night, too!), every day. The old cliché that you never have a second chance to make a good

first impression is absolutely appropriate. The Internet audience is oriented around content and speed—speed of access and brevity of attention span.

While your Web site may be a very personal expression to you and a very intimate glimpse of your creative process, certain rules apply. The most elemental causes for a viewer's early exit are if your front index page doesn't fully load on a screen within eight seconds or your presentation is dull. Ever try entertaining a five-year-old for two hours? You get the idea. Begin with simplicity. Simplicity need not connote dullness, however. Keep your design concepts, particularly your index page, aesthetically crisp, focused, and directed toward listing menu options. Each menu option is a branch inviting elaboration.

The Pitfalls of Unclear Objectives

Web sites are organic beings. They should be oriented toward growth and expansion. To be designed and marketed well, they will exact an unprecedented amount of your time and potentially your designer's time. Keep your objectives simple and clear from the beginning and accept the fact your site will require space to expand. You can't say it all with your first draft.

If you are working with a disinterested third party on your personal design, you may have great difficulty conveying the passion and enthusiasm you want your site to express. Pestering friends to complete the work as a favor may not be as economical as it first seems. The work will lack creative spontaneity, enthusiasm, and urgent need to adhere to deadlines. Often your critical project is put on their back burner of priorities. However, there is nothing unsound in paying friends (or bartering artwork) for their design services, and you will likely receive a superior end result.

You will avoid potential conflicts with your Web designer by addressing these two issues up front: who owns the Web site design and who will create future modifications.

Artists are inherently possessive of their creations, and a Web designer is no different. Even if you are paying for design services, be certain that ownership of the end result is yours. This agreement is best done in writing before the work is initiated and payment transferred. You should be given a stored copy of your Web site files on a CD or zip disc.

Make certain your contracted designer will do any changes to the site—an inevitable certainty—in a timely manner. This is a service you will likely pay additionally for, but like any monthly service contract, it is necessary. I know of several peers who have finally gotten a Web presence only to find their hands tied when they want to add new material or upload new photo images of their work.

Why? They've parted ways either artistically or physically with their Web site's designer and have no means of modifying their site. In this scenario, they are either stuck with a static presence that is generating few viewer returns or forced to start from creative scratch on their site, wiser, but economically lighter.

Make your Web site presence a priority, not an afterthought. From a practical perspective, it is far better to start on a smaller scale. Take the time to be organized and concise rather than rushed and unfocused. Remember, your Web presence is likely to be lifelong, so invest the time in thinking of it as a permanent presentation.

ARTIST WEB SITE DEVELOPMENT SERVICES

www.ArtAffairs.com
www.ArtistWeal.com
www.ArtPromote.com
www.ArtQuest.com
www.ArtSales.com
www.ArtSay.com
www.ArtSeek.com
www.Artstream.com
www.CreativeArtist.com
http://DigitalConsciousness.com
www.DCTA.com
www.DuckDogDesign.com
www.FertilePress.com
www.FolioLink.com
www.GalleryWebs.com
www.GlobalArt.net
www.MakArt.com
www.MillenniumArtGallery.com
www.Passion4Art.com
www.Penseroso.com
www.Perduraboart.com
www.Qfolio.com
www.WebFresco.com

Designing Your Own Web Site

A superior Web site is generally created by artists or galleries for themselves. They understand their subject matter best. Their direct authorship eliminates the potential thorny issues of ownership, modifications, and third-party priorities. However, this choice involves time . . . significant time. My simple

rule for understanding Web sites, computers, and technology is to never underestimate the hourly commitment involved with all labor and time-saving devices. With a Web site, you can be certain your time commitment will be stretched to capacity.

There is no absolute recipe for the perfect Web site. There are several basic logistical rules to employ. These design tactics are well documented in Internet and computer trade magazines, e-zines (electronic magazines), and Web sites. Services offering search engine placement for a fee also give some of the best advice. There are as many divergent opinions as styles, so my own voice should not be presumed as the ultimate authority.

Keeping this perspective in mind, the following ideas may serve as sound design principals to employ.

PERSONALIZE YOUR WEB SITE

Your artwork is a very intimate personal expression. There are millions of artists worldwide. Why are you different? The more you can express a personal vision of your art, the world, poetry, politics, hate, love, etc., either verbally or visually, the better the narrative. We are a culture raised on narratives. What's your unique story? With a Web site, you have absolute editorial control.

EXHIBIT YOUR ARTWORK IMAGES

This sounds blatantly obvious, but how you display your work on your site is often as critical as what you display. Bland design layouts devalue the work. Is it an accident that visual images sell better (and for more) when they are sold in a superior frame?

The computer hardware necessary to create images is typically either a scanner or digital camera. The technology has significantly improved on both outlets and prices have dropped—lower-end equipment currently starts at under $100. Do not assume, however, lower-end pricing denotes poor quality. In the example of ink jet printers or digital cameras, as the top-of-the-line equipment improves, the bar for lower-end devices rises. For Internet viewing purposes, lower-priced hardware can work competently.

Numerous image software programs are available and typically bundled at no additional expense with a scanner or digital camera purchase. Adobe Photoshop is considered industry-wide as the professional standard in image software. Both the learning curve and software pricing are steep. Photoshop is also hardware hungry. Unless you already have a pretty powerful machine, you'll doubtlessly want more RAM and processing speed.

Within design circles, Adobe Photoshop is the software resource on which most image-editing books, articles, and workshops focus. Another plus to Photoshop is its open architecture, which accepts third-party plug-ins that add features for important image touch-ups and design manipulations. While most (but not all) other imaging programs accept some Photoshop-compatible plug-ins, no program accepts all of them. With its click-and-correct capabilities, Photoshop is a digital darkroom far surpassing the physical darkrooms of the past.

If Photoshop exceeds your budget and ease-of-use requirements, the reference list below features capable substitutes, accommodating most of your basic image editing needs. The software programs can be purchased through a variety of brick-and-mortar and online computer retail outlets (including their company Web sites).

PHOTO IMAGING SOFTWARE

www.Adobe.com
www.ArcSoft.com
www.Canto.com
www.Extensis.com
www.iView-Multimedia.com
www.NewSoftInc.com
www.Photodex.com
www.PhotoElf.com
www.PrimaSoft.com
www.Ulead.com
www.V-Com.com

Limitations of Display Monitors

Computer monitors, both cathode ray tube (CRT) and flat-screen liquid crystal, impose certain resolution limitations on the display of visual images in terms of their dots per square inch (dpi). Whereas you may be able to scan a professionally taken photograph of your work at 1200 dpi or utilize a digital camera at the same resolution, the CRT will only display a maximum resolution of 72 dpi. This means no matter how clear and detailed your image is, it will lose much of its definition once displayed on the Internet.

The resulting fuzziness is not entirely bad, because it discourages the pirating of high-resolution images for commercial reprint purposes, but it may handicap your presentation if you want to exhibit extensive detail. For this reason, the background should flatter the displayed image. Most

Webmasters prefer neutral backgrounds, to accentuate the color compo-nents of the work; however, you may wish to employ a contrary strategy for work neutral colored in composition.

Image Terminology

Image photography on a Web site should be recognizable by Windows, Linux, and Unix (Macintosh) operating systems and displayed in either of two formats: JPEG (Joint Photographic Experts Group) or GIF (Graphics Interchange Format). The most widely accepted format is JPEG, condensing larger TIFF (Tagged-Image File Format) and EPS (Encapsulated PostScript) images. JPEG is a 24-bit (16 million colors) format, good for high-quality graphics and photographic images.

TIFF is an open data-interchange format for pixel-based data. It has been through many revisions, but in essence it is a format that allows software to modify pixels in various ways. EPS is a sealed box to transport pixel data. Certain PostScript-based drawing packages such as Adobe Illustrator or Macromedia FreeHand can only work with EPS files. The EPS version will contain exactly the same pixels as the TIFF version, but with an EPS wrapper that protects those pixels against the meddling of outside forces.

The second most common visual format is GIF, initially introduced for use with Compuserve, but not compatible with a growing number of Internet auctions sites. GIF is an 8-bit (256 colors) format, best for simple graphic images.

Both JPEG and GIF file formats condense extensively stored pixel information embedded in much larger TIFF and EPS file formats. Both are the standard image format for the World Wide Web. The net effect is that some variation in color may result between the much larger file and its scaled-down version, but the practicality of storing smaller files is invalu-able and essential for prompt downloading times for online viewers.

This is similar to the visual discrepancy buyers have complained about for decades between photographic prints and slides compared to original artwork. Unfortunately, it is a necessary compromise and unlikely to be resolved to everyone's satisfaction.

Make Certain Your Index Page Loads within Eight Seconds

As mentioned earlier, the load time on a browser has a profound impact on viewer stickiness or the length of time people view your site. While the state-ment "good things come to those who wait" is often true, it is imperative that your front page loads on viewers' screens within eight seconds or less. You can still maintain visual images (the slowest loading items), but keep them to a thumbnail format so the memory size of your page is smaller. Your initial

page should serve more as a table of contents than an all-encompassing explanation. Tantalize, tease, and keep them clicking for more.

Slow response times for sites are not always the result of overweighed layouts. Often a slow Web site loading time is the fault of the Web-hosting service. If the hosting service is bombarded with traffic or is malfunctioning in any way, a site will take longer to access initially. The situation is particularly noticeable among smaller Web sites, such as individual artists' sites, since these typically use a Web-hosting service (with many sites sharing service space) instead of running their own in-house servers. Holidays and other heavy "traffic" periods will compound this problem, just like holiday and rush hour commuter traffic.

Performance Monitoring Plan for Your Web Site

Is there a tangible solution to this problem? In many instances, no. Traffic spikes, delays, and server problems are a fact of existence on the Internet. However, performance monitoring of your site is an invaluable tool for minimizing the frequency of these inevitable bugs. A performance-monitoring plan should include four basic issues:

- The Web site is "online," available to visitors
- Response to page view requests is quick and accurate
- Pages appear without significant delay
- Internal and external links function correctly

Once your Web site is operational, it is easy to take for granted that it is always navigational. This certainty, however, is not always accurate, and if you don't visit or monitor your Web site regularly, you may be the last to realize that there is a problem. If visitors receive an "404 Error" on their browser when trying to access your site, they literally hit a brick wall and often will just assume your site is not operational. An additional discouragement is hyperlinks originating from your site (particularly directed to other artist sites) that are no longer valid.

On the Web, several excellent free and fee-based services exist to troubleshoot these problems and conduct diagnostic evaluations of your site, such as checking each link and reporting any malfunctioning. These are very valuable services because once you start expanding your site extensively, it becomes more difficult to track non-functioning items. A series of additional Web statistics services are also available offering free hit counters (that is, the device that counts the number of visits), but more importantly, analysis on the sourcing of your visitor traffic. This becomes very important if you are spending advertising money for banner ads, affiliate programs, or search engine rankings.

WEB SITE TROUBLESHOOTING SERVICES

www.DeepMetrix.com
www.HitBox.com
www.Hitwise.com
www.MyComputer.com
www.NetIQ.com
www.OneStat.com
www.Surf22.com
www.WebSTAT.com

WEB SITE HIT COUNTERS

www.CQCounter.com
www.Counter.com
www.CounterCentral.com
www.DigitalPoint.com
www.Easy-Hit-Counters.com
www.FreeCounters.ca
www.FreeWebWare.com
www.GoStats.com
www.HitBox.com
www.LinkCounter.com
www.RapidCounter.com
www.RoboCounter.com
www.SiteMeter.com
www.softNgine.com
www.StatCounter.com
www.SuperCounter.org
www.SuperCounters.com
www.TheCounter.com

E-COMMERCE SHOPPING CARTS

www.Ait2000.com
www.1Automationwiz.com
www.CCNow.com
www.Clickbank.com
www.DigiBuy.com
www.GloBill-Systems.com
www.Gta-Tech.com
www.HitBox.com
www.IBill.com

www.iCode.com
www.MonsterCommerce.com
www.Nexternal.com
www.PayPal.com
www.PDGSoft.com
www.ShopFactory.com
www.VCart.com
www.WorldPay.com
www.X-Cart.com

Evaluating Your Web Site Host

Availability is a critical measure of your Web site performance. A simple technique for keeping a watchful eye on your site is to make it the home page of your browser on your computer. You'll see your Web site every time you are about to browse the Internet. And, if you have trouble accessing your site, you'll know right away that your viewers are experiencing a similar problem. If this problem persists, contact your host's technical department.

Keep in mind that currently, there are as many Web-hosting companies and service combinations as colors on the Pantone index. As a consumer, you are in a negotiating position of strength to acquire the best fit for your needs. Most hosting services offer turnkey packaged accounts based on such features as storage memory, access speed, published monitoring reports offered, access to technical assistance, number of domain names hosted, and provided e-mail accounts.

There are important considerations you'll have to evaluate in determining your next hosting service.

TECHNICAL SUPPORT

When you need help or assistance you'll want to make certain you have immediate access. Some Web hosts offer phone support or even text instant messaging (IM) options. Many of the competitively priced hosting packages are limited to e-mail assistance. This limitation may prove incompatible to your timeframe needs. Make certain that good tech support is in place as there's nothing more annoying than needing assistance with your site and not being able to get it. The promptness and efficiency of their initial contact with you in the sales process is often a good indicator of what is yet to come.

SET UP/MONTHLY FEES

Some hosts charge an initial set up fee to get your site up and running on their server. This is rarely publicized in their promotional offering and

generally delegated to the fine print of their service agreement. This expense is an important comparative feature and may often range between $10 and $50. Monthly fees typically range from promotional offers starting at $7.99 to $39.99 for mid-size hosting packages, depending on the scope and services offered. Numerous reliable Web packages, ideal for artists and galleries, can be contracted at $20 monthly.

STORAGE SPACE REQUIREMENTS

How much storage space a host is willing to provide is important and usually the basis for major price discrepancies. Visualize the maximum size requirements of your site when deciding how much space you really need. Generally, 100 megabytes is sufficient for a small site, but as your marketing and design expertise improves, so too will your space requirements. Most hosting services have option plans, enabling storage space upgrades as your demands expand.

UPLOADING FILE AND FTP ACCESS

Even if you plan on using popular Web design software such as Microsoft FrontPage, Adobe GoLive, and/or Dreamweaver to manage your site, you'll still need to have FTP (File Transfer Protocol) access. Access typically comes standard, but one should never assume it's included. Make certain you keep your user name and password in a safe place. You'll use FTP to set file permissions and to upload your files to the Web server. Telnet can be very useful for troubleshooting CGI (Common Gateway Interface) scripts and changing server configurations. (Note that there are some servers that will not grant telnet access.)

COMMON GATEWAY INTERFACE ADDITIONS

This is a very important component if you're planning on adding any sort of interactivity to your site, such as forms, shopping carts, guest books, etc. This feature usually comes as standard equipment, but some of the cheaper hosting programs leave it out entirely.

E-MAIL BOXES AND POP 3 ALIASES

An important and practical communication element is to use different e-mail aliases with your domain name. For example, if your domain is *www.americanartist.com*, you may want to set up separate addresses to sort your mail, such as *paintings@americanartist.com* or *support@americanartist.com*. The e-mails may all funnel into the same mailbox, but you can establish

sorting filters at your end, making customer service a whole lot easier. If you have what's called a wildcard account, you can set up as many aliases as you like. If you have other associates who will need their own (private) boxes, check with the Web host to see how many boxes your host will allow.

STATISTICS

Once you start getting traffic, you'll want to know where it's originating from and what pages of your site are being visited most frequently. Some Web hosts will include statistical tracking with their standard package or at least give you access to your log files. Upon access, you can operate third-party software to run reports on your site's traffic.

BANDWIDTH

Bandwidth translates into how much data can be transferred in a month's time. This shouldn't be a concern unless you're getting a ton of traffic (your hoped-for objective). Be aware most hosting services do have limitations on what they'll allow and contractually provide. Any overage to this limitation is generally billed additionally (as stipulated in your contract).

OTHER HOSTING OFFERINGS

There are additional subtleties involved in your host selection, such as:

- Do they offer autoresponders?
- Are secured server options available for payment transactions?
- Is backup of all their hosted Web sites available in case of emergency or disaster?
- Is assistance provided in programming or design work, if needed, at an hourly rate?
- Is shopping cart software available?
- Are customized forms, like feedback or order forms, standard with your account?

Shop judiciously for your hosting service, as once you've made your commitment, you're often locked into six-month or annual agreements. Transferring all of your files can be a time-consuming process, so it's better to make a sound decision initially rather than a repeat one based on an unfortunate experience. Choosing a good host is essential to the success and reliability of your online presence and an important component of your selling team.

WEB SITE HOST COMPARISON SERVICES

www.AllAboutYourOwnWebsite.com
www.CreateAFreeWebsite.net
www.FindMyHosting.com
www.HostCompare.com
www.Hosting-Comparison.com
www.Hosting-Review.com
www.HostPile.com
www.HostSearch.com
www.HostVoice.net
www.NetFlipper.com
www.Upperhost.com
www.WebHostingInspector.com

WEB SITE HOSTING SERVICES

www.1and1.com
www.A-1Hosting.com
www.AITcom.net
www.AllWebCo.com
www.ApolloHosting.com
www.BizLand.com
www.Crosswinds.net
www.EasyCGI.com
www.FatCow.com
www.GlobalSpaceSolutions.com
www.Globat.com
www.HostRocket.com
www.Infinology.com
www.Interland.com
www.InternetPlanners.com
www.Ipage.com
www.IpowerWeb.com
www.Jumpline.com
www.LunarPages.com
www.Neteze.com
www.Netfirms.com
www.NJ-Web-Hosting.com
www.OCO.net
www.PowWeb.com
www.SimpleURL.com

www.StartLogic.com
www.TheArtistHost.com
www.Verio.com
www.Virtualave.net
www.WebsiteSource.com

Free Web Site Hosting Programs

Several online Web sites offer hosting services for free, but the customary catch to their generosity is you must display a required number or percentage of banner ads on your index page. These ads are the primary source of financial support for such a site. However, this clutter may greatly obscure the viewing of your own Web pages. Another requirement often imposed by free hosting services is that participating sites must be non-commercial in nature, meaning you cannot sell your artwork directly. Strict storage size limitations also may inhibit the breadth of your intended design.

You must include their URL as the primary domain name when promoting your Web site, relegating yours as a subdomain in the main address. Doing so will extend the length of your Web site address to the point where it will become very difficult to remember. Furthermore, search engines generally will not rank Web sites hosted by free hosting programs as primary domains.

Still, the appeal of anything complimentary in this age of escalating Internet fees is reminiscent of the good old days when visionaries thought that the Internet was incapable of commercial taint.

FREE WEB SITE HOSTING SERVICES

www.150m.com
www.50Megs.com
www.Angelfire.com
www.Blogger.com
www.Bravenet.com
www.DotEasy.com
www.Dreamwater.com
www.Freeservers.com
www.FreeWebHosters.net
www.FreeWebSites.com
www.FreeWebsiteHosting.com
http://GeoCities.Yahoo.com
www.Ni5.com
www.WebsiteDesignForFree.com

Memorable Domain Name

The obvious domain name for your Web site would appear to be your own full name. Unfortunately, many domain names of such type are already taken. For example, the William Smiths of the world are out of luck; a California real estate broker has already claimed this distinction.[1] It seems symbolic that a land property reseller is heir to this particular name legacy. Domain name investment (like property) can indeed become permanent ... unless the owner neglects to renew the annual registration fee.

If your full name is not available, you may consider what some artists do in utilizing variations such as initials, first names, last names, etc. The easier it is to remember, the more likely your visitors will return. Be very patient in finding something workable. Some artists and businesses prefer short catchy phrases for names, since single word names, particularly with the .com suffix, have long since been claimed (as it still remains the most popular and recognized).

The land grab for easily memorable domain names has escalated to over tens of thousands of domain names internationally every day. Thousands likewise expire weekly due to merchants, organizations, and individuals failing to renew their precious or speculative name identifications. Back when the suffixes for domain names were limited to .com (commercial or individual), .org (nonprofit organizations), .net (networks), and individual countries such as .ca (Canada), .co.uk (United Kingdom), .fr (France), the name availability pool was somewhat restricted and limited.

DOMAIN NAME GAME MADNESS

During the mid-1990s Network Solutions (now VeriSign, at *www.versign.com*) was the sole source of registering legal domain names. A sub-market of domain name resellers, sometimes cynically called cybersquatters, emerged in this monopolistic system trying to cash in on the ferocious demand of companies to capture the ultimately memorable domain name, with the preferred .com suffix. As naming rights became valuable commodities, the resale pricing often mirrored the insanity of the dot-bomb era.

Among the documented top prices included: Business.com ($7.5 million, November 1999), AltaVista.com ($3.3 million, July 1999), Loans.com ($3 million, January 2000), Wines.com ($3 million, September 1999), Autos.com ($2.2 million, December 1999), Express.com ($2 million, December 1999), Men.com ($1.3 million, December 2003), WallStreet.com ($1 million, April 1999) and eFlowers.com ($1 million, February 1999).[2]

The selection pool for finding the right name for Web sites broadened with the mid-2001 expansion of additional suffix names by ICANN (Internet Corporation for Assigned Names and Numbers). While the expansion was

initiated with good intentions—to open up the potential selection of names—the additional extensions have been widely criticized as compounding the naming chaos further.

The seven introduced in 2001 included 1) .biz (business and corporations); 2) .info (information-based services such as newspapers, libraries, etc.); 3) .name (for individuals' and personal Web sites); 4) .pro (professions such as law, medicine, accounting, etc.); 5) .aero (services and companies dealing with air travel); 6) .coop (cooperative organizations); and 7) .museum (museums, archival institutions and exhibitions).

The seven domain extensions became the first global domains approved by ICANN in over a decade, in addition to .com, .net, and .org. The narrative has only begun as ICANN has given preliminary approval to additional extensions such as .mobi (small Web pages for cell phones) and .jobs (human resource and job search–related sites). Other suffixes pending approval include .asia and .xxx, so the window of choice over time will be expansive.

Should any of these newly introduced suffixes ever match the popularity and prevalence of .com, the Internet will be an even more complicated intersection for navigation. This seems a certainty based on precedent.

The vast expansion of extensions increases the burden for individuals and organizations to protect against unauthorized uses of their names by the new, aggressive marketing by recognizable country affiliations such as .cc (Cocos Islands), .my (Malaysia) and .tv (Tuvalu Islands).

Currently, there are over 200 current country suffixes available, with more certainly to follow. This deregulation of the domain-naming monopoly has made registration services numerous and price competitive.

DOMAIN REGISTRATION PRICING AND SERVICES

Pricing and service options for domain names have likewise changed from the original $35 annual registration fee. Many services have cut registration fees to as low as $8–12 annually with discounts offered for bulk name registrations. A domain name must be renewed annually, so multiyear renewal packages are typically offered on a supplementary basis.

Today, with the sheer number of new Web sites being uploaded daily— and name variables, free URL forwarding service options, and search engine submission services becoming available—expect the prices to continue to fall and comparative confusion to reign.

DOMAIN REGISTRATION SERVICES

www.123CheapDomains.com
www.Afternic.com
www.AllDomains.com

www.BuyDomains.com
www.DiscountDomainRegistry.com
www.DiscountDomains.com
www.Domain.com
www.DomainIt.com
www.Domainregistration.com
www.DotDealers.com
www.DROAmerica.com
www.Easyspace.com
www.Enom.com
www.GoDaddy.com
www.GotName.com
www.HostColor.com
www.iGoldRush.com
www.NamesAreCheap.com
www.NameCheap.com
www.NameSecure.com
www.NameZero.com
www.PlanetDomain.com
www.Register.com
www.RegisterNames.com
www.SimpleURL.com
www.TargetDomain.com
www.VeriSign.com

DOMAIN NAME RESALE BROKERS

A secondary source of domain identity purchase is resale specialist brokers, but you may pay dearly for your name preferences. Broader buying options have induced a measure of sanity to the pricing levels of many domain names, but as certain sites continue to cultivate wide viewing audiences, their unique following often prompts asking prices in excess of a million dollars. For art-related .com domain names, the top-tiered prices average between $500 and $5,000 with plenty of room for negotiation.

DOMAIN NAME RESELLERS

www.Afternic.com
www.Auction2.net
www.BuyDomains.com
www.DomainMart.com
www.eNom.com
www.FXDomains.com
www.GreatDomains.com

www.Igoldrush.com
www.iwantmy.com
www.Register.com
www.SnapNames.com
www.URLMerchant.com

DOMAIN NAME LISTINGS

One additional alternative to the name grab game is to subscribe to a weekly newsletter or database service itemizing domain names under the .com, .org, and .net suffixes that have expired due to nonrenewal by the owners. The weekly listings number in the thousands. In many instances, these domains were name speculations gone bad or, more appropriately, left unsold. Once you've scanned a few lists, you'll understand why. However, many good, sound, and memorable names are littered throughout and now available for registration. Be nimble—domain name brokers use these services regularly and build their resale inventory from these lists of names not renewed due to negligence or failed operations. The fees for these newsletter databases vary (some are complimentary), but average between a reasonable $10 and $50 annually plus registration fees for any names you secure.

EXPIRED AND NEWLY AVAILABLE DOMAIN NAME LISTINGS

www.BizMint.com
www.eNom.com
www.DomainDuck.com
www.Domain-Registration-Bank.com
www.DomainInspect.com
www.DomainsBot.com
www.DomainToolBox.com
www.ExpiredDomainSleuth.com
www.ExpiredTraffic.com
www.NamesExpired.com
www.NameWarden.com
www.OnSnap.com
www.RedHotDomainNames.com
www.SnapNames.com
www.WebSiteHostDirectory.com

WHY YOU SHOULD OWN YOUR DOMAIN NAME

In the final analysis, there are a number of legitimate reasons to own your own domain name. The annual investment fee is nominal relative to the

benefits derived. When you have your own domain name, the address of your Web site will be in the form *www.YourWebsite.com*. Conversely, if you place your Web site on one of the free hosting services or servers, the address of your Web site will resemble *www.afreeWeb_site.com/yourWeb_site*.

The only way to establish a long-term successful presence on the Internet is by building up credibility with galleries, artists, curators, museums, etc. Having your own domain name is a good initial step. Your contacts will feel more comfortable dealing with an established and credible name. Furthermore, search engines give primary emphasis to the home page of a particular domain rather than a site hosted by a free service (since you don't own that domain). The result is a potentially substantial loss of visitor traffic.

Integrating Color into Web Site Design

Black is wonderful for eveningwear and neutrals are great as trim, contrast, and even background, but the best Web sites integrate color—and lots of it. Of course, if your art style is minimalism, perhaps neutrals are more appropriate. To put the issue in perspective, color televisions outsell black and white. Internet viewers embrace color.

Clarity of Vision

There are numerous schools of thought hatching every hour, presuming that real art possesses a certain Gnostic quality, rendering it mysterious and inaccessible. This may be a stimulus for certain artists' unappreciated creative egos, but bad for the sales of their work. The crossover between an artist's philosophies and interest in presenting work may blur the focus of a Web site.

A potential buyer or viewer is not obliged to share an artist's point of view and may outright disagree. Artists have often varied from the popular contemporary viewpoint on a variety of issues, but many of the most ardent in their dissent have been recognized for the quality of their work.

It is not a major compromise of your integrity to segregate your Web site into orderly segments such as image displays, press and exhibition listings, hyperlinks, e-commerce order forms, etc., keeping these distinct and separate from potentially divisive areas like the infamous artist statement, political perspectives, or varied complaints against the injustices of existence.

Allow your site visitors the option to view and purchase your work and evaluate your motivations in a comfortable environment, as they are accustomed with any other commercial site. Art purchasing online or through retail channels is not necessarily an intellectually or culturally enriching

experience. Buyers often have multiple motivations for making a fine art purchase irrespective of the artist or theme of the work itself.

Among such motivators may include simple décor color compatibility, an undefined sense of visual pleasure, or even the notion that the work is a sound financial investment. In a significant number of instances, it is preferable that artists not explore too deeply into the buyer's reasoning. Otherwise, a great quantity of work would never leave the studio.

Content Remains King

A single-note song becomes monotonous. Vary your content. Modify your index page periodically. Give people a reason to return. If you have very little to say or elaborate on with regard to your work, link your site to other content-wealthy Web sites or artists. Link your site to art publications, art reference groups, and organizations related to the themes of your work. Frequently, these sites will provide a reciprocal link to your Web site, drawing some of their traffic in your direction. Even if they don't, their presence may provide reference value and further insight into your techniques and personal vision.

Still, your Web site is a perfect forum to discuss what your art means to you and First Amendment rights aren't a consideration when crafting your own material. Go ahead and be controversial, but if your viewers find your material offensive, they have the editorial prerogative to leave and promptly. Rest assured, they will.

Since the English language predates each of us, a spelling and grammar check utility is an excellent tool to utilize in proofing your work. A thesaurus should be employed to vary your adjectives and nouns. The fine art industry has a unique language, but remember, not everyone is equally conversant. Likewise, since the average American reads at approximately a sixth grade level, don't assume every viewer is pursuing a doctorate degree in English literature or art history.

If your content is oriented around a subject of general interest to fine arts or other artists, you may wish to consider submitting those individual Web pages to search engines. This expands the potential references to your site enabling greater traffic flow.

Font Use and Integration

Typography is an art form and the proper representation of fonts in text can be very influential in maintaining reader interest. The size, style, and color of fonts may create a mood, grab attention, and increase the ease of viewing.

Fonts are primarily constructed in two versions, serif and sans serif. Serifs are short lines that stem from, and at an angle to, the upper and lower strokes of the letters. It is an accepted truism that the serifs lead the eye through the line of type, making it easier to read. (For example, the running text in this book is set in a serif face.) Sans serif fonts lack these extra lines. This composition of serif or sans serif is about the only stable rule involving fonts. Millions of fonts exist, from handwriting-like scripts to ransom note fabrication, and many can be easily downloaded from the Internet.

The dilemma is not so much a lack of selection, but finding a font available on your viewer's display screen. For instance, if you integrate a custom font into your Web site design, it is likely that the identical font will not be available on your viewer's system folder. Thus, your heightened sense of aesthetics will be for naught as the viewer's browser will merely convert the font to one closely resembling yours (how close is open to debate) or bitmap the font, complete with an extensive array of jagged edges. Not the pretty site you necessarily envisioned.

One way to ensure a view sees the artistry in your font selection is to create JPEG or GIF images from blocks of text, buttons, or headline titles. This may also inundate you with additional files to store on your server, but it will achieve the desired effect of integrating custom fonts.

The goal of most font layouts is harmony and readability. These suggestions may suit your objective:

- Contrast backgrounds with text, e.g., light text combined with dark backgrounds.
- The color of the text should amplify the mood. For example, red text for excitement or passion, blue text for calm or tranquility, or green text for greed.
- Alter your headline colors from your text copy to attract attention.
- If you're using multiple columns don't tombstone headlines by placing them side-by-side.
- Highlight keywords or phrases by use styling tactics such as bold, italics, underlining, strikethrough, color changes, etc.
- Make the sizing of the text proportional. Larger text for headlines and subheadings and smaller sizing for text. Caution is necessary with sizing; if your grandparents or farsighted viewers can't read it, it's too small.
- Don't overdo the use of capitalization and exclamation points. According to the (only somewhat) codified rules of the Internet, text that is entirely capitalized is equivalent to yelling. Most individuals' ears—and eyes—can tolerate only SO MUCH SCREAMING!!!!! Few things in life justify such intensity, and it's unlikely your Web site will

set the precedent. Judicious use of capitalization and exclamation points can be very effective; use in modest proportions.

■ Strive for subtlety: make using sunglasses optional. Don't overwhelm the reader's eyes by using only very bright text colors and backgrounds. Subtlety is usually more effective than overkill.

Make Your Site Easy to Navigate

Most Web sites are organized in a hierarchical manner for navigational ease. Make certain that your links actually connect to where they are supposed to and your viewer doesn't have to waste too much time figuring out the focus and contents of your site. The overall look of a site may also vary depending on the size of the monitor screen. For instance, a laptop screen will not portray the detail or sizing perspective of a nineteen-inch, flat-screen, liquid crystal monitor.

Streaming Audio and Visuals

As a novelty, you may also consider streaming in audio links such as interviews with yourself or perhaps more detailed explanations regarding your work. Video clips of exhibitions, your studio environment, or interviews are welcome additions to personalizing the experience. The creative possibilities are as limitless as your imagination.

Flash media programs offering animation and movement can be an interesting introduction, but too often they become annoying if someone is visiting a Web site to research specific information. It is unlikely they will always want to view your entire presentation with each visit. Make certain your elaborate flash programs can be disabled by a link, if the viewer chooses. There are several emerging sources of brokered flash and video programs listed below, enabling integration into your Web site. Since Napster (*www.napster.com*) paved the way for Peer-to-Peer (P2P) Web sites in 2000, sharing files has crossed over from the music industry to the video and photo imaging industries.

One problem with some of these ornaments is your viewer may require special plug-ins or software to view the features. The most common software are QuickTime, AVI-Audio Video Interleave, and Real Player. Some Web sites provide the necessary downloadable software to accommodate these functions. Make certain you offer a link to one of these download services such as CNET (*www.cnet.com*) to enable your viewer to witness your handiwork.

This area of Flash design technology is evolving at a swift pace, but has yet to be commercialized extensively. Additional universal Web site bandwidth and storage capabilities will speed the adaptation process.

FLASH MEDIA AND VIDEO DOWNLOADS

http://Downloads-ZDNet.com.com
www.Flashiness.com
www.FreeDownloadsCenter.com
www.LinuxCentral.com/flash
www.Macromedia.com
www.Mix-FX.com
www.Sorenson.com
www.SoundRangers.com
www.StreamingMediaWorld.com

FREE DOWNLOADABLE SOFTWARE

www.Analogx.com
www.Bravenet.com
www.CNET.com
www.Download.com
www.DownloadLab.com
www.FreeDownloadsCenter.com
www.FreewareFiles.com
www.FreeWebTools.com
www.JavaScriptKit.com
www.Jumbo.com
www.Newbieclub.com
www.Shareware.com
www.TheDownloadPlace.com
www.Tucows.com
www.Willmaster.com

Allow for Interaction

It is reprehensible to me that a number of Web sites have no mechanism for viewer response. These sites fail to reference e-mail addresses to contact the Webmaster and/or the artist and have absolutely no interactive opportunities. Adding a chat room, guest book, message board, blogging mechanism, or response forum to your site often extends the length of time a viewer stays and often motivates a return visit. It is not necessary for you to build a unique online community to sustain a chat line. Several online sites listed on the next page allow you to seamlessly integrate chat services into your site by linking directly to their service and community base. These free services allow you the opportunity to fortify your own Web site without the necessary investment of administrative time.

Blogs in particular have become popular outlets for personal expression as they represent the ultimate freedom-of-speech outlet. As a free flowing journal format, they invite interaction and most importantly expression. Many of the larger art industry Web sites have introduced their own blogging outlets as a means of bringing users for return visits. A well-edited, enlightened blog can be a useful means of identifying the motivations behind your artwork and enabling a direct link with your buying audience.

GUESTBOOK SERVICES

www.321Free.com
www.Advanced-Submitter.com
www.A-Free-Guestbook.com
http://dArt.Fine-Art.com/community.asp
www.Dreambook.com
www.FG-A.com
www.PHP-Soft.com
www.Recommend-it.com
www.TheFreeCountry.com
www.WebScriptsDirectory.com
www.WebtimeTools.com

CHAT LINES/BLOGS/MESSAGE BOARD SERVICES

www.Aestiva.com
www.bBlog.com
www.Blogger.com
www.BlogHarbor.com
www.Camfrog.com
www.ChatRoomWeb.com
www.DrawChat.com
www.Globalchat.com
http://Google.DigiChat.com
www.IRCXpro.com
www.InfoPop.com
www.OnlineInstitute.com
www.PalTalk.com
www.ParaChat.com
www.Server.com
www.UserLand.com
www.WordPress.org

Rules? What Rules?

George Bernard Shaw, a true credit to individualists, was once quoted as saying, "Reasonable people adapt themselves to the world. Unreasonable people attempt to adapt the world to themselves. All progress therefore depends on unreasonable people."[3] Remember, design ideas are merely suggestions and certainly not the ultimate gospel. Innovation is about breaking established rules and setting your own standards. Most artists have a healthy sense of anarchy.

A major concern to many computer users (especially if they are unfamiliar with HTML or other Web site composition languages) is precisely how difficult Web design software is to learn. I faced this crossroad myself in mid-1999 and found most Web site design programs such as Adobe GoLive, Dreamweaver, Frontier, Microsoft FrontPage, Canvas, and WebSavant feature excellent tutorials. In my case, I literally forged my way through my first Web site draft and for better or worse, completed my initial Web site within two months. Over the successive twelve months, I probably modified every single original design concept except the black background (my sole carryover, even today). This process is an essential part of the trial-and-error learning curve.

As I learned new techniques and skills, I personalized these lessons into additional design elements. Be patient with yourself. In terms of ease of use, most Web site development software is the equivalent of a good desktop publishing program, learnable on a need-to-know basis, but capable of opening up innumerable creative avenues. Just as with our own creative processes, borrowing design ideas from other sites is rampant and for the most part acceptable. There are only so many truly creative individuals roaming this planet, so don't be afraid to embellish upon a good idea.

Global Considerations Regarding Language and Currency

When analysts pause to take stock of the dizzying Internet phenomenon, several emerging trends become obvious regarding global participation. Currently, American Internet users compose approximately 45 percent of the global Web audience,[4] but that figure has been declining steadily each year as the rest of the world becomes more wired in. English is the primary language for current Internet use but is a minority language in the world (8 percent of the population). Ironically, most of the online translation efforts for foreign tongues have currently focused on European languages.

The sleeping population-giant of Asia has already made it presence felt in global trade and will ultimately alter the composition of the Internet. There remain foreign and domestic policy obstacles, particularly within

China, but over time, the sheer number of people accessing and purchasing over the Internet will reshape its user base in large proportions. It is not irrational to imagine that Chinese Internet users and Web sites alone will outnumber English ones within another decade.

What does this mean to visual artists and galleries? After all, it is a World Wide Web.

Very simply, if you wish to sell your art globally, you'd need to introduce translator programs into your Web site so that you can accommodate potential viewers in their maternal language. Viewer friendliness is as important overseas as with your American clients. Babel Fish, a free and easy-use software program can merge nicely into your Web site, providing it with an international flavoring. AltaVista (*www.altavista.com*) distributes the program, enabling translation to and from English, Dutch, French, German, Greek, Italian, Spanish, Portuguese, Russian, Japanese, Korean, and Chinese. The program will literally translate text or an entire Web page, leaving all of your images and layouts intact. Best of all, it only requires a free link to access. By simply adding a link and an explanation on how to use it on your index page, you multiply your potential audience base.[5] Some translations may be quite literal, and therefore not precise, but certainly the gist will be there and the effort on your part appreciated.

There are several free or low cost additional translator Web sites and software packages available on the Internet, making great additions into your site.

TRANSLATOR SERVICES

http://BabelFish.altavista.com
http://Europa.eu.int/comm/translation
www.FreeTranslation.com
www.SYSTRANsoft.com
www.TranExp.com
www.Word2Word.com

There are other cultural subtleties to consider aside from simply language. For instance, consider adding a currency converter or link to an online service to your order or e-commerce page(s). Not only does this reassure a potential international buyer that they understand the cost of their selections, it again demonstrates sensitivity to their needs.

CURRENCY CONVERTERS

www.OANDA.com
www.X-Rates.com
www.Xe.com

International Shipping and Delivery Considerations

Try to offer multiple international shipping options. The most convenient carrier for you may cause logistical nightmares for overseas buyers in the form of processing fees to confirm an item's duty-free status or special handling considerations.

Present information so everyone can use it. Outside of North America, toll-free numbers usually don't work, so provide an alternate, regular area code number. Similarly, translate into numerals phone or fax numbers that spell out a cute or memorable word, since overseas telephones often lack letters on their keypads.

With respect to collecting customer information on registration, feedback, or order forms, don't force users to fill in a ZIP code or postal code—some countries don't have one. Also, the date "8/11/57" signifies August 11, 1957, in the United States, but November 8 in other countries since they reverse the month and date order. Provide the names of months, not their numbers, as selection options.

Exercise caution and common sense in battling credit card fraud. A huge, urgent order from overseas appearing too good to be true . . . may in fact be just that. Fraud and scams are prevalent on the Internet. Promised foreign cashiers checks are frequently worthless but time-consuming to actually determine. Due diligence may include follow-up telephone calls to the source of the order and to the credit card's issuing bank (many have U.S. offices) to confirm the validity of the card number and payer.

It is not a bad idea to have buyers fax a copy of their order request along with a copy of both sides of their credit card and their personal signature. The confirmation process involves a certain amount of follow-up effort, but anything you verify is ultimately self-protective and prudent. Traceable shipping also helps prevent charge-backs. The bottom line is once your work leaves this country, it will be very expensive and nearly impossible to retrieve it.

One suggestion for overseas payments is to encourage your buyers to use one of the many emerging online payment Web sites, which are both secured and encrypted. By having your prospective client, for instance, prepay shipping expenses, you are enabling a trial test, confirming their intentions are honorable and source of payment reliable.

If you find yourself on the buying end, avoid rigid exclusions. Of the few merchant service companies (banks who issue credit cards) and affiliate programs accepting foreign customers, most pay via paper checks. In Europe, checks often prompt higher handling fees, so electronic transfers such as the SWIFT system, tend to be more normally employed.

As complicated as the selling process is with domestically based customers, the level of uncertainty and potential setback is amplified through

overseas transactions. Just as cultivating relationships with your American buyers is imperative, the same effort will likely be true and perhaps even more so with a foreign buyer. Once a bond of trust and a few successful transactions are completed, however, you might discover this source to be one of your most reliable and productive supporters.

Getting beyond the initial inquiry stage may require multiple e-mails, telephone conversations, written correspondence, and time, but the effort is generally worthwhile and mutually beneficial.

PROTECTING YOUR *Online Images*

One of the premier concerns among visual artists exposing their creative work over the Internet is the fear of piracy and/or unauthorized duplication and reuse.

The Impact of Freely Traded Music Files

The concern is both justified and very timely. During 2000, a renegade Web site, Napster (*www.napster.com*), pioneered the concept of file trading over the Internet on a mass scale. In this instance, Internet users freely traded compressed digital music (MP3) files through a central platform. The Web site was ultimately shut down by litigation and reborn under new ownership and management, which now charges a fee for its use.

Napster's original legacy of introducing unregulated file trading without accompanying royalty payments to either the recording artist or music industry sounded a wake-up call to the music industry. This scenario also introduced the direct and long-term financial perils of unregulated distribution to the creative community.

Was there a massive, public outcry over recording artists not being compensated for their creative output? In a word, no. Instead, an important lesson derived from the experience was this: Consumers feel minimal guilt over trading—stealing, really—creative output without compensating the creating artist. Should visual artists be likewise concerned that their unique images are prey to commercial pirates? Absolutely.

In case you hadn't noticed, the barn door is already wide open for pirating visual images. Ask any commercially licensed screenprinter or visit any weekend flea market worldwide. Unauthorized image duplication and reproduction is a multibillion dollar business and a lucrative, easy-to-establish industry.

The Emergence of Peer-to-Peer Software

Napster was not an anomaly. Coined as Peer-to-Peer (P2P) software, Napster users traded compressed, formatted data to peers without the direct involvement of manufacturers, wholesalers, or any middle level of distribution. No payment changed hands between users (or even to Napster), so revenue did not exist to compensate artists. Napster's business model was a centralized operation, making it vulnerable to litigation since its software directly facilitated file searches and actual transfers.

Subsequent versions of P2P software have emerged post-Napster, decentralized in structure and enabling users direct access to swap files with no intermediate or centralized controlling authority. The scope of file sharing encompasses a cross section of creative industries including publishing, video, photography, movies, software, and yes, visual artworks.

The process is far from flawless as users run the risk of exposing their computer hard drives to transmitable viruses and allowing security breaches within their systems. File transfers are often severed or incomplete when one of the trading parties exits, that is, goes offline. Yet, when the prize of valuable and highly desired digital content is at stake at no monetary charge, participants will endure a substancial degree of petty hardship.

Help is not far away for these concerns. The rising number of users with faster broadband access (as it becomes more affordable) is speeding up the transfer times. Most ISPs (Internet Service Providers) are fortifying their users with protective firewalls and spam filters to screen potential incoming viruses.

Despite user obstacles, the P2P software continues to proliferate rapidly, coasting under the vigilant radar of the American justice system and media scrutiny. A simple search engine request for P2P software will reveal thousands of Web page responses.

Certain P2P business models are fee-based, some pay artist royalties. Many operate in a very gray ethical fog with limited user bases. The decentralized nature of P2P software makes identifying ownership (to close them down) nearly impossible.

The emergence of P2P software has raised a fresh debate over the issue of copyright and intellectual property rights. Fresh questions about who actually owns a new design, and for how long, have been and will continue to be debated by the U.S. Supreme Court. In the digital age of mass information distribution, such complicated issues as private ownership and public domain await significant debate and possible redefinition.

The Risks of Distributing High-Resolution Images

The enhanced state of digital technology is likewise assisting the process of simplified reproduction. Over the past few years, significant advancements and improvements have been made in digital scanners (priced under $100), as well as high-resolution large format printers and plotters (new models are priced under $3,000 and used models cost significantly less). Professional quality output has become more affordable, and imaging software makes reproductions often superior in quality to original work. A new breed of unregulated publishers is emerging, technologically enabled to print orders on demand (when paid in advance) in innumerable quantities and operating in gray areas with or without an artist's participation or cooperation.

Effectively and actively policing such potential worldwide abuse is impossible. Few Web sites protect their visual images, easily downloadable in their exact state within seconds using a standard online browser such as Explorer, Safari, or Netscape.

So what's an artist to do? Cloister images away from public Internet viewing? Not necessarily—a few preventative strategies exist that artists can employ (and in many instances, without a substantial monetary investment).

The first requires no additional financial outlay except common sense, involves limiting displayed images to low-resolution 72 dpi (dots per square inch) and minimal sizing (no more than four to five inches in any dimensional direction). While a smaller image may compromise detailed viewing, it does protect the artist from enabling a larger expansion of the image for pirated reprinting purposes, because the process of enlargement will result in poor detail and jagged edges. Besides, images on the Internet can only be viewed on a computer monitor at 72 dpi, so uploading a high-resolution image for display is of little value to you, anyway.

Many artists are regularly approached to have their high-resolution images reprinted on a variety of licensed products, apparel, and reproduction mediums (see chapter 13). Be wary of who you're dealing with; once an image is available in a high-resolution format, the commercial applications are endless and varied. Any form of image distribution should be contracted in writing and clarified as to the specific use, geographical marketplace, and prohibitions.

Digital Watermarking

A second form of protection is a process called digital watermarking. In short, a pattern of bits (binary digits) is inserted into a digital image, audio, or video file identifying the file's copyright information (author, rights, etc.). The name comes from the faintly visible watermarks imprinted on paper stationery identifying its manufacturer. The purpose of digital watermarks is

to provide copyright protection for intellectual property in digital format. Unlike printed watermarks, intended to be somewhat visible, digital watermarks are designed to be completely invisible, or in the case of audio clips, inaudible. Moreover, the actual bits representing the watermark must be scattered throughout the file in such a way they cannot be identified and manipulated.

Anyone who licenses or publishes images, or uses them in marketing campaigns, can benefit from watermarking. Several museums currently use them to communicate ownership of often-copied artwork. A record company tracks the use of its musicians' photographs throughout the Internet. A major stock photo agency embeds watermarks linking its company name and contact information into all their digital photos.

Another important function of watermarks is they may enable you to locate your images wherever they go and whether they are reused on the Net. Watermarked images become homing beacons on the publicly indexible Web. When you use search tools such as MarcSpider (operated by the Digimarc Corporation, at *www.digimarc.com*), you can find out whether your images have been moved or copied, when it occurred, and where they are. While these tracking mechanisms cannot prevent image theft, they at least provide you with a source for locating their uses and potential misuses.

The integrating of digital watermarks is a sound preventative tactic, but hardly foolproof. Other digital software products are marketed to instantly remove watermarks—hardly a reassuring guarantee of the absolute security of your images.

Encryption Software

With encryption software coupling digital watermarks, computer artists can protect creative works by encrypting and hiding copyright information right into bitmaps or TIFF files. The encrypted data is invisible and uncrackable without special passwords.

What precisely is encryption and steganography? Encryption is a way of scrambling data. The two main components of encryption are the algorithm and the key. Algorithms are complex mathematical formulae (remember that advanced high school math class you loathed?) and keys are strings of bits, such as a word, phrase, numbers, or combination of numbers and letters. Steganography is a way of hiding data so it cannot be detected. Many of the marketed security software offer both encryption and/or steganography to secure data (similar to most Internet credit card acceptance programs).

In a larger context, image theft is neither unique to our culture nor absolutely preventable. Computer hackers still periodically vault the most fortified and high-profile Web sites such as Yahoo, eBay, Microsoft,

Amazon. Just as no car is entirely theft resistant, you increase your odds of foiling thieves by locking the door and adding supplemental theft protective devices.

DIGITAL ENCRYPTION AND WATERMARK TECHNOLOGY

www.ALPHTECLtd.com
www.AniDirect.com
www.Away32.com
www.CrypKey.com
www.Cypherix.co.uk
www.Cypherus.com
www.Digimarc.com
http://www.dct-group.com
www.DeltaCrypt.com
www.DES.co.uk
www.EasyCipher.com
www.Encrsoft.com
www.MediaSec.com
www.NetLib.com
www.PCGuardianTechnologies.com
www.PGP.com
www.PKZipStore.com
www.PointSec.com
www.SignumTech.com
www.Stealthencrypt.com
www.Xat.com

GENERATING Web Site Visitors

So, you've finally designed your Web site and initiated your leap into cyberspace. Like the inventor of the proverbial better mousetrap, you want the art world to beat a path to your door (or at least to your portal).

Now what?

Evaluating Types of Web Site Viewers

From the experience of my own initial Web site, *www.marquesv.com*, launched in November 1999, I have learned that the process of recruiting visitors requires clear vision, purpose, imagination, follow-up, and a concerted time commitment. The objectives of my site from inception were to cultivate qualified viewer traffic by offering a 24/7 international curated exhibition. By *qualified* traffic, I mean the potential buyers I am most interested in attracting: collectors, corporations, interior designers, the hospitality and restaurant industries, art galleries, and ultimately museum curators.

Casual Web surfers, friends, family, and even critics of my work are a bonus. However, at this juncture in my career, I have to concentrate my limited marketing time on cultivating serious buying prospects and exhibition outlets. One of the initial myths I encountered in establishing my online presence was that substantial hits translate into a perception of successful marketing. Nothing in fact could be more misleading, although it is a commonly used marketing technique to justify advertising or participation on a particular Web site.

For clarification purposes, a unique visitor is a more appropriate measurement than hits, since it denotes a separate individual viewing your Web site. Each visitor is responsible for multiple hits; each time someone visits a page within your Web site, clicks an image enlargement, or activates a hyperlink on your site, a hit is registered. Thus, if the typical user is responsible for an average of fifteen to twenty hits per viewing session (called a sticky Web site), imagine the potential confusion and inflation of traffic numbers for marketing purposes. With many commercial Web sites touting their impressive visitor traffic, the confusion is intentional.

My ongoing conclusion regarding hit counters and visitor statistical data is that a healthy dose of skepticism regarding the results is imperative. Any marketer promising high ratios of sales to visitor traffic will never be able to justify success accurately and measurably.

Reasons a Web Site Is *Discovered*

One of the first questions I had to analyze and resolve back when I was launching my site was what specific behavioral influences would cause a person to click through to my site. Over time, I've narrowed it down to four basic reasons:

1. Researching me or my work
2. Casually encountering my site via a link from another Web site
3. Responding to an ad for my site
4. Viewers looking for a specific subject area on an index or search engine

Search Engine and Index Protocol

There is an essential difference between a Web search engine and an index. A search engine is a database of Web site pages compiled on subject matter based on relevance. An index utilizes a hierarchical subject classification system to structure the organization of Web pages. The procedure for being included in both sources follows this chronology. A Web site owner submits his front page address (URL) with a brief description. The index or search engine reviews submissions, extracting relevant information and stores the reference data in its database. Search engines employ automated robots known as "spiders" roaming the Internet seeking relevant Web pages for inclusion to their index inventories.

This process, known as "crawling" the Web, involves robotic software tracking hyperlinks from Web site to Web site. Active search engines such as Google (*www.google.com*) add thousands of new sites and millions of Web pages to their database each time they crawl (generally on a monthly basis, although other search engines less frequently).[1]

The best way to have your Web site discovered by the roaming spider is to have your site listed on as many additional Web sites as possible. This is the principal value of encouraging reciprocal links with other Web sites: the more sites linking to you, the more likely your Web site will be located quickly and often.[2]

Google's Search Engine Technology

The largest search engine currently is Google, boasting searches and lists over 8 billion Web pages[3] (and growing). Google also has the capacity to organize searches based on an assortment of criteria including digital

images, group listings, and news stories. Google has emerged into its position of supremacy (41.6 percent of users) following the financial collapse and consolidation of several of its one-time direct competitors. This ascendance was based principally on the company's resolve to concentrate on building a superior search engine, fascilitated by its competitors' lack of concentration on their own search engine capabilities. As Google continues to evolve, the space of separation from its competitors lengthens.

Currently its nearest competitors and their percentage of market share include Yahoo (31.5 percent), MSN-Microsoft (27.4 percent), AOL (13.6 percent), Ask Jeeves (7 percent), Overture (5 percent), and a host of search engines with below a 5 percent share.[4] These spreads may ultimately draw closer, but with Google's successful public stock offering in 2004, it has the cash resources to widen this gap.

Aside from the established group of five major search engines are a number of metasearch engines, essentially crawling a variety of alternative search engines (including Google) to create a compilation of relevant listings. These metasearch engines are often niche businesses, oriented toward specific subject matter or industries.

As Google has established the standards for search engine operations, its published criterion regarding its own rating system (PageRank™) bears noting:

> PageRank™ relies on the uniquely democratic nature of the Web by using its vast link structure as an indicator of an individual page's value. In essence, Google interprets a link from page A to page B as a vote by page A for page B. But Google looks at more than the sheer volume of votes, or links a page receives; it also analyzes the page that casts the vote. Votes cast by pages that are themselves *important* weigh more heavily and increase another pages importance.
>
> Important, high-quality sites receive a higher PageRank™, which Google remembers each time it conducts a search. Of course, important pages mean nothing to you if they don't match your query. So, Google combines PageRank™ with sophisticated text-matching techniques to find pages that are both important and relevant to your search. Google goes far beyond the number of times a term appears on a page and examines all aspects of the page's content (and the content of the pages linking to it) to determine if it's a good match for your query.[5]

Submitting Your Web Site to Search Engines and Indexes

All search engines (including metasearch engines) encourage submissions of new or existing Web sites, and the process is generally very straightforward. In many instances, simply listing the URL address of a Web site

and a single sentence summary of the site's relevance is sufficient. Search engines do not penalize for multiple submissions and certain Web sites that handle submissions offer an automated application service for multiple search engines.

Over-submitting does not necessary enhance or diminish your Web site chance of being added. However, since most search engines conduct infrequent updates of their indexes, it is prudent to submit your Web site or important Web pages regularly until they are ultimately integrated into the database.

Indexes can be an additionally important source of potential traffic, and Yahoo remains the largest (although it seems to be evolving more into the search engine realm). An index is a database of Web sites, like a library card catalog of Web sites. Your Web site listing in an index depends on what you tell the index in your submission, not necessarily what is on the Web page you submit. Most index submissions require an approximate twelve- to twenty-four-word summary regarding the unique relevancy of your Web site.[6]

A simple dose of reality, however, about being admitted to the major indexes: the acceptance and integration process is slow. A submission may take weeks or months before it is reviewed—and possibly even rejected. Unlike your local library, which catalogs all its holdings, indexes *do not* feel an obligation to include into their database every Web site (billions? trillions?) on the Internet. They receive thousands of submissions daily, and their staffs become very indignant toward Webmasters contacting them regularly to inquire as to the status of their particular submission.

My advice for successful submission, besides patience, is to monitor the process weekly by typing in your site name to the index. Simply, once your Web site listing appears, then you've been accepted. The indexers at various Web sites will never notify you directly.

Paying Fees for the Submission Process

Back in the days of free commercial Web site submissions for Yahoo (pre-2001), I submitted my own principal art Web site, *www.marquesv.com*, via the "How to Suggest a Site" page. My Web site was initially accepted by Yahoo within six weeks and then dropped mysteriously (perhaps due to lack of immediate requests).[7]

Regardless of Yahoo's reasoning then, I reapplied and was reinstated within two weeks, and now am secure in my ranking positioning. Yahoo currently offers both a complimentary and express paid submission service (for $299) to evaluate your submission and speed up the acceptance process (although acceptance is not guaranteed with your application).[8] Other search engines offer similar fee-based services with similar price ranges.

Are the services worth paying for? The answer is a totally subjective one, since it is often difficult to measure precisely where your visitor traffic is generated, and the application doesn't ensure acceptance. I would simply advise that getting on search engines and indexes are important whether by fee or for free. A shortcut trend toward immediate listing acceptance on search engines has evolved from search engine paid sponsorship programs (discussed in chapter 5).

In pursuing the free listing acceptance strategy, there are several tactics you can employ to enhance your chances of being accepted. First, develop a fifteen- to twenty-word synopsis describing your site. Use taut, illustrative language, but don't overdo extravagant or exaggerated claims. The purpose of your description is a summary of what your Web site represents, not a hyped promotional pitch. Make the description something interesting to you as a potential viewer, because you have to sell staffs of the search engines and indexes the fact that your site is important and should be included in their systems.

Archive your descriptive statement in a word processing file. Each time you submit, you can easily cut and paste the text. Have a backup description of one pared down to a sentence, because many of the search engines/indexes will edit yours down anyway. It's preferable to do the editing for them. After all, you know what is most important about your work.

Rewards of Search Engine Inclusion

A very rewarding aspect regarding admittance to search engines and indexes is that once your site is accepted and listed on major sites, the minor and single-subject engines tend to locate your site without any additional effort on your part.

All of these submitting and positioning tactics are fine, but ultimately it doesn't matter how many people you attract to your Web site if, once they arrive, they immediately get turned off by an unattractive presentation or half-functioning structure. How soon do you personally scout the exit door when you're marooned in a tedious art exhibition? The Internet viewing generation has a minimal attention span. Web surfers only return to sites promising a glimpse of content and drama. Keep in mind that you're in the visual entertainment biz!

Even after you're accepted to an index or search engine, there are no guarantees that listings will generate instant referrals. Your site ranking on a specific search is critically important. If you are ranked as number 200 on an index search, you can be certain that few individuals will invest the required time to visit the first 199 sites before arriving to yours. An important factor in directing traffic to your site will involve tweaking a search engine hierarchy response toward your Web site to give you a coveted higher search ranking.

This wooing process involves choosing the right keywords in your page titles, descriptive index page paragraph, and most importantly, cultivating incoming links directed to your Web site. In determining the important keywords to include, many web designers err by choosing inappropriate or too generic keywords and don't spend enough time thinking about what words or phrases Web surfers might actually employ in their searches. This form of internal text design requires preparation, and many positioning services publish free, detailed information or charge reasonable consulting fees to take you through the step-by-step process.

One certainty in building traffic to your site is it will require time, research, and potentially a cash outlay. The price will either be your time or the money you pay a Web site consultant or search engine positioning service. Expense is not the sole criteria for expertise. Most of the best advice I have received has been freely published online through Web sites or zines. The more you understand about the submission process, the better you can qualify specifically what you're paying for. Shop around.

SEARCH ENGINES

www.AllTheWeb.com
www.AltaVista.com
www.AOL.com
www.Ask.com
www.Dmoz.org
www.GigaBlast.com
www.Google.com
www.LookSmart.com
www.MSN.com
www.PicSearch.com
www.Teoma.com
www.Yahoo.com

METASEARCH ENGINES

www.7Search.com
www.AllTheWeb.com
www.Canada.com
www.Debriefing.com
www.Dogpile.com
www.Euroseek.com
www.Highway61.com
www.HotBot.com
www.Ixquick.com

www.Mamma.com
www.MetaCrawler.com
www.Multimeta.com
www.Pandia.com
www.ProFusion.com
www.Search.com
www.WebCrawler.com
www.Web-Search.com
www.ZapMeta.com

INDEXES

www.About.com
www.Britannica.com
www.InfoGrid.com
www.Jayde.com
www.LookSmart.com
www.Lii.org
www.MSN.com
www.Yahoo.com

SEARCH ENGINE POSITIONING SERVICES AND TOOLS

www.Affordable-Website-Promotion.com
www.FreeWebWare.com
www.GoodKeywords.com
www.iNeedHits.com
www.iSubmit.com
www.KeywordRanking.com
www.MoreVisibility.com
www.PageTraffic.com
www.PinpointAd.com
www.PromoteYourWebsite.com
www.Activemarketplace.com
www.SearchEngineGuide.com
www.SearchEnginePosition.com
www.SearchEngineWatch.com
www.SelfPromotion.com
www.SubmitPlus.com
www.WebSitePublicity.com

PAYING FOR *Web Site Traffic*

While cultivating a significant network of reciprocal links to your site is an important component to generating Web site traffic, the most immediate and direct technique are sponsored links intended to draw highly targeted visitor traffic.

This concept of "paying for clicks" has been in existence since the Internet became a commercially viable entity. However, its integration into all current search engines as a revenue source has radically changed the landscape of how search engines prioritize the rankings of Web pages they display, a radical yet relatively unnoticed shift from original Internet searches based on unbiased criteria.

A Change in Search Engine Philosophy Based on Economic Realities

There is no mystery behind this shift in search engine philosophy. It was prompted by economic realities and the need to construct revenue-producing business models for mainstream search engines. Traditional banner ad revenues (once the staple revenue source) have declined over the past few years because banners are ineffective. Most research groups agree on a less than 1/2 percent "clickthrough" rate—that is, the number of people actually choosing to click on a banner to learn more about the advertised product or service.

Advertising revenue is the primary source of income for search engines. Successful ad formats and outlets are essential for their ultimate survival and growth. Text advertising has become this preferred revenue source integrated into their search results. The most valuable service a search engine offers is the capability to isolate and locate specific Web pages (among billions published) applying to specific keyword and subject searches.

History of Paying for Search Engine Placement

In 1997, a Pasadena, California–based company formerly called GoTo.com pioneered the concept of paying for search engine placement with the

release the following year of a sponsored search service. GoTo.com's business concept idea, then radical in the free access world of the Internet, was to enable advertisers to bid for search engine or specific keywords relevant to their businesses. The company's foresight in identifying the long-term evolving nature of search engines enabled it to successfully go public with its stock in 1998, and in 2003 its premier client at the time, Yahoo, acquired the renamed company Overture (*www.content.overture.com/d*).

Overture has retained its identity separate from Yahoo and continues to offer its biased search service through search engines that include Yahoo, MSN, and Infospace, and tens of thousands of major Internet companies such as the *Wall Street Journal, Sports Illustrated,* and CNN to provide search results on their sites.[1]

Google operates its own sponsored advertising program (including AOL) structured similarly to Overture's with a few twists. Sponsored advertising has become its primary revenue source. Although paid search positions are segregated into columns apart from search results, it isn't difficult to imagine that they ultimately influence top Web page rankings due to their prominent positioning for search engine keyword or keyphrase requests.

Effective Traffic Generators

Google and Yahoo's ad sponsorship programs are the most effective immediate traffic access sources on the Internet.

The key to successfully using these targeted advertising programs is the proper selection of keywords and phrases Web users would most likely employ in their searches. Overture offers a valuable and easily accessible Keyword Selector reference tool on its site to track the popularity of selected words and phrases.[2]

A Sample Keyword Search

As an example of employing the Keyword Selector, during a random month, I ran a volume search through Overture to determine art-related words or phrases that were requested the most frequently through its system during a thirty-one-day period.

The published results for a search of terms related to the word *art* proved illuminating. The top fifteen results based on terms and phrases (number of requests in parenthesis) ranked as follows:

art (914,434)
art print (251,151)
martial art (196,933)
fine art (195,043)

3D art (130,028)
poster art (129,761)
digital art (129,624)
fantasy art (128,512)
art gallery (125,512)
framed art (124,351)
wall art (121,979)
fine art photography (117,961)
landscape art (101,515)
abstract art (87,780)
art supply (72,001)

It is not particularly surprising the term *art* was the most requested with nearly a million requests. However, more unusual was even specialty terms of art formats such as *digital art, fantasy art,* and *landscape art* drew in excess of 100,000 requests over the month period.

During this same month, the generic term *painting* generated 212,410 requests while other specialty formats such as lighthouse art (68,000+), *body art* (66,000+), *African art* (59,000+), *animation art* (50,000+), *erotic art* (45,000+), *sculpture* (60,000+), *nude photography* (30,000+), and *nature photography* (298,000+) drew significant attention and search requests.[3]

The sheer volume of total search requests from this collection of search engines suggest there are significant numbers of Web surfers interested not only in generic art searches, but specific media and specialties. The listed Web sites appearing in the top twenty ranked positions of a specific search are the most likely to receive visitors from those searches.

What is significant however with regard to sponsored links for many of these popularly requested terms is that few artists, galleries, resellers, commercial Web sites, or organizations are bidding for placement on most of these terms.

Bidding for Placement Rankings

How does a minimally budgeted artist, gallery, or art organization Web site tap into these raw numbers and drive traffic to its respective site? The answer is surprisingly less complicated than most Webmasters or highly paid consultants would lead you to believe. The simple truth is you buy positioning for those key search terms.

In other words, when someone does a search for the word *art* on the top search engine sites (mentioned earlier as Overture contractors), the order sites are ranked in the listing is based on the amount of money they have bid for positioning. If the click originates from search engines such as Lycos, MSN, or CNN instead of Overture, the originating search engine is paid a percentage of the bid amount per clickthrough.

Try it out for yourself to see what bidding levels exist. Overture features another valuable pricing gauge within its Advertisers Center called the View Bids Tool, designed to list the top bidders for various search terms.

Conduct your own test by entering a generic search term such as *art*. The top five listings (as of this writing) each bid a payment of between 49¢ and 54¢ to Overture for each clickthrough to their site.[4] For an alternative comparison visit the Web site Compare Your Clicks (*www.compareyourclicks.com*) and type in the same term *art*. Compare Your Clicks will display comparative bidding data for nine additional "pay for placement" sites, many accept top placement bidding for only 1¢ per clickthrough versus the current higher minimum levels on Overture and Google.

Excessive Bidding Practices of the Dot-Bomb Era

An enlightening perspective on one aspect of financial lunacy during the apex of the dot-bomb explosion (September 2000) was the bidding level for terms reaching unprecedented levels. The top three bidding sites for the term *art* that September were GUILD.com (*www.guild.com*—a catalog of studio art products), BizRate (*www.bizrate.com*—a price comparison site), and Luxury Finder (*www.eluxury.com*—a site that functions like personal shopper) each paying approximately $1.25 each per visitor—the cost of acquiring viewers and not confirmed buyers. Small wonder so many of the original highly visible and funded commercial art and consumer product Web sites rapidly vaporized cashflow.

If your objective is to match bids and advertising spending levels with the well-subsidized Web sites, your promotional budget will disappear rapidly with minimal results. However, notice many specific terms beside *art* on Overture have top position placement bids ranging from 1¢ to 10¢ for high level positioning. This is potentially worthy and inexpensive to pursue. The ability to place 1¢ to 9¢ bids on Overture no longer exists (those currently showcased have been grandfathered in, since the previous policies have changed), although numerous Pay Per Click search engines will accept this lower bid level.[5]

Reasonable Keyword Bidding Strategies

If part of your visitor acquisition strategy includes paying for clickthroughs, budget your bids prudently. Concentrate on keywords more specific in nature and related to your work such as *expressionism, ceramics, figurative art, steel sculpture*, etc.

An interesting innovation most Pay Per Click search engines are now employing (with enhanced revenue potential in mind) are "match drivers," which take term misspellings, singular/plural combinations, and other variations, and map them to a primary term so a clickthrough opportunity

is not lost. The primary form is usually the most common form of the word (singular, non-punctuated, non-hyphenated, and spelled correctly).

Whether or not buying keywords and key search phrases becomes a worthwhile advertising investment for you will be determined by how many of those visitors ultimately convert into buyers. This scenario is similar to one that a retail art gallery faces with walk-in traffic in an urban location. Time and sales follow-up will ferret out the buyers from the browsers. So too with your Web site; build your following steadily, give viewers a reason to return, and ultimately sales opportunities should evolve.

PAY FOR TRAFFIC SITE SERVICES

www.About.com
www.Ask.com
www.Brainfox.com
www.CompareYourClicks.com
www.Enhance.com
www.ePilot.com
www.Espotting.com
www.eTRIT.com
www.FindIt-Quick.com
www.FindWhat.com
www.Globesearch.com
www.goClick.com
www.Godado.co.uk
www.Google.com
www.HootingOwl.com
www.IllumiRate.com
www.IQSeek.com
www.Kanoodle.com
www.Overture.com
www.PageSeeker.com
www.PayPerClickSearchEngines.com
www.Sabril.com
www.Searchfeed.com
www.SearchGalore.com
www.SearchPixie.com
www.TheInfoDepot.com
www.Win4Win.com
www.Xuppa.com
www.Yoho.com

CULTIVATING *Media Exposure*

There are numerous outlets through which to evangelize your Web site, none more potentially reliable than traditional media sources such as newspapers, television, radio, magazines, e-zines, etc. However, with e-mail, you have an advantage over traditional snail mail . . . it doesn't require a postage fee. With e-mail, you, not the post office, control when your mail will hit, although, of course, if you are sending out a press release, you still have no control over when or if it will be published. However, there are numerous tactics that may enhance your odds of success.

Distribution of Online Press Releases

Nearly every international media outlet now has a Web site, and nearly every reporter has an e-mail address. Start your own personal media database by creating a directory of these addresses and send out your news releases in batch submissions. Place the addresses in the BCC—blind carbon copy—field of the message. Addresses placed there don't appear in the header or body of the e-mail, a good thing for two reasons. First, it avoids having a long list of addresses at the beginning the message—readers who have to wade through such a list may give up before they get to your important news. Second, hiding all the addresses protects everyone's privacy, which is good for customer relations.

Make certain to always have your Web site address prominently visible and offer a hyperlink to a JPEG or GIF formatted photograph (instead of an attachment) whenever appropriate, either within the text of the news release or a separated reference heading. The resolution of an online-hosted image should be a minimum of 150 dpi, and magazines usually require 300 dpi to ensure adequate production quality. The primary reason for using a hyperlink instead of an attached or embedded file is that most media outlets currently have policies against importing attachments files due to their (justified) fear of integrating viruses into their system.

Cultivating press exposure will draw viewers to your Web site. Cultivating mass press exposure will draw thousands, potentially millions of viewers, provided there is an evident Web site reference.

When should you send out news releases? Appropriate instances might include when you launch your Web site, have a gallery exhibition, or earn an award, grant, or honor. In effect, whenever something positive happens to you in an art or career context, publicize the event to your cultivated news outlets . . . and don't forget the Web site reference. Follow-up telephone calls to reporters or editors of local/regional media outlets assist in ensuring your publicity announcements are at least read. Plus, a telephone call makes you available for accompanying quotes.

Online News Release Distribution Services

Several Web sites offer news release distribution services that generally cost $95–$500 per usage and are distributed to their unique media outlets, contacts, and sources internationally. Additional public relations sites have sprung up, offering a variety of promotional services including drafting your release, targeting your media audience, and including your release within e-zines they distribute to their unique opt-in media rosters. Some of these services are included with the distribution service fee, and others require additional cost outlays.

PRESS RELEASE DISTRIBUTION SERVICES

www.24-7PressRelease.com
www.BlackPR.com
www.CorporateNews.com
www.CyberAlert.com
www.EISInc.com
www.Emailwire.com
www.Ereleases.com
www.Eworldwire.com
www.Free-Press-Release.com
www.Majon.com
www.Market2Editors.com
www.Out2.com
www.PressMethod.com
www.PressReleaseNetwork.com
www.PrudentPressAgency.com
www.PRFree.com
www.PRNewswire.com

www.PRWeb.com
www.Send2Press.com
www.WebWire.com
www.Xpresspress.com

Several Web sites sell downloadable Microsoft Excel spreadsheet files, published reference books, and compact discs of media contacts complete with address, phone, and fax references and e-mail addresses. The investment in this raw data can range between reasonable and exorbitant, and listings can become outdated in the media industry rapidly (particularly e-mail addresses). Becoming your own public relations service may hyper-accelerate your media exposure and with the right timing, generate results on a large scale.

MEDIA MAILING LIST SERVICES

www.ArtMailingLists.com
www.Bacons.com
www.BurrellesLuce.com
www.GebbieInc.com
www.InfocomGroup.com
www.Newspapersoc.org.uk

Components in Composing E-mail News Releases

A key to successfully pitching a potential story to a media source via e-mail is to keep the message simple. Reporters receive hundreds of e-mail solicitations every day, and you need to make your message stand out to make the cut. Pitching the press electronically can be difficult. Make it easy for the reporter to filter through the clutter. In order to accomplish this ease, you need to utilize some or all of the following tactics:

- *Headline is the key:* You need to be creative and to the point. Limit the subject line to five words. Most e-mail software will not display more.
- *Keep it short:* Include a strong opening paragraph in the body of the e-mail stating the core information, and then provide a link or URL to your Web site. Long prose doesn't work anymore. If the first paragraph doesn't grab them, the reporter will delete the e-mail.
- *Create a standard signature:* Either at the top or bottom of your message (or both), include the full contact information—name, telephone/fax number, snail mail address, e-mail address, and Web site.
- *Individualize the message:* Never include your entire media distribution list in either the To (addressee) or CC (carbon copy) fields of your

e-mail template. A reporter does not want to read your recipient list along with your story idea pitch. Instead, send group mailings within the BCC (blank carbon copy) field. If you're individually sending out your story solicitation, make certain you include the reporter's name as well as the publication name.

- *Be selective and do not abuse e-mail:* Excessive e-mails will lead to the spam landfill. Your release will not be read and will simply be deleted upon receipt (or worse, caught in a spam filter and never even seen—more on this subject in chapter 7).
- *Pick the correct editor:* Don't send your fine arts related story to the news and sports editors.
- *Tailor the release to the media editorial style or content:* Remember that television requires pictures and radio, sound. Keep in mind lead and deadline times. Some magazines work on copy four months in advance. Sending a Christmas story in mid-November is wasted effort.

Other promotional outlets to consider for your news releases are Web site and page submission services that electronically submit to search engines. By formatting your news release into a Web page and hosting it on your Web site, you increase the likelihood of visibility and the odds of an alternative publication or viewer actually coming across the information and publishing it through his or her respective outlets.

Concerns about Spam

One legitimate concern about sending out mass e-mailings is that you will be accused of promoting spam. The accursed spam is the term labeled on unsolicited direct e-mail (see chapter 7). Keep in mind, however, a media's lifeline is fresh news and it has considerable column lineage and airtime to fill daily. Media sources welcome news releases, as long as they're not overdone from a single source (a maximum of twice monthly). You can be a valuable source for assisting them with original content.

DIRECT SNAIL MAIL
and E-mailing Strategies

Unsolicited direct e-mailing (spam) is a marketing tactic that provokes a strong reaction in many individuals, much of it negative. The fear of privacy invasion and marketers improperly using personal data transmitted over the Web is real and justified. The wasted bandwidth and time spent scanning incoming e-mail is an annoying component of every professional's workday.

Characteristics of E-mail Marketing

E-mail usage continues to increase with users (81 percent of consumers) accessing their accounts multiple times per daily. An average consumer receives 308 e-mails per week, an increase of 16 percent from 2003. Nearly two-thirds of e-mail received is considered to be spam, while only 8 percent is considered "permission-based e-mail." Over half consider e-mail pitches to be replacements for telemarketing and direct mail to their residences.

Consumers have developed consistent views as to what constitutes spam. Deceptiveness and unknown senders seem be equally annoying factors along with offensive subject matters. Even among e-mail senders who've been given permission to contact consumers, the frequency and irrelevancy of the message may ultimately cause the consumer to conclude a message is spam.

Technologically, consumers combat spam with software filters, but more commonly with simple deletion (72 percent). Only 7.2 percent of spam actually gets opened. Another form of filtering is the use of multiple e-mail addresses. Forty percent of consumers have at least three e-mail addresses to manage their various forms of online activity and communication. Over half use a unique e-mail address for purchases, paying bills, adding subscriptions, etc., apart from their primary contact address.[1]

Growing Use of E-mail as a Marketing Tool

Despite these apparent misgivings, consumers acknowledge e-mail as a legitimate and relied-upon marketing channel. Despite the fact that two-thirds of e-mails received are considered spam, consumers are likely to

make purchases either online or offline in response to permission-based e-mail (PBE). Nearly 80 percent of consumers have used e-mail for customer service inquiries.[2]

E-mail as a marketing tool can be an extremely effective selling tool. Initially used primarily for acquisition of new customers, its role has since shifted to promotional and client relationship marketing.

Forrester Research Inc., one of the leading American marketing profile sources, conducted a poll of leading business advertisers, posing the question: "In three years, will marketing's effectiveness increase, stay the same, or decrease in each of the following media?"

Their results were significant. Businesses participating in the poll confirmed that they forecast an increase of effectiveness with Web sites (88.4 percent), online ads (76.9 percent), e-mail (67.4 percent), direct mail (33.7 percent), and a decrease within traditional mediums such as magazines (30.1 percent) and newspapers (44.7 percent). Equally interesting was that 36.2 percent saw television advertising decreasing and only 20.6 percent saw its effectiveness increasing. The conclusions were clear; spam or not, the future is bullish on online marketing and particularly promotional e-mail.[3]

Using E-mail Marketing Intelligently

Direct e-mail will not disappear any more than anti-spam coalitions will ever adequately monitor the Internet. And why should legitimate direct e-mail disappear? It can be very effective and like any mass mailing tactic, more successful when the receiving audience is targeted.

The dynamic of sending, retaining, and even discarding e-mail are unique. Most junk snail mail is discarded in a round file. Bulk e-mail on the other hand disappears with a simple press of the delete key. Today, a significant amount of unsolicited e-mail is filtered out into discard files with vigilant anti-spam software.

How Spam Filters Operate

Spam filters use a set of predefined rules to assign a point score to incoming e-mail messages. Except for the most obvious profanities, first-generation filters scan only the sender's name and the subject line, not the entire text of the e-mail. These spam filters typically look for these words: *free, complimentary, cash, Fwd, get, you, your, year, DVD, software, money, earn, lose, win, increase/size, Viagra, approved/approval, sale/discount, fun, guarantee, loan, save/saving, mortgage/loan, limited time, compare, buy, won, prize,* and symbols including: %, ™, ®, &, !, +, and *. Second-generation filters typically filter more deeply into a message looking for dubious content.

Users may configure their e-mail software differently to suit their preferences but generally if the score of an incoming message exceeds a minimum level, it will be filtered as spam. The scoring system is principally based on the utilization of certain key words, employment of exclamation marks, excessive font sizes, and word combinations within sentences (tactics consistent with most unwanted e-mail).

Spam filters are fine for most obvious transgressing e-mails, but many messages still infiltrate the fortress, based on the increasing savvy of e-mail marketers. E-mail marketing has become a multibillion dollar industry with annual growth rates anticipated to more than double over the upcoming decade.

E-mail marketing is not inherently evil, but it should never be abused and if not used intelligently and with discretion, has the potential to backfire. Many Internet Service Providers (ISPs) will drop accounts receiving excessive complaints of sending out inappropriate or excessive correspondence.

Permission-Based E-mails

The effectiveness of e-mail marketing, just as with snail mail, is directly contingent on the quality of the distribution list. Permission-based marketing, where recipients specifically request to be on a mailing list, has been the most effective and proven form of Internet advertising. This manner of compiling e-mail lists is called "opt-in" because the receivers choose to receive your e-mails.

E-mail is significantly cheaper than traditional direct marketing methods such as postal direct mail and telemarketing. Various research estimates conclude the average cost per e-mail message in the United States is less than a cent, compared to between $1–$3 for telemarketing and 7¢–$2 for direct mail. Success with direct e-mail is nearly always most effective to individuals who are already familiar with you or your work.

Sources of Business Contacts

Your best contact list is self-compiled, including people who have purchased your work, requested to be kept up-to-date on your activities, and/or shopped at your gallery or online Web site. This group forms your elite mailing list, as these are the most likely prospect for doing business with you on a long-term basis. The top tier of this elite group includes those individuals who have purchased from you on two or more occasions. They already know about you and the quality of your work and/or merchandise, and they have proven it by coming back on multiple occasions.

In compiling your network of contacts, it is imperative to encourage those appearing on this elite list to provide you with their e-mail addresses. Update them on a monthly or quarterly basis about your progression as an artist, including such information as upcoming exhibitions, Web site updates, or the introduction of a new series of work(s).

Renting or purchasing opt-in e-mailing lists from brokers may be an option for jump starting your promotional efforts and expanding your lead base.

Other e-mailing list brokers may sell or rent you e-mail names and listings of individuals or business interested in the category of art information. Their rates are often steep (8¢–15¢ per listing depending on the category) and, if rented, only provide single use capability.

Sources of Mailing Lists

The source of mailing lists come from two origins: either compiled or response lists.

Compiled lists are a common source of names and records collected and entered into database software. The sourcing of these names may originate through public records, such as nationwide telephone directories or trade association membership rosters. Unless there exists a mechanism to update records—a process called cleaning the files—the information may become dated over a short period of time and ineffectual.

Response lists are data from people who have responded to a specific advertisement or perhaps purchased from a catalog, direct mail campaign, media ad, or other offer.

The best mailing lists are composed of groups of people sharing characteristics in common, making them the perfect potential audience. This form of targeted marketing can be very effective if you can identify and match these definable characteristics closely. Trade magazine subscription lists within the art industry are often excellent for this purchase (if the publisher makes them available for resale). With more than 10,000 magazines in circulation, a good fit is very likely available to your perfectly targeted buyers. Publishers maintain accurate records on their average viewer demographics so this information can usually be broken down into income levels, education, geographical location, interests, reading habits, and other valuable data.

Membership lists of local and regional arts-oriented organizations can also be excellent since members have already expressed interest and personal investment in the subject matter.

Weighing an opt-in prospect's interest may be another issue. The prospect may have indicated an interest in art and art-related products—an art products supplier, trade magazine subscription list, or special event

list—that has no relation or association to you. In other words, there is a slim guarantee the receiver actually will be interested in your specific work and may view your contact efforts as simply spam.

Encouraging a Mutually Beneficial Business Relationship

Sending out brief e-mail invitations is generally acceptable providing it doesn't a follow the format of blatantly irresponsible spam. The message should stress you've taken the time to find out who the recipients are and you'd like to invite them to do business with you. Keep your follow-up attitude tactful and non-threatening. Let the reader know that you will not pursue incessantly, but will wait until he or she expresses interest before you make contact again.

This form of low-key approach should be non-offensive, and anyone objecting to contact in any form should certainly be removed from future e-mailings without hesitation. A prospecting e-mail should never be sent out more than quarterly (monthly, only if you are certain of a receptive audience).

ART MAILING LIST OUTLETS

www.ArtMailingLists.com
www.ArtMarketing.com
www.InfoUSA.com
www.WorldWideArtsResources.com

OPT-IN E-MAILING LIST SERVICES

www.BocaNetworks.com
www.Copywriter.com
www.EEEMedia.com
www.Email4Marketer.com
www.E-Target.com
www.HTMail.com
www.Inetgiant.com
www.OmniPoint.com
www.PennMedia.com
www.PentonLists.com
www.PostmasterDirect.com
www.ProspectsInfluential.com
www.SpamAlternative.com
www.Topica.com
www.USAOrder.com

Purchasing Blanket E-mailing Prospect Lists

A host of dubious mass e-mailing services offer "millions of prospects" from their distribution lists for resale. The reality regarding these prospects is their reliability can neither be tracked nor verified. The probability of a successful direct e-mailing strategy founded essentially on a matter of reaching sufficient numbers of people is very naïve. Your credibility becomes suspect, aside from potentially being labeled a spammer or violating current state laws. To achieve positive results, make certain your audience is both targeted and interested in your subject matter.

Rate of Return for Bulk E-mail Lists

The rate of returns (undelivered e-mail) will be significantly higher than a comparably purchased snail mail list, whether opt-in or not. Consumers and companies change e-mail accounts and Internet servers regularly and within this constant state of flux, permanent e-mail addresses are a rarity. In particular, major mass e-mail outlets such as AOL, Hotmail, Yahoo, and Earthlink have a significantly high rate of account closures. The reasons include 1) accounts are terminated after a period of non-use, 2) the free promotional period of new complimentary accounts expire, and 3) most site hosting packages come with personalized e-mail accounts utilized when a new Web site is activated.

Return rates in excess of 30 percent are not unusual, although returns are not always indicators of an e-mail accounts closure. Certain spam filters send return notices automatically to bulk e-mailers in an attempt to have an address removed automatically from a database. Even your requested and legitimate correspondence may prompt this autoresponder message. Updating the data regularly in your mailing lists is important and necessary to keep your own inbox uncongested with returns.

Long-term Objectives for Direct Mail

Cultivating a mailing list is a long-term objective and a key component of professional longevity and credibility.

An important and critical component of any ongoing direct mail strategy is cultivating viable leads and potential buyers of artwork. The artist and reseller must determine who is most likely to purchase art and how they can initiate contact with these individuals and/or institutions.

Who consistently buys artwork? We know from experience the average art collector is anything but average, much less easily identifiable. We may spend a career trying to discern the demographic patterns of these buyers, but much of it is wasted effort since income, neighborhood

of residence, and even age are often unreliable indicators of an art buyer with contemporary tastes. So let's concentrate our priorities on what we know:

The essential groups who regularly and consistently buy art or utilize art images from artists include:

- Repeat art buyers
- Art galleries (as resellers)
- Hotels and restaurants
- Interior designers/decorators
- Corporations and businesses
- Advertising agencies
- Publishers
- Architects, real estate agencies, and property managers
- Builders and developers
- Public agencies

With this market group defined, it is imperative to establish a network of contacts to market work. The extent of the network can be as intimate or extensive as budget limitations will restrict. Using a storage mechanism (such as database software like Appleworks, Microsoft File Maker, or a spreadsheet program like Microsoft Excel) is important, so that it can be reused or converted into mailing labels. Remember, you are cultivating long-term relationships, so a single contact will rarely be sufficient.

REPEAT ART BUYERS

This is the motherlode for most successful artists and resellers because generally it results in the most percentage of sales. Ironically, our own repeat buyers are the least expensive forms of sales to cultivate. *Cherish them.* Their investment in your work often mirrors the growth of your popularity. Maintain a file of your buyers including address, telephone, and e-mail address contact information. Never lose your linkage with this group because they are the easiest to resell to (they already know something about the product and creator).

This group is slightly different from individuals who simply inquire about your work. The inquirers are also important to maintain records on, but you should regularly access how serious they are about actually buying. Your repeat clients have demonstrated intent and action. This group has merely hinted at interest, a huge distinction.

ART GALLERIES (AS RESELLERS)

It seems most artists spend a disproportionate amount of time recruiting galleries to resell their work. Galleries exact a generous commission (50 percent and often more) for their efforts—and yet a good gallery is worth every ounce of the investment and more. They have access to buyers most artists will never have. They can also embellish reputations and establish pricing levels for work most artists would never dare ask.

The most exhaustive regional gallery guides are typically published through an urban art center or in most parts of the country by Gallery Guides. *Art in America* magazine publishes an extensive national listing in its annual August issue, and mailing list brokers offer extensive database and mailing lists targeting contemporary galleries. Even if you're affiliated with a gallery, keep your options open. Galleries that are not producing on your behalf are preventing you from obtaining representation in their geographical area that might be productive.

Choose your partners carefully and maintain good relations with as many gallery owners as possible. The gallery system is indeed a network functioning on multiple levels many artists are scarcely aware of.

Art galleries can also be a secondary selling outlet for other dealers. They typically split the sales commissions involved with each transaction.

HOTELS AND RESTAURANTS

The hospitality industry purchases a tremendous volume of original and reprinted artwork, sculpture, crafts, etc., to create unique themes for their properties. Some of these properties are owned by the corporate franchises, some individually or through private investment groups. They all require wall and lobby décor. The best way to research the market regionally is to contact a developing company when it is in the early stages of building a property to find the correct decision maker. Another place to find these people is at trade events, where vendors from within the industry congregate.

Each of these trade shows and exhibitions publishes a directory of exhibitors valuable for national leads. Keep in mind, national hotels and restaurants are often reluctant to work directly with artists because direct, personal contact runs counter to the corporate purchasing procedures employed by hotel chains and developers, and may be perceived as unprofessional. Despite this bias, fear not. Every professional starts somewhere and many properties actively search for a unique design environment. If you have access to reprinting your work, a potential order can be substantial.

Three useful trade media outlets for sourcing franchise contact leads include Hotel and Motel Management (*www.hotelmotel.com*), E-Hospitality.com

(*www.e-hospitality.com*), and Hotel Online (*www.hotel-online.com*). Within each major hotel chain is a design director who coordinates the acquisition and purchase of art. These chains are regularly listed in each publication. Like most media outlets, they accept advertising and may rent their circulation list.

INTERIOR DESIGNERS/DECORATORS

The yellow pages of any telephone directory are a good starting point (although tedious) for research. Most urban centers have design districts and trade associations of designers. They schedule regular social meetings and events, which can prove an excellent source of networking. There are hundreds of publications (mailing lists, advertising) devoted to the design industry and trade shows nationwide. Each publishes exhibitor directories, providing an excellent source of leads. Most urban areas also have chapters of trade industry interior design groups. Participating in their scheduled programs and social activities may serve as an excellent networking tool.

CORPORATIONS AND LOCAL BUSINESSES

Within most companies (large or small), there generally exists an individual responsible for facilities management. This individual purchases all interior décor and wall art for company offices, conference rooms, and office expansions. Knowing such individuals on a regional level is important, particularly when they need to refurbish old décor. On a national level, a trade group, the International Facility Management Association (*www.ifma.com*), promotes this professional expertise, sponsors trade events and regional mixers, and publishes reference directories.

ADVERTISING AGENCIES

What better way to expand your exposure than having your work be incorporated into the visual images of a print or visual media advertising campaign, either locally or regionally? Nationally, this exposure can be phenomenal for your recognition factor, particularly with regard to the number of eyeballs viewing television or print media. In most instances, agencies may pay a licensing fee for the use of your images and/or royalties (percentage) each time an ad is employed. These fees are often determined and based by the reputation of the artist and distribution of the ads (local, regional, national, etc.) and the strength of the negotiated contract.

PUBLISHERS

Like advertising agencies, publishers typically pay a percentage or royalty on the wholesale sales price. This type of arrangment does not appear to be very lucrative. However, if an image is popular with consumers and the publisher has solid distribution sales network, the volume and royalties may be significant. This whole area of licensing sales (see chapter 13) is exploding beyond the traditional lithographs, posters, etc. Revenue sources currently exist in a substantial number of product lines such greeting cards, apparel, product packaging, screen savers . . . the opportunities are extensive.

ARCHITECTS, REAL ESTATE AND PROPERTY MANAGERS/ BUILDERS AND DEVELOPERS

As long as buildings are being constructed, there will be demand for fresh interior and exterior décor. Building design, contracting, and maintenance professionals are excellent references for new business and often direct decision-makers themselves. City building departments publish lists of new developments coming to their respective cities, as the builders require permits and zoning approvals. Scanning such lists is an excellent way to monitor local building activity, but simply keeping your eyes open for new restaurants under renovation or construction is equally effective.

PUBLIC AGENCIES

Most of these projects are competitive bidding situations, but many do not attract large amounts of artist bidders. There are a variety of reasons for this, including insufficient publicity about the commissions, small budgets, or short notice deadlines. Many of these projects are listed in national trade publications, and most are funded by local requirements legislating that 2 percent of the gross budget on all new developments must be allocated toward public art purchases.

It should seem obvious the sourcing of potential direct buyers is as exhaustive a task as you choose to make it. The key is focusing your time and research into the market segment with which you are most comfortable. Many of the art marketing resources are relatively new for selling this lead information, so documented success stories are minimal at the present time, but likely to increase with the maturity and increased sophistication of these methods.

Integrating Direct Snail Mail with E-mail

The intent of this book is to integrate an evolving new sales medium with strategic marketing tactics that have worked for visual artists in the past. For this reason, it is important to emphasize that e-mail should never entirely displace direct snail mail, nor should an artist substitute e-mail correspondence and a Web site presence for direct selling and contact with both potential buyer and gallery selling outlets.

Certain objectives need to be established and realized through all direct mail and marketing activities. The primary objective in utilizing a mailing list is to market your artwork more efficiently. The artist's job is to cultivate a variety of beneficial relationships through the postal mail and through Internet technology.

Direct mail, whether via paper or electronically, is a communications tool for establishing trust, continuity, and credibility. The success of this marketing outlet is typically only as relevant as your audience, your message, and your follow-through.

Whenever I speak of the subject of marketing, I always stress the elements of successful relationship building. After all, the art industry is built and based on relationships. The most obvious relationships include those between the artist or gallery and collectors, curators, and—most importantly but less defined—buyers. Patrons of artwork form the lifeblood of our continued creative output. Our direct mail efforts serve as an invitation to those who know our work (and those soon to know of our work) to build a relationship.

Crafting a Direct Mail Message

The focal points for crafting and preparing a direct mail piece can be divided into two parts. These are the strategic objectives you are striving to achieve and the actual mechanics of putting the piece together.

In evaluating the principles that consistently work, the best business models employ enduring techniques. Enduring communication principles are successful and thus, repeated. So what are these basic principles? How can an artist conceptually incorporate them into direct mail contact?

SIMPLICITY

Most successful sellers know the fine line between small talk and getting to the point. We are a society inundated with information, and most people do not read letters past the first paragraph unless stimulated by the text.

Your written message needs to be organized and concise, and state clearly why you are requesting readers' attention. Anything less focused will be discarded.

SINCERITY

Slight exaggeration may be acceptable and even anticipated in a sales promotion, but credibility is imperative. Don't stretch the truth with your references and credits if you cannot document or back them up. If you have to backpedal on the validity of many of your statements, you will be vulnerable to being outnegotiated by a potential buyer and/or gallery or worse, dismissed because your ethics are suspect. The consequences from suspect ethics and deceptive practices can be frighteningly brutal. Hold your higher ethical ground if you intend to make art a lifetime professional commitment. In a perfect world, artisans could focus solely on their medium(s), and material concerns would resolve themselves. Even if we have an aversion to the business elements of the profession, it is imperative we have both control of our product and a basic understanding of the marketing process.

CONFIDENCE

Never apologize for what you haven't done or accomplished yet with your career. Every artist starts at the bottom, without exception. Instead, emphasize what you have accomplished and what you are capable of. The premier sellers I've noted are less than modest when they name drop about their galleries, collectors, and commissions (as though they've cultivated a quasi-family). Why? Individuals want to be a part of an extended family. eBay, the premier direct selling enterprise on the Internet, understands the necessity of this effective fraternal component. Its respective buying and selling communities are very passionate about their participation and reach the ultimate goal of relationship building.

INITIATE RESPONSE AND ACTION

If you intend to invest the time, expense, and follow-up to make direct marketing work, it is essential you consistently ask for response and follow-up on an action. I've heard some very impressive sales pitches fall uncomfortably flat because there was an assumption that the listeners knew what was expected of them and yet no course of action was specially requested. The purpose and objective of your direct mail piece, namely selling or representing your art, should be threaded throughout the message.

Strategies for Sending Effective Snail Mail Sales Messages

Let's examine the mechanisms for composing various direct mail pieces. The most commonly used direct mail piece is snail mail, but it is far from the fastest growing medium. In fact, electronic mail has become such a popular communication movement that the United States Postal Service (USPS) is reexamining the way it conducts business. Since becoming a self-funding operation (through its own product lines and services), it has bathed in red ink, suffering tremendous paper-losses.

However, the USPS is also currently in the process of reinventing itself into a twenty-first century enterprise, incorporating technology and software into its delivery service package. Although presently its prospects for profitability are slight, I would scarcely sell short its ultimate capacity as a communication server.

Integrating all of the components just described into a sample direct mail letter, I would structure most snail mail pieces using the following parameters:

- *Utilize a good quality paper for at least your cover letter.* Impression is everything and skimping in such an obvious manner speaks volumes about how you value your work.
- *Design a letterhead logo and center it at the top of your page.* If you don't have a personal logo, center your first and last name in an attractive large font or in lowercase letters. This format stresses your ability to conduct business in a businesslike manner.
- *Limit your cover letter to one page unless it is imperative to elaborate.* Abraham Lincoln's Gettysburg Address is a brief but masterfully crafted document. The speech preceding it exceeded three hours. Do you recall the author?
- *Organize the structural content of your letter.* The first paragraph should introduce yourself and indicate why you're contacting the receiver in no more than three sentences. The second, third, and possibly fourth paragraphs should emphasize your qualifications, background, awards/honors, and prior exhibitions. Don't over-extend your descriptive adjectives but establish your credibility as a professional.
- *Personalize the letter whenever possible.* If you are doing a mass mailing, you might want to use the generic salutation *Gallery Director* or more comfortable and flattering *My Valued Supporter* (for your collectors or prospect lists). It is difficult to be too personal in a mass mailing, but anything expressing appreciation is welcome. Remember, you're building a long-term relationship (it will require time).

- *For a letter, limit a legal-sized envelope to no more than three pages.* Otherwise, consider using a half-size or full-size envelope to avoid unnecessary folds and a rumpled look.

- *Hand sign each letter or at least use a script font to resemble a signature.* This personalization separates it from junk mail and form letters.

- *Write in the same manner as you speak.* This conveys a true sense of your personality.

- *Have your letter proofed by someone beside yourself.* Our familiarity with the content usually makes us somewhat careless in the editing stage. Even spelling and grammar checkers miss items that a quick read-through by an objective reader would catch. These types of errors are very distracting from the content of your message.

- *Your final paragraph should restate the objective of the letter and specifically outline your availability and willingness to cooperate.* A telephone or fax number should be listed along with a contact e-mail address.

- *Include contact information.* Most people put the street address, telephone number, Web site and/or e-mail address in the bottom section (footer) of the word processing document. Even if you include it in the letter's text, don't hesitate to have it visible elsewhere.

- *Remember weight considerations.* If your letter with enclosures exceeds one ounce and you have only a single stamp on the envelope (based on the current rate), you will get your mail stacks returned with an unimpressive "returned for insufficient postage" stamp on each letter—or worse, the postman will attempt to collect postage due for the additional ounce from the recipient.

Valuable Observations about Direct Snail Mail

"It costs more to acquire a new customer than to retain one you already have. In fact, the most important order you ever get from a customer is the second one because a two-time buyer is at least twice as likely to buy again as a one time-buyer."[4]

"Test mailings: 1,000 is a fair test."

"According to research regarding color, men prefer blue, red, violet, green, orange, white, and yellow in order of preference. Women are thought to prefer red, violet, blue, green, white, and yellow."

"Two-page letters pull the best [response rate] when printed on two sides of a single sheet."

"The headline is responsible for 50 percent of the returns obtained from any advertisement."

"When the telephone is combined with direct mail, it can result in an increase in your response by two to six times, or more."[5]

POSTCARD PRINTING SERVICES

www.48HourPrint.com
www.4Over4.com
www.CustomPostcards.com
www.Dynacolor.com
www.ImageMediaPrint.com
www.ModernPostcard.com
www.OvernightPrints.com
www.PKGraphics.com
www.Postcard.com
www.Postcard.co.uk
www.PostcardServices.com
www.PremiumPostcards.com
www.PrintandMailCenter.com
www.PrintingForLess.com
www.PSPrint.com
www.PurePostcards.com
www.TreatyOakPress.com
www.VistaPrint.com

Composing an Effective E-mail Sales Message

The text composition and content of an e-mail sales message is not significantly different from a snail mail letter, but the two most important elements of the message are the subject line and the choice of vocabulary.

The subject line, like a headline in a major advertisement, is the primary reason why your message gets read or tossed. Choose each word carefully. A subject line that is too long will be displayed as a hacked-off sentence in your reader's e-mail in-basket. Experiment with a variety of words to determine the most effective for response.

People hate the sense that they are being sold something. A subject line pitch that says "come and buy from me" is ineffectual because it is overused and thus ignored. Messages that are direct and personal are by far the most effective. When you write as you speak you are personalizing your content. Think like the audience you're writing to. What satisfaction can your message or artwork provide? An attention-grabbing subject line, short and focused on the needs and wants of your audience, is a critical starting point.

A strong opening paragraph in the body should address the purpose of your e-mail, and hyperlinks are preferable to attachments due to virus concerns. Keep your messages tightly focused and in summary format because e-mail tends to be an abbreviated medium. Most e-mail messages have the length of memos rather than full business letters.

Establishing a Complimentary E-mail Account

Establishing an e-mail account is rather straightforward and quick application process. Many major search engines, indexes, and hub Web sites offer complimentary accounts, although fewer than before. The original motivation for free accounts was to encourage return visitors to the site, inflating viewer statistics. These viewer statistics serve as the basis for establishing advertising rates.

Most complimentary e-mail accounts limit storage space (with upgrades available) and enforce prohibitions against group mailings. These complimentary accounts are very easy to establish, very easy to abandon, and consequently, difficult to trace. If your e-mail originates from one, your return address may undermine your credibility. Most online spam and scam appeals originate from these addresses, so prospective clients may be reluctant to receive your sales inquiry with the good faith it doubtless merits.

FREE E-MAIL SERVICE PROVIDERS

www.EmailAddresses.com
www.Mail.com
www.MyOwnEmail.com
www.Hotmail.com
www.Kaxy.com
http://Mail.Lycos.com
www.Rock.com
www.Walla1.com
www.Yahoo.com

Fee-Based E-mail Programs

If you are seeking optimal communication tools, a premium e-mail service provider can offer customized e-mail templates incorporating state-of-the-art HTML design features, flash media, embedded photos, and images and, most importantly, the capabilities of managing large e-mail lists and databases. HTML-based mail also enables you to track when e-mail is opened, read, and forwarded through complex code built into the software. Their services involve monthly fees, but in terms of impression and marketing management, the modest service charge may justify a premium first impression.

As part of your Web site hosting package, you should receive one to multiple e-mails accounts (see chapter 2). This form of identification works well because of the direct tie-in to your Web site.

PREMIUM E-MAIL SERVICE PROVIDERS

www.AcquireWeb.com
www.AdvancedWebmail.com
www.BigFoot.com
www.Burntmail.com
www.Canaca.com
www.Cryptoheaven.com
www.EmailAddresses.com
www.EmailUniverse.com
www.ExactTarget.com
www.GMSI1.com
www.GotMarketing.com
www.Imap4All.com
www.Incredimail.com
www.LuxSci.com
www.MailSnare.net
www.Redpin.com
www.Simplicato.com
www.TheDomainWorks.com
www.Webmail.us
www.WhatCounts.com

Another e-mail service proven very useful enables users to access multiple e-mail accounts simultaneously through a single remote channel. These remote e-mail Web sites provide file storage capabilities and maintain an address book, calendar, and bookmarks, all in a single offsite location. The advantage to this service is that while in transit, you have unlimited access to your e-mail and don't have to rely on your ISP's local access numbers.

REMOTE ACCESS E-MAIL SERVICES

www.E-MailAnywhere.com
www.GoToMyPC.com
www.Mail2Web.com
www.PJWeb.co.uk
www.Webbox.com

When you change ISPs, it is also important that you forward the e-mails sent to your old address to your new one. Several unique services retrieve these stray messages and redirect them to your new e-mail address. They also notify the original sender by autoresponder that the message has

been re-routed (but it does not include the updated e-mail address, so if you purposely change e-mail addresses to evade certain contacts, they will have difficulty locating you).

E-MAIL FORWARDING SERVICE

www.Dyndns.org
www.EmailAddresses.com
www.Email-Forwarding.biz
www.ForwardPortal.com
www.NetForward.com
www.Pobox.com
www.Returnpath.net
www.UltraDNS.com

Autoresponders as a Sales Tool

One of the evolving marketing technologies of the Internet is the ability to track visitors to your Web site and maintain ongoing, automatic contact with them. Sequential autoresponders enable Webmasters to follow up a prospect a number of times, at planned intervals, with different messages, giving you multiple opportunities to make a sale.

This technology explains why it is often so difficult to be removed from spam lists; they are electronically preprogrammed to send out their messages. Furthermore, they insulate the sender from any complaints, since the sender never actually views an e-mail request for removal from the list. This use of course is an abuse of the technology, but also one of the reasons why spam is here to stay.

Autoresponders allow you the important ability to personalize your messages. With the insertion of a simple tag, the prospect receives an e-mail that appears to be only for that one reader. Your stored message, which the autoresponder saves, is created in the same manner as a simple e-mail.

Marketing propaganda on several autoresponders suggests the more frequently (five to six times minimum) and consistently prospects are contacted, the more likely they are to convert from pedestrian prospect to client. The technology also compiles a list of each e-mail contact inquiry, enabling you to develop a database of potential clients who have had some exposure to your Web site.

AUTORESPONDERS

www.1AutomationWiz.com
www.ARPros.com

www.Autoresponders.com
www.Autoresponders.org
www.AWeber.com
www.FollowingUp.com
www.FreeAutoBot.com
www.Gammadyne.com
www.GaryNorth.com
www.GetResponse.com
www.Infogeneratorpro.com
www.RealReply.com
www.Responders.com
www.RobotReply.com
www.SendFree.com
www.TheSiteWizard.com

Using a Pop-up Ad on Your Web Site to Build Your Mailing List

A simple, non-threatening pop-up ad for your index page, encouraging visitors to provide you with their e-mail address, can help you locate propective clients. Upon receipt of their e-mail address, send them an upbeat welcome letter and periodically contact them about your professional activities, exhibitions, and special events, or create a newsletter addressing these points. This is a first step in establishing long-term goodwill. Many artists direct this pop-up ad response to a designated e-mail address linked with an autoresponder, so all follow-up correspondence is done automatically and on a prescheduled basis.

A good incentive for encouraging e-mail sign-ups is to offer free promotional gifts for their registration such as a gift certificate for their next purchase, an excerpt from a book you've written, sampling of your poetry, a digital image for their screen saver, or complimentary greeting card of your work or an artist you represent. These promotions cost you nothing and provide a unique welcoming invitation.

chapter 8

LINKS, ARTIST Resources, and Supplies

There are two primary purposes for establishing hyperlinks with other Web sites: credibility and visitor traffic.

Reciprocal Links Aid Search Engine Rankings

Credibility comes from affiliating yourself with established art institutions, artists, resellers, or publications. If these sources think enough of your work to invest space on their commercial Web sites to promote you, then they acknowledge you are a serious, professional artist (not that you doubted this after the first thousand hours invested in promoting your Web site).

From a traffic standpoint, unless the source of your link gets a substantial volume of traffic itself, you will be unlikely to see a significant portion of its viewers head your way. However, as mentioned earlier, inbound links are most important in improving your search engine rankings, potentially opening up selling opportunities.

The clearest proof incoming hyperlinks translate into Web site traffic is to conduct a search of the term *art* on any of the major search engines. The top listed art Web sites (whether or not they advertise on the Pay Per Click programs) all share a commonality. They all have a substantial number of other Web sites pointing in their direction through reciprocal links.

For instance, Art.com (*www.art.com*)—a Getty-owned retailer of custom framed art prints, posters, and fine art originals—boasts an impressive 123,000 incoming links, while even more impressively, Fine-art.com (*www.fine-art.com*), a small, privately owned Houston, Texas–based Web site, features 224,000 incoming links. Art News (*www.absolutearts.com*), a biweekly e-zine, and its sister Web site, World Wide Arts Resources (*www.wwar.com*), features 150,000 and 13,700 links respectively, thus creating separate streams of incoming links to the same sources.[1]

Once your Web site is stationed in the top tier of search engine ranking, your upper location assures you a higher rate of sustained visitor traffic. Most clickthroughs on search engine research are limited to the top twenty listings. While it may not be possible or practical to attempt

to accumulate 100,000+ incoming links toward your Web site, the more you can accumulate, the greater the likelihood your Web site may be discovered via a search engine.

Most links are created from banner images or text listings that, when clicked, transfer to your Web site URL. One design consideration in adding links is that they may congest your front index page if there are too many. This cluttered result causes slower download times of your index page and often makes it difficult to determine whether your Web site is an actual showcase for your art or a portal for the assorted art world community.

Strategy for Accumulating Reciprocal Links

Keep your links page separate from your index page with a visible direct link button. Make cultivating incoming links a top priority. Why? By serving as a portal to additional reference information, you give viewers more reasons to return to your site. The best sources for links are typically commercial art sites, domestic and international art galleries, art consultants, peer artists, virtual art broker services, art publications, and interesting diverse Web sites (related to your work). Target Web sites of artists who have high rankings in the keyword search categories of the indexes you're interested in being highly rated. The logic follows that if they're rated well, why not piggyback on their exposure?

However, let me restate the importance of these links being reciprocal; they must be mutually exchanged. Why, unless you're innately altruistic, should you promote another commercial site if they don't return the favor? You'll have Web sites reply to your linking invitations indicating their company policy forbids it, but they would grant permission to link to theirs. Umm ... thanks, but no thanks. The greatest selling point for reciprocal links (particularly if they are related industries) is search engines give more relevance value. Thus, both participating Web sites receive benefit even if very little traffic is generated from the direct link.

Once you have a section devoted to reciprocal links, monitor it periodically to ensure every site you're linked to responds with an in-kind link. If not, simply remove it from of your reference list or drop a quick e-mail reminder of the obligation to link mutually.

There are several additional techniques you can employ to source potential reciprocal links. One is a search engine guide Web site featuring a listing of over 3,700 search engines and directories. Conducting a search for art-related search engines would enable you to isolate more industry-related Web sites. The other is an online source that measures link popularity and enables searches for related themed Web sites. Start visiting these sites and drop them a quick e-mail to see if they'll consider add your link to their network.

SEARCH ENGINE GUIDE

www.SearchEngineColossus.com
www.SearchEngineGuide.com

LINK POPULARITY SERVICES

www.AdvMediaProductions.com
www.AntsSoft.com
www.EtrafficJams.com
www.LinkATeer.com
www.LinkingMatters.com
www.LinkPopularityCheck.com
www.LinkPopularity.com
www.LinkPopularityService.com
www.Links4Trade.com
www.Mikes-Marketing-Tools.com
www.Relevant-Link.com
www.SubmitShop.com
www.TextLinkBrokers.com
www.Uptimebot.com
www.WebRanking.com

If you visit a site with a guestbook, forum, or feedback section, send it a quick message requesting a reciprocal link (include your Web site address). The more visible your Web site becomes from a variety of sources, the more often individuals and organizations will approach you with these requests.

Another tactic Webmasters use is to create design awards, which they present to other Web sites. The design awards are posted on the winner's site. When viewers click on the awards, they are transported to the site of the award-giving Webmaster, thus increasing traffic. What their criteria for selection consist of is usually anyone's guess, but all enjoy recognition and the ornaments of praise. Posted testimonials are also a good resource for attracting attention to you. Make certain you accompany any positive comments with your own Web site reference URL. In a society and industry so rife with criticism and negative commentary, its welcome to read positive affirmation (particularly if the sentiment is genuine) among peers.

Several software programs are designed to automate the task of finding reciprocal links by searching the Web and finding sites meeting specified criteria that you establish. These tools accumulate a directory of like-minded Web sites and then e-mail each requesting a reciprocal link.

The process, being automated, enables you to do this research with minimal time commitment. Link brokerage services also exist, creating a database of interested sites willing to exchange links. The system works by you making offers to Web site participants and their agreeing to make reciprocal trades.

RECIPROCAL LINK SOFTWARE

www.ApexPacific.com
www.AutoLinksPro.com
http://Axandra-Link-Popularity-Tool.com
www.Cyber-Robotics.com (Zeus)
www.Info-Pack.com
www.Linkalizer.com
www.LinkAutomate.com
www.LinktoLink.com

Valuable Information Outlets for Artists and Resellers

Just as the volume of collector and curator reference information on the art world has become prolific, so too is the accessibility of quality advice and product sourcing for the art community in general. Though our creative environment and studios may represent an island or oasis of solitude, artists are far from being alone in terms of positive reinforcement. The Internet features a substantial number of outlets, providing excellent resources and updated news and information on the industry.

Most of these Web sites specialize in building communities of their participants through discussion groups, chat lines, blogs, news updates, job lines, workshops, exhibition listings, and bulletin boards. Many stretch their service base much further by offering portfolio services, sales and auction outlets, extensive database of reference links, published opportunity listings, e-mail accounts, and so forth. Many are complimentary information portals, and some charge fees for specific services.

DIRECTORY OF ART FAIRS AND FESTIVALS

www.ArtandCraftShows.net
www.ArtFairSource.com
www.ArtNet.com
www.ArtSeek.com
www.CraftLister.com

www.CraftmasterNews.com
www.CraftsFairOnline.com
www.CraftShowsUSA.com
www.FestivalNet.com
www.Jolaf.com
www.SunshineArtist.com

DIRECTORY OF ART WORKSHOPS

www.ArtShow.com
www.CourseJunction.com
www.MangoArts.com
www.ShawGuides.com

Despite a popular perception that the artistic life is a solitary existence, there is a substantial base of support (resources and individuals) available and a wealth of experience and advice to tap into. Information technology crosses substantial boundaries and points of view. The art marketplace is becoming more transparent due to the immediate accessibility of informational Web sites and the growth of communication tools such as e-mail. This industry visibility is perhaps the greatest vehicle of change and certainly the most direct format for enabling opportunity.

ARTIST REFERENCE RESOURCES

www.AABC.com (Art Vision International)
www.AASD.com.au (Australian Art Sales Digest)
www.A-L-B.org (Artist League of Brooklyn)
www.American-Artist.net
www.Art-Contemporain.com
www.Art-History.com
www.Art-In-Canada.com
www.Art-Support.com
www.ArtAccess.com
www.ArtAdvice.com
www.ArtAffairs.com
www.ArtBoomer.com
www.ArtBusiness.com
www.ArtBuyerLists.com
www.ArtCafe.net
www.ArtCellarExchange.com
www.Artchive.com

www.ArtDaily.com
www.ArtDeadline.com
www.ArtDeadlinesList.com
www.ArteMedia.com
www.ArtExpo.com
www.ArtInContext.org
www.Artist-Info.com
www.ArtistCareerTraining.com
www.ArtistHelpNetwork.com
www.ArtistRegister.com
www.ArtistResource.org
www.Artists.ca
www.ArtistsNetwork.com
www.ArtistsRegister.com
www.Artistsspace.org
www.ArtistTrust.org
www.ArtistWeal.com
www.ArtJob.org
www.ArtKrush.com
www.ArtLex.com
www.ArtMarketing.com
www.ArtMailingLists.com
www.ArtNet.com
www.ArtNetWeb.com
www.ArtNut.com/intl.html (International Directory of Sculptural Parks)
www.ArtPromote.com
www.ArtResources.co.uk
www.ArtResources.com
www.Arts-Crafts.com
www.ArtSales.com
www.ArtsandBusiness.org
www.ArtSeek.com
www.ArtShow.com
www.ArtsInAmerica.com
www.ArtSpaceSeattle.org
www.ArtSpan.com
www.ArtsUSA.org
www.Artswire.org
www.ArtTable.org
www.ArtTalk.com
www.ArtUpdate.com
www.Artwell.com
www.AskArt.com

www.AvivaGold.com
www.Canadian-Artist.com
www.CanadianPortraitAcademy.com
www.CanArtScene.com
www.CanSculpt.org
www.CenterForDigitalArt.com
www.CenterForDigitalArt.com
http://collections.ic.gc.ca/waic (Women Artists in Canada)
www.ColorMatters.com
www.CommunityArts.net
www.CourseJunction.com
www.Creative-Capital.org
www.CreativeArtist.com
www.Desires.com (Urban Desires)
www.Detritus.net
www.DIFA.org
www.EchoNYC.com
http://elia-artschools.org (European League of Institutes of the Arts)
www.Eyedia.com
www.FertilePress.com
www.Gertrude.org.au
www.GlassEncyclopedia.com
www.GlobalArt.net
www.GlobalArtInfo.com
www.Hospaud.org (Hospital Audiences)
www.InLiquid.com
www.JIverson.com
www.KTCAssoc.com
www.LastPlace.com
www.LucidCafe.com
www.MarketingArtist.com
www.MBVan.org
www.MeNobodyKnows.com
www.MillenniumArtGallery.com
www.MTEWW.com
www.MyArtClub.com
www.MyStudios.com
www.NAIA-Artists.org (National Association of Independent Artists)
www.Nuovo.com
www.NWS-online.org (National Watercolor Society)
www.Oboro.net
www.PaintersKeys.com
www.PaintingSpot.com

www.Passion4Art.com
www.PerduraboArt.com
www.PewArts.org
www.Sculpture.org
www.Studiolo.org
www.SueViders.com
www.TheArtGallery.com.au
www.TheArtSource.com
www.WetCanvas.com
www.WomanMade.net
www.WsWorkshop.org (Women's Studio Workshop)
www.Wwar.com (World Wide Arts Resources)
www.YourArtLinks.com

Industry Online Publications and E-zines

Instead of traditionally subscribing to a few monthly, industry-standard trade publications, you should open your eyes to new electronic offerings. The Internet features extensive news sourcing, focusing on every medium and segment within our industry. Most art publications have a Web site presence and many offer free content postings, industry reference listings, and other such opportunities. Many provide reciprocal Web site links upon request. Not all publications offer their entire editorial content (competing with their snail mail subscriber base), but many will offer a sampling of articles to give you a flavor of their focus.

Many of these publications are formatting their design into HTML format for easy online viewing. Many likewise encourage direct feedback and discussion, enabling further depth to what traditionally has been passive reading with no encouragement of mutual dialogue. Working professional artists, dealers, and resellers all need to keep current on their profession in order to recognize trends and gauge the general current of the industry. As the art world becomes more decentralized in its structure, the components reshaping it will likely come from diverse origins.

Online publications typically invite subscriptions based on simple e-mail requests. Some offer complimentary e-mail addresses using their domain names. Others make subscriptions mandatory in order to access their archives of past issues.

One of the fundraising avenues mainstream trade publications are implementing is a fee-based access to archival issues. Ultimately, the aim is to recoup some of the enormous set-up expenses involved in compiling these back issue databases.

ONLINE ART AND MEDIA PUBLICATIONS

www.7am.com
www.AbsoluteArts.com
www.AirBrushAction.com
www.American-Artist.net
www.Art-Of-The-Day.info
www.ArtAccess.com
www.ArtAffairs.com
www.ArtAndAntiques.net
www.ArtBusinessNews.com
www.ArtCalendar.com
www.ArtDaily.com
www.ArtFind.co.nz
www.ArtFocus.com
www.ArtForum.com
www.ArtistsMagazine.com
www.ArtKrush.com
www.ArtMonthly.co.uk
www.ArtNet.com
www.ArtNews.com
www.ArtNexus.com
www.ArtResources.com
www.Arts-Crafts.com
www.ArtsManagement.net
www.ArtTalk.com
www.ArtUpdate.com
www.Artweek.com
www.Bowieart.com
www.Burlington.org.uk
www.CaffeineDestiny.com
www.Coagula.com
www.CollectingChannel.com
www.Contemporary-Magazine.com
www.CreativeArtist.com
www.Design-Museum.de
www.DigiZine.com
www.Electronic-Publishing.com
www.Espace-Sculpture.com
www.FindArticles.com
www.FindArtInfoBank.com
www.GlassEncyclopedia.com
www.International-Artist.com

www.JCA-Online.com (Journal of Contemporary Art)
www.LatinArte.com
www.LeftCoastArt.com
www.MillenniumArtGallery.com
www.Newsgrist.com
www.Newslink.org
www.NewYorkArtWorld.com
www.OnlineNewspapers.com
www.PaintersKeys.com
www.Photographic.com
www.Pixiport.com
www.Sculpture.org
www.Stateart.com.au
www.SunshineArtist.com
www.TFAOI.com (Traditional Fine Art Organization, Inc.)
www.TheArtNewspaper.com
www.TheBlowUp.com
www.TheGalleryChannel.com
www.WetCanvas.com
www.WoodWest.com

Art Supply Outlets

If you are located in an isolated or rural environment and have limited access to art supply outlets or simply wish to comparison shop, cyberspace might prove a hospitable sourcing ground. A significant number of art supply chains and even individual outlets offer online catalogs for direct order. In many instances, online ordering gives you access to a broader selection of materials, as well as price comparison capabilities. Many of these sites also offer publications, frames, canvases, videos, and a small but growing number even give online instructional courses. Others offer professional discounts and subsidized shipping rates, making online shopping an efficient and cost-reducing alternative. Since a uniform national policy on collecting sales tax has not been enforced, shopping out of state may even save you more if the store outlets do not collect sales tax on purchases.

ARTIST ONLINE SUPPLY AND PUBLICATION SALES OUTLETS

www.AardvarkArt.com
www.AaronBrothers.com
www.ABCArtbooksCanada.com
www.AllBooks4Less.com

www.Allworth.com
www.Amazon.com
www.AmsterdamArt.com
www.AOEArtworld.com
www.ArtSupplies.co.uk
www.Art-Sales-Index.com
www.ArtBooks.com
www.Artisan-SantaFe.com
www.Artist-Supplies.co.uk
www.ArtistsCorner.co.uk
www.ArtistSupplies.com
www.ArtNexus.com
www.ArtPlace.com
www.ArtPurveyors.com
www.ArtSelect.com
www.ArtsManagement.net
www.ArtStorePlus.com
www.ArtSuppliesDirect.com
www.BarnesandNoble.com
www.Black-Horse.com
www.BookLocker.com
www.BooksAMillion.com
www.Bookstorming.com
www.Borders.com
www.CheapJoes.com
www.Crafts-America.com
www.CyberEditions.com
www.Daler-Rowney.com
www.DickBlick.com
www.DiscountArt.com
www.Draw-Art.co.nz
www.FineArtStore.com
www.FrameandArt.com
www.Gordonsart.com
www.Herwecks.com
www.HofCraft.com
www.In2Art.com
www.IslandBlue.com
www.JerrysCatalog.com
www.KentPaint.com
www.Lawrence.co.uk
www.Mangelsens.com
www.McCallisters.com

www.McintoshArt.com
www.Meininger.com
www.MerrellPublishers.com
www.MillerBlueprint.com
www.MishMish.com
www.MisterArt.com
www.MITPress.mit.edu
www.NetLibrary.com
www.NYCentralArt.com
www.NYSchoolPress.com
www.Powells.com
www.Prestel.com
www.Pygmalions.com
www.RedwoodArt.com
www.RexArt.com
www.RichesonArt.com
www.SaxArts.com
www.Sinopia.com
www.StudioArtShop.com
www.TexasArt.com
www.TextbookX.com
www.ThamesandHudson.com
www.ThePierceCo.com
www.TotalCampus.com
www.Tridentart.com
www.TSquareArt.com
www.UrsusBooks.com
www.UtrechtArt.com
www.Walsers.com
www.WetCanvas.com
www.WsWorkshop.org (Women's Studio Workshop)
www.Yalebooks.com/art

E-MAGAZINES AND
Affiliate Sales Programs

The decentralization of the art industry ultimately will establish new channels of information and techniques for promotion. A growing number of artists have opted to create their own electronic magazines (Web zines, e-zines, or just zines) where they can update their various publics and recruit additional awareness about their work. There are generally two methods of distributing an e-publication.

Publishing an E-Magazine (E-zine)

Initially, most e-zines are distributed by publishers/artists who send out a simple e-mail to the addresses their address books. The natural evolutionary process usually includes subsequently posting the content to a hosted Web page. As the audience for the information grows (most e-zines are based on free subscriptions), the distribution process generally expands to utilizing a mailing list service provider to handle and make the necessary maintenance requirements. These services may include processing new requests (with opt-in filters) and eliminating returned e-mail addresses.

If you regularly send group e-mailings, the clean-up process of your lists may require a substantial time commitment. Many of the direct e-mailing list providers offer these services for free or very modest service charges. Several of these services likewise publish a directory of e-zines, encouraging additional recipient sign-ups.

In some instances, these mailing list houses plan to compile opt-in lists (your subscriber base) for resale. It is very important to find out if your distribution list will remain confidential or if it will be sold to groups you are completely unfamiliar with. Few things remain free on the Internet, and companies e-mailing out e-zines are either going to seek funding through monthly fees or opportunities to expand their mailing list inventory and sales.

E-ZINE LISTING AND DISTRIBUTION SERVICES

www.E-Target.com
www.E-ZineZ.com
www.EzineListing.com
http://Groups.Yahoo.com
www.PennMedia.com
www.WritingForTheWeb.co.uk
www.YourMailingListProvider.com

The Eclectic Nature of E-zines

Many e-zine publications are little more than specific artist promotional pieces with credited articles from other Internet sources. E-zines are typically published monthly, quarterly, or as several publishers have indicated, periodically (I assume when they feel like it). E-zines have proven to be an excellent source of building community and within visual arts circles. This strategy cannot be overstated. Remember, repetition is a key element to success in marketing. By reaching out to a subscription base on a monthly basis or even more frequently, you become more of a known, familiar individual. If your publication has something unique to offer from your distinctive voice, you may become an authority.

Most e-zines are exercises in expressions as opposed to money generators. Building viewer traffic depends upon your e-zine's content, continuity, and consistency. Don't rely on methods that promise a burgeoning subscription base, such as advertising in other e-zines, swapping ads, or allowing your columns to appear in various publications throughout the Web. These are all-important sources for generating new subscriptions, but don't expect tremendous response initially. If you're doing something worthwhile, the word will ultimately filter out and you'll see a steady response.

After self-publishing an e-book, *Selling Art on the Internet,* in December 2000, I felt it imperative to provide a follow-up vehicle due to the tremendous changes and opportunities evolving online. As I was aware of no other commentary voice in this niche of the market (except an occasional article, more overview than insightful), I felt that the timing was perfect for dialogue on the subject.

In January 2001, I began publishing my own e-zine with the same title and focus. Over the two years of distribution, there was a steady growth in readership and subscriber base. Offshoots of the project were speaking engagements, articles, seminars, and participation in exhibitions. In my case, my lack of available time to edit and publish necessitated ending the publication, but it served its initial objective.

Keep in mind the process of marketing yourself as a visual artist often means entering through back doors. Publishing a well-followed e-zine may be one strategy for opening unforeseen options . . . assuming you can afford the time and do the necessary article research or editing. Content is not a problem and numerous resources are available providing good commentary. Usually, their only compensation is editing credit and a link to their Web site. Some of these resources are listed below:

E-ZINE CONTENT RESOURCES

www.ArticleCentral.com
www.DirectoryOfEzines.com
www.EBooksnBytes.com
www.E-zineZ.com
www.EzineArticles.com
www.EzineHub.com
www.EzineNewswire.com
www.Freesticky.com
www.IdeaMarketers.com
www.Ozemedia.com
www.PagesMag.com
http://ThePhantomWriters.com
www.Web-Source.net

E-ZINE CONSULTING ADVICE

www.BoostBizEzine2.com
www.EasyEzineToolkit.com
www.EzineMarketingCenter.com
www.EzineQueen.com
www.EzineSolutions.com
www.MerlesWorld.com
www.MerryMonk.com
www.OSSWeb.com
www.Newsletter-Resources.com
www.SiteBuilderNews.com

Advertising Revenue from Your E-zine

Once you've built your subscriber base to a significant level, selling advertising space on your publication may provide a source of income. Most e-zine publishers tend to barter space on their publications in the early going. Some potential sources of no-risk advertising revenue are from

Web sites such as Advertising.com (*www.advertising.com*), Ezine Ad Auction (*www.ezineadauction.com*), and EzineAdvertising.com (*www.ezineadvertising.com*), which compensate e-zine publishers both via clickthrough and per impressions from provided banner or text ads run on their e-magazines.

The key to earning significant income from ads is to have a sizable enough readership that will actually respond to the ads. Over time, some advertisers seeking a unique and focused audience may find you and offer various propositions to be part of your content. Remember though, try and keep your editorial content focused on a specific niche or your publication may become viewed as another unwanted piece of spam and become a casualty of the delete key. Always offer your readership the option to unsubscribe. It is not only proper etiquette but now also the law in most states.

E-ZINE ADVERTISING SOURCES

www.Advertising.com
www.BannerSpace.com
www.EzineAd.net
www.EzineAdAuctions.com
www.EzineAdvertising.com

Affiliate Programs as Sales Outlets

Affiliate program relationships can be established when your site is used as a portal to sell products from other merchants. Typically you are paid a percentage of any sales originating from the result of a visitor finding a merchant through your site via a direct link or banner advertisement.

There are thousands of affiliate programs available on the Web where you can participate in selling a diverse selection of products such as pharmaceuticals, loans, domain names, Web hosting, search engine placement, design services, stocks, and, of course, books. The unfortunate truth is most of these affiliate programs will never earn you more than a few dollars (if they ever get around to paying you).

The Amazon.com Example

Amazon.com offers the mothership of all affiliate programs (it invented the concept in 1996). Currently its Web site indicates a selling base of over 900,000 affiliates worldwide. Its affiliate program is a key ingredient to its current success rate of nearly 13 million weekly Web site visits (ranked sixth behind eBay and ahead of the U.S. Government).

Ironically, a small percentage of its affiliates earn the largest base of commissions, since most buyers purchase directly from the Amazon Web site. However, the sales commissions for referral fees are generous (up to 10.5 percent on qualifying revenue). Amazon provides detailed traffic and earnings reports to associates and updates them with its own e-zine about the latest news and opportunities.

In return, Amazon cultivates an enormous sales staff, unprecedented incoming links directed toward its Web site, and goodwill in establishing an extensive international community.[1] This form of wealth sharing and relationship building is precisely the winning formula employed by the other five most-frequented Web sites (Microsoft, AOL, Yahoo, Google, and eBay).[2]

Selling Affiliate Products from Your Web Site

The secret to a successful affiliate program is to have your own unique product and service, not having thousands of other affiliates competing with you. For the products and services you distribute, there must be an opportunity to develop high demand with very limited competition. Many affiliate programs (particularly e-book sellers) are based on products liberally distributed online, so selection is critical, as is the opportunity to actually make a profit.

Original artwork as an affiliate product currently lags behind most other product categories in the short term, but may emerge ultimately as a solid resale product among affiliate sellers, particularly under the category of household products. The most likely successful affiliate products include reprint artwork in the form of Giclées, lithographs, or greeting card lines.

An affiliate popularity report conducted by Shawn Collins Consulting in *Internet Retailer* magazine reported that books, music, and movies make up the top products affiliate Web sites prefer to promote (53 percent). Of the affiliate Web sites polled, 53 percent said that they were willing to carry books, movies, and music. Forty-four percent said they would carry toys and hobbies. Other items affiliates agreed to sell were computers and electronics (42 percent), toys and hobbies (44 percent), computers and electronics (42 percent), apparel (41 percent), home and garden (39 percent), flowers and gifts (37 percent), sports and recreation (37 percent), health and beauty (36 percent), magazines (31 percent), and travel and auto (31 percent).[3] In numerous instances, the affiliate respondents represented multiple products on their Web sites.

While the range of fine art derived revenue is not likely to rival galleries or even direct artist sales now, these outlets may ultimately serve as supplemental source as the affiliate industry matures.

AFFILIATE PROGRAM RESEARCH SITES

www.5StarAffiliatePrograms.com
www.100Best-Affiliate-Programs.com
www.2-Tier.com
www.Access-Affiliate-Programs.com
http://AFFDirectory.com
www.AffiliateGuide.com
www.AffiliateMatch.com
www.Affiliate-Programs-Guide.com
www.AffiliateWorld.info
www.BestAffiliatePrograms.com
www.CJ.com (Commission Junction)
www.Find-Home-Business-Opportunities.com
www.SimplyTheBest.net
www.WebAffiliateManager.com
www.WebAffiliatePrograms.com

Establishing Your Own Affiliate Program for Your Products

Another form of affiliate program may be financially more lucrative. The business model is direct. Your own art product lines are sold through other Web sites and those sites are compensated on a commission basis. Listing your Web site as a merchant in one of the above affiliate programs may also become a calculated risk investment for adding viewer traffic and ultimately sales.

Many online affiliate lists do not charge for your listing, which may be a source of recruiting possible sales outlets for your work. Make certain that when entering into any agreements with these outlets, you specify what product lines you wish to resell (originals, reprints, framed work, etc.) and what the rate of commission you are offering is based on (gross price less delivery charges). A typical commission structure averages between 10–40 percent. Keep in mind though, you may need to pay the listing service a percentage of each transaction as well.

If you are able to partner with Web sites attracting thousands of unique visitors, such a listing may ultimately translate into a legitimate source of revenue. Be selective about the merchants whom you select as partners and who represent your work. Otherwise, your credibility may suffer and no one benefits financially.

If you decide to create your own commission-based affiliate network, at the very least you will require an e-commerce shopping cart system (varying from free to a monthly processing rate). As part of your sales tracking mechanism, you will need to program in a unique code for each affiliate

outlet (embedded in their order buttons) to track their sales and reimburse them with their due commissions.

The most successful business model formula for affiliate sales programs tends to be structured in the following manner. Your affiliate gets the order, collects the customer's payment, and then places the order directly with the selling source Web site (yours). You deliver the product/service to the affiliate business or send it directly to the ordering client (if the affiliate has sufficient trust in you to contact its clients directly). You bill your affiliate on a monthly basis for the net sales costs it has incurred.

This system works fine provided there is a mutual trust between all participating parties. For this reason, be very selective as to who sells your products or services on your behalf. An ethically suspect reseller can tarnish your reputation and cause you significant clean-up duties if they practice spotty customer service or neglect to pay you.

If you choose to have their clients contact you directly with orders, make certain your tracking mechanism is sound to provide them with proper credit and reimbursement. Otherwise the selling longevity of your product(s) will be extremely abbreviated.

AFFILIATE PROGRAM SOFTWARE

www.Affiliaterunner.com
www.AffiliateShop.com
www.AffiliateSoftware.net
www.AffiliateTracking.net
www.AffiliateWindow.com
www.AffiliateWiz.com
www.Clickbank.com
www.DirectTrack.com
www.FreeFiliate.com
www.Linkshare.com
www.Modulocom.com
www.MyAffiliateProgram.com
www.MyReferer.com
www.SimpleAffiliate.com
www.YourSoft-TM.com

ART PORTFOLIO *and Virtual Gallery Web Sites*

The online marketplace for original fine art is an underdeveloped one. With some exceptions, most online sales are under $1,000. For artists with established reputations and recognized works, sales transactions of significant amounts occur, but are currently the exceptions. This sales pattern seems to reinforce a perception that most contemporary art remains best sold exclusively through art dealers and galleries. But don't assume this exclusivity will continue indefinitely.

Fears Impeding Online Purchases

The original notion that big-ticket luxury goods were too speculative, extravagant, and risky for the Internet marketplace was fueled by concerns about the safety of online purchase transactions and legitimacy of resellers. Consumers' fears about the safety of online purchases have been steadily decreasing as the level and frequency of purchases online have annually risen. Even more revealing is the increasing percentages of online buyers encompassing all demographic categories. However, some safety concerns remain.

An Aberdeen Group report in 2003 estimated that identity theft losses could reach $2 trillion by the end of 2005 (300 percent annual growth rate). These figures were based on actual reports of $221 billion lost to identify theft during 2003 alone (the American market constituted one-third of those losses).[1]

Despite the real concerns about identify theft, most global financial institutions offer a growing number of online services. These expanding services include clients' online access to their accounts and the ability to make direct fund deposits, withdrawals, transfers, and payments. Traditionally these capabilities were limited exclusively to branch office transactions.

The Internet as a Maturing Marketplace

With or without security concerns, Internet use is expanding internationally and in the process, evolving into a permanent marketplace. Higher valued art will ultimately become a staple and sellable product as the marketplace continues its maturing process.

The maturing process will continue to create opportunities for individuals and institutions willing to gamble on the inevitable future development. Despite numerous early entries and highly financed and profiled online failures within the art industry, the number of Web sites marketing fine art and showcasing artists seems to be proliferating. The emergence of many of these fresh selling outlets has been lower profile than the flashy overspending pioneer mega-virtual galleries of the dot-bomb era. However, unlike their predecessors, many are successfully selling artwork and are geared toward establishing a longer-term presence.

The current hybrid of virtual gallery seems more focused in its selling agenda, more streamlined in its operating staff, and more focused in the clientele it is cultivating. Less money is being allocated toward acquiring visitors and more toward establishing a buyer base.

As with any evolutionary process, further fallout is inevitable, but for artists, exposure possibilities are limitless. Individual artists may thrive within this new environment because they are unbeholden to any single sales outlet source. Artists are routinely encouraged to post their images on a variety of art sales and portfolio Web sites and pay generous, below-industry commissions of 10–25 percent if work actually sells (very modest risk). Even better, there are rarely exclusive agreements or expectations. An artist may be inclined to participate in thirty sales outlets without surrendering a single piece of inventory. Broad exposure inevitably breeds opportunity, a single premium sale justifies the time investment.

The Financial State of Virtual Galleries

Virtual galleries are not obliged to publicly report their financial statements, since they are privately owned and operated. Few bother. Most of the original, larger, venture capital–funded Web sites have by this time either merged into other sites or ceased operations. Since generally your interest in a virtual gallery is as a supplemental sales outlet and not as an investor, this loss may not be a problem.

However, the more intimately involved or contractually committed you become with an enterprise, the more concerned you should be with its financial health. If the gallery ceases operations while holding your consigned artwork, you may be left with only a digital image memory. In several instances

during the dot-bomb period, consigned artworks were used as collateral to pay off creditors, much to the chagrin of the unpleasantly surprised artist.

For the visual artist, virtual gallery sites may ultimately be responsible for some sales and certainly added exposure to an art-oriented buying market. Qualified exposure is always welcome. Beware of exclusive commitments to a single site. Ultimately, exclusive agreements with artists for online sales may be a successful formula for online galleries. At this point, however, unless selling outlets will guarantee in writing a minimum sales volume or quota to maintain their exclusive arrangement (highly unlikely), I would be very hesitant to work with only one.

Artist Cooperative Online Galleries

Some of my artist colleagues have created their own cooperative virtual galleries even if their real estate storefront consists of nothing but an attractive Web site and memorable domain name. These virtual co-op galleries approach more receptive art auction and selling Web sites (such as galleries) and utilize their services as a broker. Instead of the industry's traditional 50/50 split (or less for the artist) with a retail gallery, auction sites typically take between 5–15 percent in sales commissions, leaving the artists and creators with a healthier return on their sales.

Becoming an art gallery is as uncomplicated as becoming an artist. A resale license issued by a city business license department or county Board of Equalization qualifies you as a legitimate business. More artists are beginning to realize that becoming a virtual gallery enables negotiation with a commercial gallery for exhibitions, pricing, and commissions to be conducted on a peer level. A codependent relationship between artist and art reseller makes more sense than total artist dependence.

Expectations in Working with a Virtual Gallery

For artists looking to participate in as many of these Web sites as possible, the conditions vary depending on the nature of the site. Some charge a participation fee to cover their production time. Many Web sites promise extensive exposure and some allow direct linkage to your own Web site. If a Web site fails to address a specific niche of the market and is too generalized in the mediums of its participants, don't raise your expectations. A site may be evasive when you ask about its sales figures, but if the site asks for financial participation from you, it's in your best interest to inquire.

Many Web sites are concerned about the quality or specialty of the work they represent. The Webmasters may request digital samples of your work, prior professional exposure, and other background material.

This screening process, reminiscent of walk-in galleries, can ultimately only improve the caliber of virtual gallery offerings.

A decision to exclude your work from a gallery isn't an insult to your talent or the merit of the work. As a virtual gallery's popularity, client base, and success increase, its focus must narrow toward the mediums, style, and content that interests its active buying public. The Internet is subject to the same laws of supply and demand that affect any other business.

Expand Your Base of Selling and Exposure

It is a sound procedure to investigate the nature of each virtual gallery or portfolio site before investing the time (or money) involved in participation. Be comfortable with its format and exhibited art styles. Virtual galleries will probably not replace traditional dealers any more than fine art will become an exclusive online visual medium. Many virtual galleries have become extensions of traditional retail galleries, and this situation can only be a plus for artists taking advantage of the marketing experience. Online exposure may also open up traditional exhibition exposure and representation opportunities.

Broaden your base of selling and exposure as you do with any other marketing enterprise. Successful artists, galleries, and resellers rely on multiple sources for exposure and sales leads and are relentless in their pursuit of both. Your own online commitment should be no less thorough and all embracing.

ARTIST ONLINE PORTFOLIOS

www.Art-In-Canada.com
www.ArtistRegister.com
www.Artists.ca
www.ArtNet.com
www.ArtReach.com
www.Artshow.com
www.ArtsOfParadise.org
www.ArtSpan.com
www.Artstream.com
www.AskArt.com
http://Dart.Fine-Art.com
www.Espectro.com
www.GlobalArt.net
www.iTheo.com
www.PaintingsandPrints2.co.uk

www.TheArtGallery.com.au
www.WomanMade.net
www.WorldDigitalArt.com
www.WsWorkshop.org (Women's Studio Workshop)
www.Wwar.com (World Wide Arts Resources)

VIRTUAL FINE ART MARKETPLACES

www.AbstractEarth.com
www.AJP.com (Artistic Judaic Promotions)
www.AltPopArt.com
www.Art-AOA.com
www.Art-Connection.com
www.Art-Exchange.com
www.Art-Gallery-NewZealand.com
www.Art-In-Canada.com
www.Art-On-Net.com
www.Art-Online.org
www.ArtNet.com
www.Art.net
www.Art4Business.com
www.ArtAdvocate.com
www.ArtAffairs.com
www.ArtAssociates.com
www.Artatoo.com
www.ArtBank.com
www.ArtCanyon.com
www.ArtCellarExchange.com
www.ArtCnet.com
www.ArtCrawl.com
www.ArtDial.com
www.Artekas.com
www.ArtFaces.com
www.ArtForAfterHours.com
www.ArtfulFraming.com
www.Arthbys.com
www.ArtHeals.org
www.ArtHoldings.com
www.ArtIsLife.com
www.Artlink.com
www.ArtLondon.com
www.ArtMagick.com
www.ArtMajeur.com

www.ArtMania.com
www.ArtMango.com
www.ArtNexus.com
www.ArtPrints.ch
www.ArtQuest.com
www.ArtReach.com
www.Arts-Cape.com
www.ArtShowPlace.com
www.ArtSpan.com
www.Artstream.com
www.Artworksf.com
www.AZBronze.com
www.b17.com (Art Galore!)
www.BelgiumAntiques.com
www.BrushStrokesArt.com
www.BuyArt.com
www.CarrieArtCollection.com
www.China-Avantgarde.com
www.Circline.com
www.CollectFineArt.com
www.CollectorsEditions.com
www.CounterEditions.com
www.Courtyard-Gallery.com
www.CowboyArtShow.com
http://Dart.Fine-Art.com
www.DragonflyProductionsInc.com
www.E-Artivity.com
www.Easeworldwide.com
www.EBuyNativeArt.com
www.Elite-Art.com
www.Espectro.com
www.ExtraLot.com
www.Eyestorm.com
www.eZiba.com
www.FineArtc.com (Fine Art Clearinghouse)
www.FineArtExplorer.com
www.FineArtSite.com
www.Gablesart.com
www.Gallery-A.ru
www.GalleryByte.com
www.GalleryPrint.com
www.GlobalArtCollection.com
www.GlobalGallery.com

www.Guild.com
www.Haefner-Art.com
www.InternetArtFair.com
www.InuitArtEskimoArt.com
www.InuitArtZone.com
www.iTheo.com
www.JustOriginals.com
www.KlimArt.com (Klim Art Publishers)
www.LAArtists.com
www.LatinArt.com
www.LatinArte.com
www.Leonarto.com
www.Magic-Lantern.ch
www.MeterGallery.com
www.MillenniumArtGallery.com
www.MixedGreens.com
www.ModernAmericanArt.com
www.MoodyArtServices.com
www.NeoImages.com
www.NewYorkArtists.net
www.NextMonet.com
www.NovaScotiaArt.com
www.Novica.com
www.NYFew.com
www.OldMasters.net
www.Onart.com
www.OnlineArtistsUnited.com
www.OTCart.com
www.PaintingofRussia.com
www.PaintingsandPrints2.co.uk
www.PaintingsDirect.com
www.Perduraboart.com
www.PeterLaneFineArts.com
www.PhotoArtistsNetwork.com
www.Photocollect.com
www.Photoeye.com
www.PhotographersRep.com
www.PicassoMio.com
www.Pixiport.com
www.PodGallery.com
www.PostPicasso.com
www.Rareart.com
www.Rogallery.com

www.RussianArtGallery.com
www.SelfRepresentingArtists.com
www.Shopart.com
www.Si-i.com (Selected International)
www.Soarts.com
www.SoFlaArtwork.com
www.StockArtRep.com
www.Stop4Art.com
www.TheArtGallery.com.au
www.TheArtLimited.com
www.Viewseum.com
www.Virtuartnet.hu
www.Wwar.com (World Wide Arts Resources)
www.W3Art.com
www.WetPaintGallery.com
www.WildArtlink.com
www.WomanMade.net
www.WorldWideArtAgency.com
www.Yes2Art.com
www.Your-Art.com

SELF-REPRESENTING ARTIST AUCTION SITES

www.Art-AOA.com
www.Ebsqart.com
www.eMOMA.org
www.IBND.org
www.Ismudge.com
www.QAEArtists.com
www.SelfRepresentingArtists.com

ONLINE PAYMENT *Services*

Luxury-goods consumers are justifiably feeling more at ease making large purchases online with the development and maturity of secure payment services. These electronic-transfer and credit-card-encryption programs have demonstrated consistent safety and are introducing international payment programs for foreign currencies.

Online Payment as an Emerging Industry

Secure payment Web sites assume responsibility for credit card chargebacks, a nightmare for any artists having had prior experience with bank merchant services accounts. Many traditional, bank merchant services are very reticent about encouraging online credit card payments due to security concerns. Punitive tactics, including tightening their online credit card acceptance policies and imposing minimum monthly service charges, have alienated small businesses and artists from growing reliance on online sales.

Online payment services have carved an impressive and growing niche amid this inflexibility.

The paper check (as we know it currently) may become history in our lifetime. An e-mail address and the right electronic payment service translate into the flexibility of paying and receiving payments anytime and anywhere. This option becomes the most expedient and advantageous method to move money around. It offers potential clients greater flexibility and options in arranging their payment methods.

Two prototypes below are among the largest, fastest growing, and most popular of the electronic payment sites. Their respective fee structures are very competitive with traditional merchant service accounts for onsite payments. Both accept direct payments, bank transfers, and most major credit cards.

- PayPal (*www.paypal.com*) was founded in 1998, publicly traded stock during 2002, and was acquired by the auction exchange eBay (*www.ebay.com*). PayPal is a global leader with over 56 million accounts.

It offers three categories of accounts: Personal, Premier, and Business, dependent on service requirements of the accounts. *Fees:* Merchant accounts fluctuate between 1.9 percent and 2.9 percent for each transaction plus a base charge of 30 cents. There are no fees for, setup, maintenance, gateway, or tools including shopping carts. The service is available in forty-five countries worldwide.[1]

■ BidPay (*www.bidpay.com*) is owned by Western Union and was devised to make moderate-sized payments easier. Established accounts transfer money either directly to U.S. checking accounts or U.K. checking accounts (registered to receive checks). A third option is via Money Order, either snail mailed to the destination or via express delivery services. E-mail confirmations are sent to both buyer and seller. *Fees:* Senders pay service fees starting at $1.95. Sellers generally are not charged to receive funds.[2]

ONLINE PAYMENT SERVICES

www.AuthorizeNet.com
www.Bidpay.com
www.Certegy.com
www.eChecks.com
www.Ecount.com
www.GeoTrust.com
www.iKobo.com
www.LiveProcessor.com
www.Neteller.com
www.Nochex.com
www.Paypal.com
www.Protx.com
www.SecPay.com
www.Telecheck.com
www.Verisign.com

ONLINE AUCTION *Exchanges and Merchant Stores*

Two additional outlets available for selling your artwork outside of online virtual galleries and directly through your Web site include consumer/business auction exchanges and merchant stores.

Consumer Auction Exchanges

A host of consumer and business-oriented auction Web sites have evolved into international marketplaces. The direct seller-to-buyer auction sites pioneered and dominated by eBay have caused a profound change in the mid- to low-tiered auction market. For premium and higher end fine art, these selling outlets have demonstrated a dubious track record of success.

Despite a lack of successful high-end sales, auction listings may provide a low-cost source of Web site traffic. This strategy requires ingenuity since eBay prohibits direct inclusion of hyperlinks within an auction description. However, every policy has flaws. Some art listings include JPEG images listing a reference Web site URL. Using this visual promotional vehicle instead of an embedded hyperlink promotes the objective, but may run some risk in continued exchange participation.

The race for supremacy is not close. With over 18 million weekly viewers, eBay's competition auction sites—uBid, Yahoo, Amazon, and Priceline.com—service a fraction of eBay's traffic (for online auctions exclusively).[1] Plus, eBay is operational in twenty-four countries and is effectively the sole outlet for higher-priced artwork.[2]

Characteristics of Selling through Consumer Exchanges

Most artwork sold tends to be priced under $200, narrowing the actively selling market to photographers, emerging artists, and reproduction art. A growing number of artists are sustaining livelihoods from online sales,

often banding together into niche, self-representing groups. An ability to produce finished artwork prodigiously is essential to survive primarily through this selling medium, but what becomes apparent is certain artists are cultivating and developing a solid online client base. The evidence is the number of successful transactions (as shown by feedback rating) these artists have completed, and the fact that bids for their work start at a higher level than it does for others. Over time, the income levels of their patrons should elevate the demand and pricing level for their work.

Galleries love artists whose work sells and who likewise understand the importance of cultivating a clientele. Market mechanisms directly influence the value an artist's work sells for assuming a demand exists. The self-representing artist may be cultivating the business model through consumer exchanges, later becoming the benchmark for all beginning artists. As artists, we've all sold work for less than our perceived value. When you're starting out, the thrill of a sale is sustainment enough.

Consumer auction Web sites for artwork may be currently a one-note tune sung modestly by eBay, but the portal of opportunity is always open to the innovative. As the online selling community refines its own strategies and more profiled success stories emerge, this direct selling medium may become a legitimate outlet.

Five years or even ten years is a premature period for judgment. The auction house movement as a whole started from simple origins. Growing international Internet usage suggests that a conduit for bringing buyer and seller together is a mere innovation away. After all, before eBay became an international marketplace and lifestyle, it was a humble exchange designed to buy and sell rare PEZ dispensers.[3]

CONSUMER AUCTION EXCHANGES

www.Amazon.com
www.AuctionFire.com
www.Bidz.com
www.Bid-Mania.com
www.BuySellTrades.com
www.Deremate.com
www.eBay.com
www.eBid.co.uk
www.QXL.com
www.uBid.com
www.Yahoo.com

Business Exchange Opportunities

Two potential emerging sources for business and commercial auctions include reverse auction Web sites and Business-to-Business (B2B) exchanges. At the height of the dot-com era in 2000, direct business-to-business exchanges were viewed as an emerging trillion-dollar industry of opportunity. Those wildly enthusiastic forecasts have been prudently downsized to more realistic levels. The promise of offering single-source buying outlets for business purchasing departments still makes sense.

Although artwork in general has not evolved into a business staple product such as copy paper, file folders, or office supplies, décor is an integral purchase of most corporate facility managers. Over time, it is likely that more enterprising fine art marketplace Web sites will merge their product inventory (particularly framed reprinted works) with other corporate business suppliers and participate actively in these purchasing exchanges. Artist-entrepreneurs may precede this evolution by simply joining these business exchanges directly and initiating direct sales inquiries with other businesses.

The format for reverse auctions is straightforward. A potential buyer posts a request for a specific product or service. In the case of art-related categories, buyers typically specify the details of they are seeking—the style of art, artist, budget range, medium, etc. Registered sellers for specific industry categories are notified by e-mail of these specific requests. Sellers then make direct contact with the buyers if they can fulfill the request made through the posting service via e-mail.

If the buyer is interested in the seller's offer, the buyer has the option to contact the seller and negotiate with the seller directly. Throughout the process, the potential buyer's e-mail information is kept confidential from the seller unless the buyer chooses to make a direct contact. Buyers are under no obligation to purchase from the sellers who contact them, but frequently receive numerous offers to consider.

The reverse auction process features a significant spectrum of products and services, and the fine art industry is growing in participation with this process in an equal degree with other industries. The logic behind the system is sound because these are targeted leads. The sellers pay the hosting Web site a fee for the right to respond to requests, and the potential buyers rate the type and quality of response they receive from potential sellers.

REVERSE AUCTION WEB SITES

www.BackwardBids.com
www.Respond.com
www.Sorcity.com

B2B EXCHANGES

www.Bocat.com
www.EC21.com
www.Exchange.Oracle.com (Oracle Exchange)
www.GlobalSources.com
www.HousewaresDirect.com
www.PlanetBids.com
www.WorldBid.com

Procedures for Conducting Consumer Exchange Auctions

Auction sales listings, at one time complimentary, now nominally priced (depending upon the starting bid price or minimum price reserve level), typically retail at $3 per listing plus selling commissions of approximately 5 percent. Four strategies employed by consistent auction sellers include 1) joining a self-representing artist exchange, 2) uploading a regular inventory of finished artwork, 3) paying for upgrades on the placing of their listings within the auction category, and 4) maintaining a database of previous buyers and updating them regularly based on upcoming listings.

Online, there also exist unaffiliated auction resources, offering bulk-uploading software to enable you to post directly to eBay and also set up storefront showcases on Web sites such as Yahoo, Amazon, and Froogle. These services earn their revenue via a small commission on all successfully completed sales. They also feature supplementary services such as direct billing, follow-up autoresponded letters, and automatic re-listings, also commonplace eBay tools. For large-volume sellers (power sellers), these tools can be excellent time-savers.

AUCTION TOOL PROGRAMS

www.Andale.com
www.AuctionInc.com
www.AuctionInsights.com
www.AuctionMeThis.com
www.AuctionTamer.com
www.ChannelAdvisor.com
www.InkFrog.com
www.Vendio.com
www.Zoovy.com

Choosing an Auction Category

Most listing forms for consumer exchange auctions are constructed under similar formats. A respective application listing requires a selling category that is assigned a number. For fine art, these categories typically include paintings, sculpture, and prints with many offering sub-classifications such as folk art, nudes, multiple techniques, photography, reproductions, and ceramics.

A listing will additionally require a product title with a limitation on the number of characters (usually no HTML text is allowed). This is a critical component in attracting viewers since a dull title amid 40,000 listings is highly unlikely to stimulate much attention. Some sellers incorporate into their titles an abundance of capital letters and exclamation marks for added emphasis. Few of these items justify the attention or hype, but that doesn't discourage the strategy (which I suspect is usually unsuccessful).

A third component of an auction listing is the description box, your opportunity to describe the work in detail and often elaborate on yourself. HTML codes are allowed in this section, and I strongly suggest either inserting a link directly to your Web site or at least mentioning your URL address if this practice is allowed (some sites have adopted policies to eliminate these links to prevent direct sales from bypassing the auction site). Participating artists should take the opportunity to explain the emphasis behind their work and perhaps state their respective credentials.

In many auction sites, you have available space of up to two hundred words to complete the description section. At one time, when I actively participated in numerous auction sites, I created short, medium, and longer descriptions for each item and saved them on a Microsoft Excel spreadsheet. Using this strategy, I simply cut and pasted the description I required based on the auction sites' allowable word limits.

Adding Photo Images

To complete your listing form, make certain to upload a photo image of your work (all selling sites accommodate this) or use an image stored on the Internet with a specific URL location. In many instances, auction sites will place a limitation on the number of images you may include, but more can be added through HTML commands within the product description. The two accepted photo formats for most auction sites are JPEG and GIF, but an increasing number will only accept JPEGs. With this in mind, I would create my images in JPEG format and try to keep the file size less than 100 KB (kilobytes).

This reduced image sizing can be accomplished by keeping your largest dimension size at 250 pixels, easily viewable on a computer screen. Remember, monitors are only designed to view images at 72 dpi, so all images on the Internet, despite software image manipulation, will be viewed at this lower resolution level. You can be fairly assured when selling artwork, if potential clients cannot see the item clearly, they will not risk a bid or invest in a purchase.

For sculpture and crafts, I would suggest showing two to three images from different perspectives. Additional photo images are allowed in a listing if incorporated into the description section with HTML text and hosted on another URL. Most regular auction participants, who own Web sites, reference the images on their own site for their listings.[4]

Auction Exchange Exposure

The intrinsic beauty of Internet auctions is you cannot buy this volume of exposure (in excess of 18 million eBay users weekly, over twenty-four international markets and growing)[5] in any media outlet or gallery exhibition for such a low price. Sales may be sporadic, but the artwork category *does* sell works daily, and this prospect may more than justify the time and minimal monetary investment.

The subtleties of drawing attention to display listings are evolving. For instance, eBay, Yahoo, Amazon, and most other auction programs allow you to upgrade your listings in various formats toward the top of their selling categories for modest fees ranging between $1–$100 and depending on the popularity of the category and number of sellers. This can be a critical element to a successful sale because with 5,000–40,000 listings in a specific art category, your listing easily becomes buried. This whole concept of category upgrades will continue to evolve based on the lucrative revenue potential to auction sites (much more promising than increasing basic listing fees and alienating potential sellers).

The Evolution of Consumer Auction Exchanges

The fact is that eBay has a substantial lead in the areas of innovation, listings, community, and sell-through ratios over its competitors, and the gap seems to be widening as this sales channel continues to mature. In the early, introductory stages of consumer online auctions, Yahoo and Amazon had periods where they were narrowing the gap, but various tactical missteps on their parts and the sheer momentum of eBay's growth have made its position as the largest online auction site a certainty; it's the best site as far as reaching sheer numbers.

Deadbeat Bidders

Experience, not all of it good, teaches us numerous auction sales tactics. A winning bid is not a guaranteed payment. A colony of deadbeat bidders roam cyberspace, uplifting the expectations of sellers, only to literally disappear when payment is due. What are your alternatives when you encounter such a species? Regretfully, you have precious few options. Auction exchanges intervene to a limited extent and try to solicit payment on your behalf, but my own experience has borne minimal fruit when it comes to these bad seeds.

Feedback sections are an important component in establishing auction site credibility. Report AWOL bidders on their feedback record to hopefully spare another seller a similar experience. This is often more symbolic than effective, however, as deadbeat bidders normally have multiple accounts with various auction sites, and my suspicion is they are more interested in promoting annoyance than upholding any sense of ethical standards.

Another prudent policy to follow is *never* send your artwork to confirmed buyers until their payment has been received and verified.

The Importance of Good Feedback

As for your own feedback track record, cultivate it zealously, as it offers reassurance to buyers who don't know you that they can expect fair and prompt service when they deal directly with you. Of course, you *must* offer fair and prompt service. Only the actual buyer of one of your auction listings can rate you and each favorable rating increases your selling stature. Conversely, a negative rating reduces your selling reputation. Whether you buy or sell on auction sites, I strongly advise you to liberally spread around positive ratings and request politely that your respective buyer or seller reciprocate. One can never be too favorably rated on the online auction site circuit.

Merchant Stores and Malls

Merchant store programs are the equivalent of cybermalls, providing potentially high traffic in exchange for a percentage of completed sales transactions. Some of these Web sites charge participation fees and many offer a variety of support services to their merchant partners. Most of the major consumer auction sites have introduced a variation of this merchant shop concept as an opportunity to earn additional revenue through fixed price sales.

A limited number of galleries and artists have established online retail formats using this format. The most successfully selling items appear to be

the same photography, emerging artist work, and reproductions prevalent among auction listings; thus it is likely that they are targeting primarily the same audience.

As with an auction exchange, your online store is tapping into a much larger traffic base. The process for working with online merchant store services has become a pretty straightforward process, as nearly all feature template storefronts that enable the quick and efficient set-up and maintenance of your storefront. By inputting your artwork descriptions on an Excel file and having your images available for hosting or already hosted online, you can generally upload every item in a matter of minutes.

As with the online art portfolio Web sites, your rate of success will be directly proportional to your time and resources spent promoting your online store.

ONLINE MERCHANT STORES/MALLS

www.Amazon.com
www.eBay.com
www.Falloon.com
www.FreeMerchant.com
www.Froogle.com
www.MallKing.com
www.ShopAtHome.com
http://Shopping.Yahoo.com
www.ShoppingCartsPlus.com
www.VStore.com

SELF-PUBLISHING, *Licensing, and* *Greeting Cards*

Aside from the practical exposure element the Internet provides, fresh revenue opportunities are being introduced for artists through licensing and self-publishing opportunities.

The greatest future sales potential of reproduction art may ultimately become digital reprints (called Giclées). The evident differences between Giclées and traditional reprinted art are 1) ease of production, 2) lack of laborious skill or technical knowledge to create, 3) reasonable cost, enabling significantly lower minimum runs, 4) quality of the finished product, and 5) ability to use multiple printing media including canvas, watercolor paper, and museum-grade paper stocks.

The multiple-income potential for your images is staggering due to the reasonable production costs and ability to print on demand in single units instead of large quantities. Giclée printing is a printmaking process utilizing a large format digital printer. Millions of minute dots of ink are squirted onto a paper or canvas surface producing tonalities that result in high-quality fine art prints.

The evident advantage of this process is you can keep your selling prices down for your reproduction work (helpful for selling on auction sites and business exchanges) and still retain your originals for bigger ticket sales. Thus digital reprints are potentially a substantial growth area for art sales. Oddly enough, many painters have never even conceived this outlet could apply to them.

The Giclée production process is relatively straightforward once you have your work converted to a digital format. The process for converting an original work to a high-resolution file can be accomplished in three different approaches.

Scan Your Photographic Images

Take a professionally photographed image of one of your paintings in a slide or large photonegative format to a local digital reproduction and printing service. Make certain the slide or negative is composed almost entirely of your work (minimal background) to ensure the scan records as much detail as possible. Many photographic services own drum scanners, able to capture remarkable detail.

If you are reluctant to spend the necessary fee for a professional service, purchase a high-resolution scanner to create your own digital images. Scanner technology improvement has kept pace with the microchip to the degree that excellent scanning equipment with professional capabilities often retails for under $200. When you scan your photographs or slides, make certain your settings are at the highest resolution possible. Accommodating such high-quality scans requires a large memory space for storage on your computer—and patience. Most computers have between 128–256MB of RAM (Random Access Memory). However, you can upgrade your system to accommodate more. The higher the resolution of the scan, the slower your machine will operate. However, a large photo image file of exquisite detail is more than justified when you view the final output print.

The size of a final scan is important because it stores valued information about each pixel of your image. For a small reprint on an inkjet printer, the amount of pixel content information can be marginal. However, as your reproduction needs increase in size and detail, pixel content becomes critical because the more data available, the truer the color reproduction to the original and the clearer and cleaner the output. Where pixel image data is lacking in an image, a printer will attempt to fill in the missing profile, sometimes with disastrous results. A high-resolution scan made directly from the artwork source (as opposed to a photograph or slide) is ideal and will always be superior in detail.

SCAN THE ORIGINAL WORK DIRECTLY

A direct scan will depend primarily on the size of your original work and the size of the printing services equipment. It will offer you the absolute best quality reproduction capabilities and likely cost you the most (the equipment investment is substantial). Museums are archiving their collections with this format in increasing numbers. For larger scale reproduction work such as murals or wallpaper, this quality and file size of scan is essential for maximum clarity.

TAKE A DIRECT DIGITAL PHOTOGRAPH OF YOUR WORK

Many professional photographers have resisted high-resolution digital cameras because of their perceptions that the quality and clarity output did not rival film. The technological improvements of digital cameras have recently narrowed the gap significantly and many of the consumer-priced models (under $500) produce images successfully reproduced as Giclées without sacrificing image or detail quality. Many artists are photographing their own digital files or using printing services that have the appropriate equipment.

Digital cameras are rapidly replacing their film-based counterparts due to improved mechanics and simplicity of operation. More importantly, with larger liquid crystal displays prominent on the rear housing of the camera, you can view your results immediately without waiting for film development.

There are numerous comparative features to determining which digital camera would be best for your needs, aside from price. A digital camera's megapixel count is its most important specification. The megapixel rating is another way of expressing its resolution. The higher the pixel count, the higher the resolution, enabling better quality images.

However, there are other considerations, such as the quality of the lens, battery life, exposure controls, focal range (zooming capabilities), and storage capabilities. Most digital cameras enable removable storage media, so you can simply replace these chips and upload images directly to your computer or printer.

PRESENTING YOUR ARTWORK AT ITS BEST

What works ideally for your needs may be based on your budget constraints, but representing your finished work in greatest possible clarity should be a concept you never compromise on. It will often cement the decision as to whether your work sells or resellers choose to exhibit and represent you.

The nightmare days of visual artists sending out costly 35 mm slide packets to galleries, curators, competitions, and collectors are fading into history, replaced by digital file transfer. Not only are digital images often better quality images than photography or slides, but significantly more detailed and accurate in terms of color representation.

Of course, the art industry, historically resistant to technological change, has not completely abandoned film-based images. For many artists securing exhibitions, public art commissions, and gallery representations, the older practice of submitting slides or photographs may still linger over the next few years.

Creating Giclées

A Giclée, the most popular commercial form of digital reprint, is typically sourced from a high-resolution image file in either TIFF or JPEG formats. Once the TIFF or JPEG files have been saved and stored to a disk, the raw format can be enhanced with photo-imaging software mentioned earlier.

The finished Giclée image will reprint in remarkably true fashion at full size or nearly any proportionate size you require. The larger the file size and the higher the resolution scan, the higher the quality of the reprint due to the amount of information stored about the image. The technology has become so advanced in many instances, it is difficult to distinguish an original from a Giclée, and often the reprints not only rival the original, but even exceed the production quality of the original by smoothing out the rough edges and imperfections of an original composition.

LARGE FORMAT INKJET PRINTERS

The second component of the digital printing process is dependent on a large format inkjet printer. In the beginning, these monster image producers were mainly used by commercial printers, advertising agencies, and publishing houses, due to their expensive price tag and operating costs. Only an enterprise regularly printing out large volumes of orders could justify the investment expense.

However, just like the fax machine, smaller inkjet printer, pocket calculator, personal computer, cellular telephone, and a host of modern electronic devices, the pricing points are now becoming financially accessible without compromising quality. Certain new large format printers retail for around $3,000 while used models are significantly less. This pricing pattern should continue, as we witness a decline in pricing and increased sophistication in capability.

In determining the actual costs of operation, you must also factor in the RIP (Raster Image Processor) software, which can be expensive (upwards of $2,000), although many of the newer model printers now include this software as part of their overall package. The RIP software enables your computer and printer to directly communicate and process the necessary data a large image printing job requires. The software takes your image and text and tells the wide format printer where and how to place each squirt of ink on the paper or canvas. Large format printing can be an excessively slow process and tie up significant memory in your computer's temporary memory (RAM). As desktop computers continue to package larger amounts of RAM and storage memory, the efficiency and speed of reprinting will continue to increase.

INKS AND DYES

Another major cost consideration weighed and factored into operational expenses is the cost of inks coming in both cartridge or bottle form (both expensive) depending on the printer model. Each Giclée requires enormous volumes of printer ink based on the size of the reprint, and a single color cartridge may not last longer than five to ten reprints.

The caliber of printing has steadily increased over the last few years with the introduction of dye sublimation inks. Dye-sublimation uses high heat and solid dyes to produce photo lab–quality images. Printers lay down color in continuous tones one color at a time, instead of dots of ink. The color is absorbed into the paper or canvas rather than sitting on the surface. This process creates a more photo-realistic output, more durable and less vulnerable to fading than other previous ink technologies.

Many of the newer color pigmented inks, combined with dye mixes, claim a lifespan of vibrant color exceeding 200 years. Since none of us (to my knowledge) will ever be around to confirm this claim, it is likely most prudent to hope for the accuracy with a sense of restrained optimism.

RESEARCHING PRINTERS

An excellent, unbiased resource available to conduct detailed research on various printer models, projected costs, and the realities behind self-publishing is sponsored free by a nonprofit organization called the FLAAR information network. It was established to promote public education and research on large format inkjet printers and other digital image equipment, including digital photography, scanners, and laser printers.

FLAAR's eight Web sites listed below research and publish downloadable practical observations and comparative advice on the quality and performance of nearly every current model of large format printer, RIP software, and associated digital imaging hardware and software.

SELF-PUBLISHING EQUIPMENT AND SOFTWARE RESEARCH

www.Cameras-Scanners-Flaar.org
www.Digital-Photography.org
www.FineArtGicleePrinters.org
www.Flatbed-Scanner-Review.org
www.Laser-Printer-Reviews.org
www.Large-Format-Printers.org
www.Wide-Format-Printers.net
www.Wide-Format-Printers.org

Self-Publishing

Currently, as an artist, you have the capability of publishing your images in numerous formats and you can legitimately wear the title of publisher. This capability of self-publishing in itself is revolutionizing the art world. No longer must an artist speculate on a single image and invest in a mass-production reproduction run to justify the set-up costs. In the past, this is how large publishing concerns have been able to negotiate low royalty fees with artists, since the publisher was taking on a large production expense.

The concept of *printing on demand* (once you have a physical order) is ideal for smaller printing runs. You can economically print out one copy or multiple copies (depending on your order volume). Better yet, you can utilize or vary your media such as watercolor, textured or photo image papers, or even canvas. You can design custom promotional posters and greeting cards with your images, or license out your images to various commercial concerns.

ECONOMICS OF SELF-PUBLISHING

How economical is the printing process? If you opt to own or lease your own equipment, the costs will fluctuate based on how efficiently you learn to manage your resources and maximize your media space. However, the markup potential is enormous, and subcontracting your service to smaller printing outlets, galleries, or artists directly may provide you with some significant income opportunities. The playing field of small contract publishers is not yet overly crowded, but as the production equipment continues to drop in price and used equipment creates outstanding buying opportunities, I expect this to ultimately be a huge growth area of commerce.

If you choose to have your work printed by outside sources, the production estimates vary on jobs anywhere from $8 (large orders) to $25 per square foot in various media (canvas, watercolor paper, etc.). Digital printers duplicate on large drum rolls usually sized between twenty-four and sixty inches in width. Most standard models are now evolving to a width of sixty inches, so printers with a twenty-four- to thirty-six- inch maximum may prove excellent bargains in the used market circuit.

This printing expense is likely to continue to drop in the future and can be further reduced with volume reprints, so these savings will be passed on to the artist.

To gauge the sample production economics of a Giclée on canvas, if the dimensions of your average canvas painting are sixteen by twenty inches you will require approximately three square feet of canvas material. This sizing

is generally what the printer will base its charges on. However, many base cost on the size of the actual image (better for you). Do the math. The reproductions expense should range between $24–$75. The quality level of the inks and canvas stock will also directly influence this production total. Regardless, the finished work may easily wholesale from $100 and upwards and provide you a comfort level of price negotiation capability for volume, retail outlet, or repeat client sales outlets.

IMPLICATIONS OF MULTIPLE SALES OUTLETS

Instead of traditionally painting one original and selling it for what the market will bear, you now can reproduce this item in a limited edition of 100, 250, or whatever desired figure you decide to sign and number. Since Giclée reprints have not taken on collectable or investment status and they can be reprinted at will, *limited edition* may become a very subjective term. Each work of art has the income capacity of being very lucrative. A completed work of art has the capacity to generate one amount for the original and another sum for the reprints (which you don't even have to print until you have a physical order).

The potential for additional revenue through self-produced Giclées is one of many new sources of income that can be expanded through Internet sales, but an artist should be extremely cautious about who has access to these image files. Be very judicious when distributing your high-resolution images or hosting them online. Anyone (meaning any artist) with access to a computer and large format printer can become a publisher too . . . of *your* work. Beware of services offering to pay you royalties for products of an undetermined nature; your images may take on a life of their own without financial compensation for you.

Keep your digital files very secure and make multiple copies for yourself, as they may ultimately prove your one secure source of art income and legitimate retirement fund.

Licensing Opportunities

In the spirit of multiple income and exposure sources, the licensing industry offers one of the largest growth opportunities due to the expansion of digital imaging capabilities. If you think visual fine art is exclusively about creating original visual images and selling through single exclusive outlet, think again.

The Pop Art movement of the 1960s abruptly shifted exposure of contemporary fine art from the exclusivity and confines of collectors, galleries, and museums to the mainstream public. The ensuing years have seen

artwork gravitating from the stretched canvas to the commercial market-place variety of media including:

- Apparel, clothing, and jewelry
- Electronic and entertainment products
- Food and beverage labeling
- Games, toys, and kids' products
- Furniture and home décor
- Kitchenware, bath, and linen products
- Product packaging
- Stationery, compact discs, and greeting cards
- Sporting goods

WORK-FOR-HIRE JOBS

Unfortunately, one of the ways in which artists sell their work for reuse does not involve licensing and usually does not offer the artist a lot of remuneration. If a work is licensed, the artist is entitled to royalties. However, if the artist creates art under a work-for-hire arrangement, the artist signs over full future revenue rights to the contracting company. One celebrated example of work-for-hire is the original design of the Nike swoosh logo, contracted out to a graphic design student in 1971 for $35. Imagine how lucrative a royalty-fee deal would have proved for the designing artist, who at the time was "fresh out of school with a design degree and hungry for work."[1]

LICENSING ROYALTIES

Royalty revenues for a licensed design are determined by a contracted percentage paid based on product sales. This percentage is based on the wholesale price, and not the ultimate consumer purchase price. In the contract that the licensee offers to the artist, the terminology defining the sale prices may vary from gross wholesale price to an adjusted gross revenue factoring in accounting realities such as returns, allowances, bad debts, or credits. If the contracting company maximizes the use of your image and operates its business soundly, and the item containing your image sells well, your potential revenue level should rise proportionately. A key to successfully maximizing your agreements is to clearly specify the nature of the use for your image, compensation rate, the marketing (and geographical) territory where it will be used, cancellation, buy-out and termination options, and the length of time for the agreement.

Additionally, you should request in your signed contract the right to have the licensor's books audited (at your expense) to ensure you are compensated what is legally due to you for the use of your images. Maintaining ownership control of your images is critically important to leveraging its use for future projects. Licensing should be oriented toward limited and specific uses and any contract transferring the ownership of copyright, reproduction, original work(s) and/or sublicensing rights should be suspiciously investigated before being actually signed.

INDEMNIFICATION CLAUSES

Another important concern often escaping scrutiny by most artists in their licensing dealings is an indemnification clause, in effect, stating that the contracting company will protect you from any lawsuits arising from any of their business. You should always have the option to approve or disapprove the final product version. Prevent unforeseen unpleasant surprises by requesting layouts, product samples, or a copy of the actual objects to evaluate.

LICENSING DISTRIBUTION CHANNELS

The distribution channel for your licensed work may be a major consideration, particularly if you are concerned about having your name associated with a particular marketplace. Products may be sold through mail order, department stores, gift shops, or discount shops (be careful!). Artists may also license images for products sold through one distribution channel to one licensee, while another licensee sells products through a different channel.

Territory is also an important consideration in terms of where the licensed imagery will be sold. An artist may license the same imagery for other products elsewhere in the world. Make certain you clarify what markets the products will be entering and in some instances, negotiate your compensation terms accordingly.

LEGAL ADVICE

There are numerous legal subtleties involved with the commerce of licensing images. You can become more familiar with the type of contract a licensee will offer you and what provisions you should look out for by perusing books such as *Legal Guide for the Visual Artist* and *Business and Legal Forms for Fine Artists*, both by Tad Crawford (Allworth Press). However, as the complexities and income potential mount, so should the caliber of your advice and legal representation. In addition to books, there are

excellent guidelines regarding the licensing strategies published on scattered Web sites, which can be accessed by search engines, but their information should not serve as a substitute for qualified legal advice from a specializing attorney-at-law.

ART-ORIENTED LEGAL REPRESENTATION

www.Artistic-Law.com
www.Artslaw.org
www.ClemCheng.com
www.ClickandCopyright.com (Professional Copyright Registration)
www.CTArts.org
www.Danziger.com
www.ErkLaw.com
www.Feldman-Law.com
www.JJKaufman.com (Joshua Kaufman)
www.Kunklelaw.com
www.Orrick.com
www.StarvingArtistsLaw.com
www.Venable.com
www.VlaNY.org
www.WCCLaw.com/contact.htm (Wasserman, Comden & Casselman)

LICENSING OUTLETS AND REPRESENTATION

www.3Cor.com
www.4KidSent.com
www.6DegreesInc.com
www.ABC.net.au
www.ActiveLicensing.com
www.AmurePrints.com
www.ArtImpressionsInc.com
www.ArtInMotion.com
www.ArtisticLicensing.com
www.Art-Licensing.com
www.ArtMakersIntl.com
www.BaileyLicensing.com
www.BCreative.com
www.Beanstalk.com
www.BeckerAssoc.com
www.BigIdea.com
www.BigTent.tv
www.BKNKids.com

www.BlissHouse.com
www.BradfordLicensing.com
www.BrainstormLicensing.com
www.BrandCentralgroup.com
www.Brand-Genuity.com
www.Brand-Sense.com
www.Brandven.com
www.BravadoUSA.com
www.BrownandBigelow.com
www.Bslg.com
www.BuzzLicensing.com
www.CanadianArtPrints.com
www.CapLicense.com
www.CCIart.com
www.Cinar.com
www.ClassicMedia.tv
www.CLC.com
www.CMGworldwide.com
www.ConceptMarketingGroupInc.com
www.Consor.com
www.Copyrights.co.uk
www.Cosrich.com
www.CreateChart.com.au
www.CreativeBrandsGroup.com
www.Cridge.com
www.CruiseCreative.com
www.CSG-Design.com
www.CTDStudio.com
www.DCComics.com
www.DelMarDay.com
www.DesignDirection.net
www.DesignsByCurrent.com
www.DidItAgain.com
www.DimensionalBranding.com
www.Dingles.com
www.Discovery.com
www.DPIS.com
www.DragonballZ.com
www.DRIlicensing.com
www.EquityManagementInc.com
www.EvergreenConcepts.com
www.EximLicensing.com
www.ExtremeVision.com

www.FashionArtBank.com
www.Felixr.com
www.FineArtPublishers.com
www.FineLineProperties.com
www.FrendsLicensing.com
www.Freud.co.uk
www.FSartists.com
www.FXLabs.com
www.Gaffney.com.au
www.GalaxyofGraphics.com
www.G-Artists.com
www.GGNY.com
www.GilmanLicensing.com
www.GlobalIcons.com
www.GraceLicensing.com
www.HadleyLicensing.com
www.Hakan.com
www.HamlinMarketingGroup.com
www.HeatLicensing.com
www.HLGLicensing.com
www.HollywoodLicensing.com
www.IconosphereMarketing.com
www.ImageByDesign-Licensing.co.uk
www.Image-Source.co.uk
www.Imca.net
www.IMCLicensing.com
www.IMGWorld.com
www.Immersivecc.com
www.ImpulseWear.com
www.IngearSports.com
www.Intercontinental-Ltd.com
www.Jaguartc.com
www.JCGLtd.com
www.JessicaMarks.com
www.JGStanley.com
www.JinDesign.com
www.JoesterLoriaGroup.com
www.JRLGroup.com
www.Kennebeck.com
www.KeylineLicensing.com
www.KryptonImagination.com
www.Lallyinc.com
www.Laughingstock.com

www.LearningCurve.com
www.LevisonDesign.com
www.License-One.com
www.Licensing.org
www.LicensingConsultant.com
www.LicensingPages.com
www.LifestyleLicensing.com
www.LindaMcdonald.com
www.LittleTiger.co.uk
www.LLC2Lykelic.com
www.LMA-Inc.com
www.LMIuk.com
www.LookingGoodLicensing.com
www.LostLinkDesign.com
www.LWorks.com.au
www.MagnaGlobal.com
www.MarketingOnDemandllc.com
www.MaximumLicensing.com
www.MGAE.com
www.MGL-uk.com
www.MGREntertainment.com
www.MHSLicensing.com
www.Millpond.com
www.Modaintl.com
www.ModernPublishing.com
www.MoonMesa.com
www.MosaicLicensing.com
www.Panic-inc.com
www.Papertroupe.com
www.PBJdesign.com
www.PBS.org
www.PennyLanePublishing.com
www.Performance-Brands.com
www.PlaymatesToys.com
www.PMDesignGroup.com
www.Porchlight.com
www.PorterfieldsFineArt.com
www.PPWgroup.com
www.Promo-Vision.com
www.RandrLicensingLtd.com
www.RipeIdeasInc.com
www.RJMLicensing.com
www.Scholastic.com

www.Schurman.com
www.SerenataGroup.com
www.Shopro-Entertainment.com
www.SignaturesNetwork.com
www.SilverliningProductions.com
www.SloaneVision.com
www.SomersetLicensing.com
www.Sportfun.com
www.SSAIct.com
www.StoneAmerica.com
www.StudioLicensinginc.com
www.SturgesReps.com
www.Sullivan-Ent.com
www.Sunbeam.com
www.SusanOsborneLicensing.com
www.SyncLicensing.com
www.TangleToys.com
www.TeamingPond.com
www.TheBuffaloWorks.com
www.TheImageForum.com
www.TheLicensingCompany.com
www.TheLicensingGroup.com
www.TheWildFlowerGroup.com
www.Tippingsprung.com
www.T-M.co.nz
www.Toycraze.com
www.TradeMarketingServices.com
www.TRILicensing.com
www.TurnerPatterson.com
www.TVNZEnterprises.com
www.Viking-Publications.com
www.VirtueProducts.com
www.Vision3Productions.co.uk
www.WildApple.com
www.WildWings.com
www.WinchesterEnt.com
www.YakityYak.com

E-Card Opportunities

Based on a survey commissioned in 2004 by the Greeting Card Association (*www.greetingcard.org*), an advocacy trade association, over 7 billion cards are sold per year domestically. An average American household purchases

thirty individual cards per year and an average person receives more than twenty cards annually. A growing segment of this market is going to e-cards and self-publishers.

The revenue model for e-cards is based on licensing your visual images with software, creating custom or event-oriented greeting cards. Delivery of the end product to the buyer is either via snail mail, or, in many instances, as an e-mail attachment. Participating artists typically use such a vehicle to further promote their art images, due to the expanded exposure offered by an e-card reseller, and hope a financial reward may likewise sweeten the exposure benefit in the form of a royalty check.

Many e-card outlets offer their services for free, in the hopes of marketing additional affiliate products and services on their Web site. This strategy does the artist very little good in terms of monetary remuneration, but sometimes small-scale exposure may open the door to larger scale opportunities.

GREETING CARD PUBLISHER REFERENCE OUTLETS

www.GreetingCard.org
www.GreetingCardAssociation.org.uk

BARTER AND *Cashless Transactions*

As the selling market for artwork tightens (and when doesn't it seem that way?), strategies for creative selling have never been more challenging. An emerging trend among consumers and businesses conserving cash is the old-fashioned practice of bartering.

Direct trade between artists and service businesses is nothing original on a small scale. Restaurants and coffee outlets have been trading meals for décor for years, but a broader vision is required to make such transactions worthwhile financially.

There are essentially two approaches to consider. Do you wish to establish a personal barter network regionally or expand the opportunities nationally (and ultimately globally)? Keep in mind, most barter arrangements are cashless transactions, so the key is trading for services you actually need or items you would normally expend cash on out of pocket.

Regional Barter Exchanges

Starting with a regional focus, your initial potential trading partners could be any commercial enterprise requiring interior/exterior décor, wall art, or photographic services. This group constitutes a large pool of professional services including law, medical, dental, architectural and accounting offices, restaurants, hotels, publishers, management services for commercial property, printers, design companies, hair stylists, and numerous other categories.

The possibilities for exchanging both original and reprinted artwork are innumerable. Some of the items and services you might barter your work for include office furniture, supplies and equipment, tax preparation services, Web site design and hosting, business card and flier printing, hotel accommodations, catering services, advertising space . . . you get the idea. In effect, you trade your unique creative talent for professional expertise or much-need inventory.

When an economy sputters to a slower pace, many companies are still stocking (and stuck with) excess inventory following successful years

of the recent economic boom. Companies and service businesses undergoing a flat sales periods tend to be more open to exchange their inventory or expertise for something else having value. Needless to say (especially among artists), original artwork has a unique and desirable value, giving the creator a favorable bargaining position. Most collectors or designers prefer original art to mass-produced and distributed images and sculpture.

Placing an equitable dollar value on your work is crucial to making an exchange transaction mutually satisfying. Trading at your normal retail cash price may result in cutting your earning margins too thin, particularly if you have fixed production costs in creating your work. Personally, I tend to mark up my starting prices at approximately 30–60 percent higher with the understanding that, as with merchandise offered through classified ads in daily newspapers, haggling is anticipated. Flexibility is an important part of the negotiation process, but obstinacy will kill most deals. Start with a higher markup and negotiate toward the middle range (if necessary).

Online Barter Exchanges

Nationally, the Internet is providing some exciting barter opportunities that have proven legitimate sales outlets for visual artists. This sales concept is slightly different, however, than a regional direct trade. Successful Internet barter sites feature businesses (both urban and rural) posting their respective products, services, and pricing requirements online within the sites. The currency utilized is "barter" or "trade dollars," a site's unique value medium. What makes this form of transaction more attractive than regional trading is you are not required to trade directly with the person or business bartering for your work.

For instance, say you're based on the West Coast. If a company in Cleveland purchases one of your reprints or an original for 200 barter dollars, then you (the seller) can take this sales currency and purchase business cards from a different vendor (perhaps a printer in Dallas). Thus, you are not required to buy something from your buyer in Cleveland, but can use the funds for practical items that your business needs.

The commonality among all three parties to this exchange is they are all registered members of the barter site. The only cash changing hands is a transaction fee (generally 5–6 percent) the hosting barter site earns from each participating buyer and seller. The barter site earns its revenue on the transaction, the selling party provides the desired product and/or service and then can use the proceeds to purchase something it wishes or requires. It is a simple, efficient system and one requiring minimal time investment.

THE EVOLUTIONARY PROCESS OF ONLINE BARTER

The critical component for success in this type of network is both size and the frequency of transactions. Over the five years that I've participated online with several barter services, there has been extensive consolidation and fall-out among sites. This scenario has been consistent throughout the dot-com era, but emerging are stable sites with thousands of trading partners, creating thousands of transactions daily. Fortune 500 companies have recognized the long-term potential, and several are active participants.

A proliferation of regional and national sites emerged under the URL banners of AllBusiness, Alliance, BarterGiant, BarterNet, BarterTrust, BigVine, BXI, Continental Trade Exchange (CTE), Compass, ITEX, LassoBucks, Tradaq, Ubarter, and Valuenet. The need for a substantial volume of transactions to successfully finance such an extensive exchange has resulted in a significant dissolution and consolidation of these barter exchanges into the current principle survivors: Alliance, BarterBucks, BarterCard, BarterOne, BXI, CTE, Intagio, ITEX, and Tradia. There are several hundred single-location barter exchanges with Internet presences, most of which have reciprocal agreements with the large multiple location exchanges. Some of the large sites boast membership enrollments of over 20,000 with a smaller contingent of active traders. Even if the enrollment numbers are somewhat inflated, the sheer potential buying numbers offer numerous sales opportunities for visual artists and galleries.

UNDERSTANDING HOW TO TRADE ON EXCHANGES

One of the thornier issues involved in a universal acceptance of barter is the online education curve required for users. Educational issues include such elementary questioning as: Why would someone barter an item? What is a barter (or trade) dollar? How do you value a product? What is the cashing out process? All of those questions have to be addressed before individuals or companies become active traders.

One of the ways barter sites augment trade among their members is by employing barter trade specialists who specifically contact registered barter firms and stimulate trade transactions. Their compensation is typically included in the transaction fee so their free services can be invaluable to locating potential buyers of your work and sellers for items you require.

The cost for participation in various Internet barter exchanges varies, and most have introductory participation fees ranging between $100–$400. This fee is often negotiable, depending on the exchange's business revenue model and compensation structure for their brokers. The exchange's

success (as well its participants') is based on a large volume of successful transactions and trading products/services regularly. Hoarding large sums in barter accounts by members becomes useless, since no mechanism exists for converting this faux money to cash.

What can make a barter system most advantageous for artists and galleries is recruiting other people who already do business with them into the exchange network. This inclusion ultimately can be a very productive way to expand your selling network and promotional exposure and minimize some of your direct cash expenditures. The possibilities are endless and currently not sufficiently exploited by your professional artist peers.

TAXATION OF BARTER INCOME

The Internal Revenue Service views barter transactions in the same light as cash transactions, so you are required to report revenue from these sources as income. Trading for business-related services could be claimed as legitimate business expenses of equal cash value, so it is in your best interest not only to sell frequently, but to spend the proceeds toward professionally deductible expenses as well.

The concept of barter, like person-to-person sales services such as eBay, is a unique variation on an old business concept. However, with a global mass-communications vehicle such as the Internet, mutually beneficial exchanges make logical sense. Barter provides a legitimate alternative outlet during economic downturns and should continue to flourish when the economy is repositioned to expand again.

BARTER SERVICES

www.ABC-Barter.com
www.ACXBarter.com
www.AdvantisInternational.com
www.AlamoBarter.com
www.AmericanExchange.net
www.ATXBarter.com
www.BadgerBarter.com
www.Barter-Works.com
www.BarterBing.com
www.BarterBrokers.com
www.BarterCard.com.au
www.BarterConsultants.com

www.BarterDepot.com
www.BarterFirst.net
www.BarterForBusiness.com
www.BarterGroup.com
www.BarterNetwork.ca
www.BarterOne.com
www.BarterPartners.com
www.BBU.com (Barter Business Unlimited)
www.BizXChange.com
www.BNIusa.com
www.BroadwayMedia.com
www.BusinessTradeExchange.com
www.BXInsider.com
www.CalCoastBarter.com
www.CTEBarter.com (Continental Trade Exchange)
www.CornerstoneBarter.com
www.CrescentCityTrade.com
www.FloridaBarter.com
www.GreenAppleBarter.com
www.GulfCoastTrade.com
www.HenryStreetTrading.com
www.Illinoistrade.com
www.ITEX.com
www.JamesRiverTrade.com
www.KansasTradeExchange.com
www.MalibuExchange.com
www.MBEBarter.com
www.MetroTrading.com
www.NationalBarterCompany.com
www.NCBarter.com
www.NCEbarter.com (National Commercial Exchange)
www.NewEnglandTrade.com
www.RTEinc.com (Alliance Barter)
www.SouthernBarter.com
www.TeleTrade.net
www.TexasBarter.com
www.TheBarterCo.com
www.TheTradeExchange.com
www.TheTradeExchange.net
www.TradeAmericancard.com
www.TradeFirst.com
www.Tradeitg.com

www.TradeNetwork.org
www.TradeSource.net
www.TradewindExchange.com
www.Tradia.net
www.Tradx.net
www.UnitedTradeNetwork.com
www.VIPBarter.com
www.WeTradeNetwork.com

chapter 15

YOUR WORK *Should Be in (Motion) Pictures*

Actors are not the only people who dream of appearing on television or in motion pictures. Visual artists and art galleries whose fine art appears as set décor in a film production can potentially expose their work to millions of viewers.

While it's true that most of the actual buying and selling of "set art" is not accomplished online, most of the companies and organizations involved have Web presences. The Internet is certainly the best way to begin to research contacts in this often overlooked rental/sales market.

A Generally Untapped Form of Exposure

Because of a general unfamiliarity with the set decoration and film-making industries, very few working artists and galleries pursue this form of artistic placement and exposure. This unfamiliarity is rooted in misconceptions about such issues as: 1) who is directly responsible for renting or buying artwork for film production sets, 2) primary rental and sales outlet sources for artwork, 3) standard film industry compensation for use of artwork, 4) geographical and time-sensitive considerations for delivering artwork, and 5) essential permission clearances and license rights needed by film companies to shoot artwork as background decoration.

Working with Set Decorators

The principal renters or buyers of film set design artwork are professionals called set decorators. As defined by their own national trade association, the Set Decorators Society of America (SDSA) (*www.SetDecorators.org*), set decorators are key members of the design team for film, television, commercials, and other filmed media. Once the background sets are built and painted, or a specific location is chosen, the set decorator's job is to bring

in the objects and surroundings that "dress the set" or create the ambiance necessary to complement a screenplay's physical setting. Most television and motion picture productions require multiple sets during the process of filming. Each set may require a specific or unique theme and color design determined with the design team and actualized by the decorator.

The very dizzying nature of the film industry and production shooting involves tremendous adaptation and flexibility by decorator professionals. A set decorator is generally the last individual preparing the physical set before a film shooting company arrives and assumes the ultimate responsibility for its upkeep and readiness. Set decorators tend to be transient freelance artists hired on a per project basis (often weekly or monthly) unless they are contracted for a specific television series or motion picture production (potentially extending for months or years). Their professional networking skills and reputations serve as their résumé, and these strengths are elevated by cultivating a solid base of reliable vendor outlets (including artists and art sales outlets).

Their primary interaction with the visual art community comes in the form of their shopping responsibilities for specific set décor objects including artwork, furniture, fabric, industry specialty items, lighting fixtures, etc. The most consistent and commonly used source for renting and sometimes purchasing artwork are independent and studio property (prop) houses, carrying large inventories of decorative accessories. The evident advantages for a set decorator to utilize a prop house are convenience and an expansive inventory selection.

Working with Prop Houses

Prop houses are in the service business of providing short-term rentals and, often, convenient door-to-door delivery services. As shoppers, set decorators are generally hands-on, insistent on seeing items as they visually integrate rental selections into the overall design context of their project themes. Direct purchases of artwork (as opposed to rentals) may be an option if a particular set will be utilized throughout an entire extended shooting season, but they are rare and not a source of revenue most prop houses anticipate or encourage (since it depletes inventory that must be replaced).

Prop houses must carry a significant volume of décor items inventory in order to remain a relevant rental source for decorators. Some develop a reputation for carrying strong time period or style inventories of décor items and evolve into specialists. Set decorators have variable needs depending on the specific project they are working on and most prefer to make their décor selections from a minimal number of rental outlets. Thus, spree or bulk rentals (called yellow tagging) are not uncommon practices.

Prop houses may not serve the best interest of a visual artist or gallery since they rarely enter into consignment arrangements, preferring to purchase artwork outright, along with the "cleared" permission rights from the creating artist to rent the work to set designers. By signing away these rights, an artist is unlikely to be given a copyright mention during the rolling credits at the conclusion of the film. This lack of official of published recognition may serve as a major disincentive for an artist looking to enhance his or her creative résumé.

Cleared Artwork

Utilizing cleared artwork is an essential formality that all reputable production houses and their legal departments insist upon. Their potential for litigation for artwork filmed without written permission by the creating artist is too great a financial risk. If there is no signed documentation for a work, or if its creator's identity is unknown, it is unlikely that it will be used in a film.

Since future rental income from a particular work of art is the primary buying motivation of a prop house, its ultimate purchase price from an artist will tend to be low. The typical rental pricing scale is oriented toward price reasonability and short-term use (often for less than seven days). Thus, an individual painting or sculpture may rent out for an average of between $100–250 weekly with pricing breaks available for extended periods of usage. Framed photography tends to be priced less (often under $100). In a best-case economic scenario, many prop houses hope to average $3,000 in rental income over the lifespan of their ownership of a piece of artwork, so their own investment tends to be significantly less. The use of Giclées is also gaining professional acceptance, since digital reproduction work is more reasonably priced and as a filmed backdrop, look as convincing as an original work of art.

Specializing Art Consultants

A second, more artist-friendly resource for placing artwork in film productions may be engineered through art consultants specializing in this form of placement. The SDSA maintains a membership roster of both prop houses and art consultants, distributed free of charge upon request.

The primary value of a film industry specialized art consultants is their network of set decorator contacts and valuable experience in making transactions work to the satisfaction of both parties. They often split the rental fee with the artist and sometimes access a percentage from that fee for marketing, advertising, and sales generation expenses. A customary rental fee accessed to the production company can range between

10–20 percent of the retail-selling price for works under $5,000 and negotiated rates for higher priced works.

Many insider art consultants do not require exclusive representation contracts with artists, but will not represent artists who sell their work directly to prop houses, since they are direct competitors. A consultant's clientele base is cultivated through a positive professional reputation, a diverse selection of art styles, and the ability to deliver works as promised, in a timely manner and with minimal complications.

Most consultants are open to considering new artists' work for representation, but they expect artists to offer consistent quality work and to behave in a professional manner. Art consultants, like their set designer counterparts, have zero tolerance for working with difficult or temperamental artists since their own professional reputation and livelihood are at stake.

Some art consultants provide additional representational services, potentially resulting in license fees paid to artists or the estates of artists for the use of their broadcast images. The license fees are typically based on whether a work is a featured showcase or incidentally displayed, the distribution channels of the film production and length of time a license is required for a filming. Use fee structures are also based on whether or not the production company is educationally based, a charitable institution, or low-budget producer.

Permission Request Process

The permission request process a licensing company employs for approving the use of artwork on film involves the production company: 1) submitting the title of the film or program with a synopsis outline (to determine the suitability of the request), 2) outlining the planned distribution of the film or program (such as public, network, cable television, film festivals, etc.), and 3) elaborating on if and how a specific artwork will be directly mentioned in a script.

These factors are then considered by the artist (or the artist's estate) and representatives before granting consent for use. If permission is granted in writing to use or reproduce a specific work of art, the production company is legally obligated to provide a copyright credit line for the end credits.

Direct Contact with Set Directors

A third and often more circuitous route to film art placement can involve direct contact between an artist and gallery with individual set directors. Obtaining home addresses and telephone information is frowned upon. However, if a decorator is collaborating with a specific production company, that organization can be an excellent starting point for contact.

An excellent reference source for set directors and their current projects is published quarterly in the SDSA's trade magazine *Set Decor*. Some set decorators may prove receptive to this form of direct sales contact while others may be more reluctant to vary from their traditional source outlets. Forwarding digital images, Web site addresses, slides, or photographs of your work may be helpful but most likely if you are an unknown supplier; the decorator will need to view your work in person.

Tenacity and timing will be the key to success in direct selling or rentals as production schedules are sometimes drawn up weeks before actual shooting dates. An out-of-area artist or gallery must be willing and able to ship work out upon demand, quickly, and often at its own expense. This may not make financial sense for rentals based on the amount of total income potentially generated.

Geographical Realities

A geographical reality working against many interested artists concerning placements is that the film industry within the United States is located principally in Los Angeles and New York (where nearly all of the prop houses and industry-oriented art consultants are based). Regional film shooting opportunities exist but they are infrequent, typically smaller budgeted, and sparcely staffed. Overseas, most film work is done in large urban centers through production companies, sometimes publically financed or structured on a skeletal scale (like American regionally based production companies). Set decorators remain your principal source of contact at any geographical location.

Taking all of the placement complexities into account, having your artwork appear on film may significantly enhance your recognition and credibility. As working artists, we understand the longshot nature of gaining greater exposure for our work. Perhaps our own reach for the stars may find us on a wealthy exposure road less trodden by our peers.

SET DECORATOR AND PRODUCTION COMPANY RESOURCES

www.DocumentaryFilms.net
www.KFTV.com
www.Mandy.com
www.ProductionHub.com
www.ScriptSales.com
www.SetDecorator.org
www.TheKnowledgeOnline.com
www.TVSpy.com

chapter 16

BUSINESS *as Always*

Despite evidence the Internet is forever changing the way business is being conducted, the fundamentals of selling remain unchanged. Selling online is an additional tool in ones marketing arsenal, but displaces none of the other selling outlets to pursue.

The Rules of Commerce Prevail

Whether we are artists or sellers, the manner in which we conduct our business will directly influence our prospects for success. Artistic license does not translate into business negligence. Art buyers have an enormous (and growing) selection of artwork, styles, and artists, and if you fail to conduct your sales efforts professionally, they will find satisfaction elsewhere.

For every sales inquiry a Web-based listing generates, whether it is located on your own Web site, another virtual gallery, a blog posting, or an auction exchange listing, your prompt follow-up is essential. Internet correspondence is built around speed of response, and the hesitant generally lose out on opportunity.

The fine arts industry is a unique, eclectic business, but it remains a business. Professional longevity is typically measured by sustained sales.

The World Wide Web may open significant new channels for exposure, but its inherent liability in presenting visual images in low-resolution formats (72 dpi mentioned earlier) require a consistent strategy for anticipating follow-up clarifications. Many of these selling strategies can be included within the design of your Web site, but don't assume the average art viewer or buyer is as keen on reading your descriptions as you are in preparing them.

Preparing for Sales Inquiries

With this note of caution in mind, it is important you have basic information about your artwork available for immediate follow-up for each online

143

inquiry you receive. Among the information for potential buyers you should have readily accessible are:

- Dimensions (height by width in inches for American and English inquiries and in centimeters for European and other international inquiries)
- Medium (acrylic, oil, bronze, mixed media, etc.)
- Delivery capabilities and approximate costs
- Acceptable form(s) of payment
- Selling price and whether sales tax is applicable to the purchase
- The creation year
- Other relevant provenance information, particularly about the significance of a specific work or influencing factors

Art buyers adore an interesting context story they can repeat to viewers of their new purchase.

The Unpredictability of an Artwork Sale

While these selling points may appear somewhat obvious and routine, there is rarely anything predictable about an art sale from the final negotiated price to the motivation behind the purchase. The best marketing strategy for selling art remains establishing and cultivating a relationship between buyer and seller (even better, between artist and buyer). A simple follow-up telephone call to an online inquiry often serves as an excellent bridge to overcome the inevitable anxiety over an online sales transition. The Internet as a medium will never fully displace our need for human contact in the sales area.

Closing a sales transaction need not be a traumatic experience for either buyer or seller. Unlike many consumer sales presentations, most art transactions are upbeat in nature and buyers usually react poorly to high-pressure tactics. Many online art purchases are not impulsive buys, and often art buyers have gone to great inconvenience to track down a work they desire or artist they admire. Thus, their invested research efforts are very effective sales motivators once they isolate the prize they are inspired to purchase.

In these instances, the buyers have practically sold themselves and your job is to simply make certain the payment and delivery details proceed smoothly. The extent to which you maintain contact following the sale as elaborated in earlier chapters will make subsequent sales significantly easier.

Classical business model or not, selling art remains a relationship business. Whether that relationship is initiated online, via walk-in traffic, or by reputation, it will remain a business as usual.

part 2

THE BUYER *and Collector* *Perspective*

SHORTENING THE *Distribution Chain*

The fine arts industry is undergoing a metamorphosis.

The significance of this transformation is no less profound than was the emergence of art dealers as the primary source of art distribution over 150 years ago. Traditional and respected division lines between resellers such as auction houses and dealers have become blurred and the growing influence of the Internet is reshaping the professional relationship between gallery and artist. These changes are unacknowledged by many entrenched within the industry, yet their future roles may become significantly altered over time.

The Origins of Art Collecting

The collecting of fine art began when the catholic clergy started acquiring artworks to use as tools of visual instruction, and it evolved into an aristocratic diversion. Currently art collecting is a cross between a quasi-investment strategy and a way for consumers to obtain vast amounts of "collectible" decorative items in a variety of formats.

The traditional formats and definitions have even liquefied and broadened from exclusively wall-hung canvas paintings and three-dimensional sculptures to include such mediums as photography, digital design, glass shaping, graphic design overlays, and video multimedia. Each contemporary art medium has forged a unique identity and marketplace in collectors' consciousness. Americans have traditionally been a culture of collectors, but never in history have so many entrepreneurs created livelihoods from the servicing of this new consumer passion.

Disbursing the Old Guard

The communications medium of the Internet, through enormous community-building Web sites such as eBay, AOL, CraigsList, and Yahoo has fostered a convergence of collective interests in the form of chat rooms,

same-interest groups, blogs (web logs), and message boards. Individuals globally share experiences, expertise, and even unverified information or opinions mascarading as facts ultimately influencing perceptions, credibility, and market values at cyberrates of speed.

It is of little wonder that the traditional, cloistered, art world sales outlets have been less than enthusiastic about the expansion of the Internet into their marketplace. Numerous mainstream art gallery owners over the past few years have voiced to me personally their very vehement hopes that the Internet would simply vanish or go away. Their wishful lamentations for a more controlled selling environment become less relevant and more insignificant as the Internet becomes a media institution within a continually growing world of households.

To fully understand this common art dealer paranoia (confined to the unadaptable), one must understand the traditional insular world of art sales and its institutional inefficiencies. The fine art industry is based on relationships and industry participants' maintenance of their specific roles within the confines of the traditional selling process.

The Business Model for the Art Industry

In traditional business distribution terms, the artist is the manufacturer, the gallery is the retailer, and the buyer the ultimate consumer. The least understood channel in the process is the linkage between the artist and gallery, a relationship often diffused by intermediaries (agents, art consultants, curators, publicists, interior decorators, consigning galleries) assuming various roles and percentage compensations in the overall sales process. This stratum of middlemen ultimately inflates the retail pricing of fine art and only becomes more entrenched as the measure of an artist's reputation rises.

What few collectors and buyers realize is that fine arts industry pricing is often so bloated in the middle that the higher an artist's reputation ascends, the less control that artist ultimately has over the pricing of his or her finished work. The profit ensured by this protected inefficiency is probably the sole argument for preserving the status quo in the established art world. But this layer of people separating the buyer from the artist is the very thing that is vulnerable to Internet insurgence. By lessening the middle layers, buyers will cultivate a new model for pricing negotiation.

Keep in mind, though, the Internet is merely one additional channel in which to purchase fine art and is so underdeveloped as a buying outlet at present that it will likely take years before it is a primary selling outlet, particularly for original, big-ticket artwork.

An Overview of the Evolutionary Process

The purpose of this guide is to provide an overview based both on what the Internet currently represents with respect to art buyers and to what I perceive it will ultimately evolve. The road, as with any glimpse into the future, is likely to occasionally stray in a false direction (based on present assumptions) or into overstatement. I will likely even underestimate the significance certain innovations (currently in existence or soon to be introduced) will have upon the whole industry.

However, with unwavering confidence, I am certain the Internet will radically transform and decentralize the fine arts world as it has made inroads into nearly every other sector of contemporary business. I am likewise convinced the succeeding generation of visual artists and art resellers will be as equally adept at manipulating the medium as the consumers who opt to use the Web as their principal buying outlet.

Artists from remote parts of the world whose very names inspire linguistic gymnastics will have their work prominently displayed in suburban shopping malls and possibly within the confines of architect Frank Gehry's latest Titanium-laced ribbon museum. Why this potential for success and exposure against all reasonable odds? The *right* person will view their hosted digital images during a Web-surfing session. That *right* person with connections will have his or her own unique network to hyperaccelerate the recognition of these once destined-to-remain-obscure artists. The art world will also likely remain as relationship-based as its current business environment. The very nature of these relationships may ultimately be different, however.

The Internet widens the prospective business environment. As technology expands in regions globally once assumed inaccessible, so too will the manner in which relationships evolve. Improved and more available telephone service, wireless devices, broadband width, satellite capabilities . . . all are technologies which ultimately shrink the expanse of civilization into smaller neighborhoods and accessible markets. For better or worse, visual art will be redefined within this framework, and the new limitless options will make for better-informed buyers.

To begin with, let's examine the variables collectors and buyers will need to consider when utilizing one of the three primary outlets where fine art is sold (galleries, artists, and auction houses). Each of these respective components is undergoing individual evolutions as defined by the new rules of the Internet. Understanding the mechanisms, restraints, unique challenges, and operational tactics of each of these industry segments may provide a clearer overview of the emerging changes to come.

As a buyer, you've never had more opportunity to influence the marketplace based on your growing numbers than at the present time.

THE GALLERY *Scene*

As a professional visual artist, I have mixed emotions concerning art galleries and dealers. Many of my peers despise them (particularly if no gallery represents them). Some adore them (especially if the income proceeds from their last exhibition served as a down payment on their current mortgage). Some can live without them . . . most cannot. Professional art dealers have furthered the expansion of private art collecting during the twentieth and twenty-first centuries more profoundly than any comparative source and will likely do so for many decades (or even centuries) into the future.

The Perilous Roles of an Urban Art Dealer

Gallery dealers have hyped-up schools of art (no degree required), orchestrated cultural happenings, birthed reputations, and promoted professional mythology among both the worthy and unworthy within the creative community. They have been responsible for creating unimaginable perceived commercial value for objects of minimal usefulness . . . yes, namely works of art.

The typical urban art dealer navigates the perilous waters of consumerism in order to handhold, reassure, and cultivate the emerging esthetics of collectors, decorators, and sometimes monied, but good taste–challenged art buyers. Of course, the dealer may be perceived as a form of serpent, but a serpent that understands the selling environment and the prevailing current of the water.

Gallery resellers may not understand the influences behind the evolution of Abstract Expressionism into Pop Art. However, if they happen to represent an artist employing either style, they will certainly understand that individual's contribution to the movement (however modest) with the fervor of an evangelist. Their conviction may be financially motivated, but most dealers I've spoken with genuinely like and often love the work of the artists they represent. Introducing one more new artist's work into the congested mainstream of art world recognition and acceptance is no simple task.

The fine arts industry is one brutal business devouring its stray orphans (artists who lack marketing representation).

Perhaps the struggle for galleries to champion new faces and unique visual images for resale would be easier if artists, like professional athletes, had shorter career spans. Artists instead, like professional golfers, often practice their craft and trade until they lose their vision, reason, or inspiration (often occurring in no particular order). Some practicing artists actually die prematurely, but statistically, most exceed normal lifespan expectancies. In short, there are far too many artists, and a substantial majority is in no hurry to fade away. Even more ironic, many have absolutely no clue as to how to find the path to financial success.

The Mixed Art Dealer Perspective on Online Sales

There exists a lot of exceptional creative expression in the form of visual art awaiting appreciation and commercial sales. Thus, the role of the art dealer and gallery will remain secure and an integral part of the present and future of commercial art sales. Most art gallery owners are as ambivalent about the Internet as artists are about dealers. Those dealers who have recognized the Internet's selling capabilities use it fervently and prosper. The role of an art dealer is of a businessperson running a sales operation and no selling outlet is apt to be outright dismissed.

Many traditional galleries and high-end outlets tend to view the Internet art sales as a competitive threat. Some have gone as far as threatening to cancel representation contracts if an artist creates a Web site and sells directly online. Some galleries have followed-up on these threats, an action both shortsighted and ultimately futile.

The Burden of Online Expectation

Not since the Industrial Revolution has an emerging commercial trend been expected to revolutionize the economic and social structures of nations worldwide. Over the past eight years, the Web has withstood volatile extremes, including rocket growth, massive commercial fallout, and stock ownership volatility. Based on its initially intended purpose as a universal research tool, it has wildly exceeded expectations.

Within the artistic community, many artists initially crowned it as a new and superior alternative distribution channel to the traditional sales pipeline of galleries, brokers, showrooms, and assorted middlemen. This wishful concept has a nice ring to it: The artisan selling work directly to the

buying public, empowered by greater financial rewards. But was such an expectation realistic? Do most artists want to cross over into the full-time marketing of their work?

The answer varies among artists. The current financial reality is that art will not sell unless it is well marketed. While the sales of art via the Internet has not not matched the sales of consumer products such as books, electronic equipment, and kitchen products, major trends are emerging. In the process of separating hype from substance, fresh client contacts and international exposure outlets, previously accessible to only a minority of artists, are becoming universally available.

Elimination of Territorial Sovereignty

The principal marketing shift the Internet has caused is that it has eliminated territorial sovereignty. Galleries and high-end outlets that have invested years and a substantial advertising investment toward cultivating a geographical territory have sound reasons to feel threatened. The Internet is irrespective of geography. Artists can sell just as easily to their regional marketplace as halfway around the world.

This shift becomes the greatest distinction of Internet-based sales. The same local gallery has the identical opportunity to expand its sales base. Rather than viewing the Internet as an intrusion into its limited slice of pie (customer base), the Internet in effect creates a substantially larger pie.

How Galleries Must Walk the Exposure Tightrope

A more objective view of the eventual importance of the Internet as a selling tool is gradually taking root within the gallery community. This is evidenced by the fact nearly all art galleries now have Web sites. Many galleries actively employ e-mail in their sales solicitation efforts, and galleries are more frequently offering to represent artists based on their posted Web site digital images (instead of traditional slide sheet viewing).

Art galleries must walk a very taut line with their own Internet exposure, particularly if they stress the stable of artists they represent. Internet-savvy buyers can easily track a gallery-represented artist's name via a search engine and locate that artist's own Web site, initiating direct sales contact and bypassing the gallery. The Internet creates a unique free agency status within the artist ranks and this position can (and sometimes will) become a source of irritation between gallery owner and artist. The ultimate outcome may result in either a terminal rupture or renegotiated terms of understanding between the two parties.

The Internet has and will continue to cause dissention between artists and galleries and particularly with the roles each has traditionally assumed.

The die has been cast and the gallery-controlled selling environment will soon be as obsolete as are exclusive sales agreements for the totality of an artist's output.

The Co-reliance between Dealer and Artist

During the twentieth century, art dealers exerted unprecedented influence over the art distribution channels. It was not uncommon during the post-war (World War II) period for most high profile artists to be utterly financially dependent on their dealers. Their fidelity was often ensured in the form of cash advances against potential future sales. These advances enabled artists to concentrate solely on their productive work while simultaneously providing them sustenance to live off (however humbly).

It was a calculated risk in most instances, because the artist's work was consigned exclusively to that dealer. It was not necessarily a prudent financial risk for the dealer, since most artists were unable to return their investment. Many art dealers who endured this period did ultimately reap lucrative financial benefits on their investment if the artist emerged into a top thoroughbred seller. Art dealership, however, has always been a hazardous profession with a high ratio of casualties.

The risk for the dealers involved in this form of arrangement was that most artists do not penetrate the top tier in their lifetime and fade into obscurity upon their death. In fact, some sources have estimated only .05 percent of all art created has any material value (a generous estimate). This gallery patronage system arose when a few generations of very motivated dealers assumed nearly all of the marketing and promotional functions on behalf of their artists. This dependency likewise created generations of artists ill-equipped to participate in any aspect of the business management or marketing of their work.

This luxury of marketing ignorance by artists began evaporating coincidentally at the point when galleries could no longer afford to subsidize the living expenses of their artists. Most artists are now by circumstances and economic issues in the position of having to participate in the selling process. This scenario is often an unfortunate one for an overstimulated right-brained creator and equally undeveloped left-brained manager.

Why Dealers Are Still Important and Necessary

If on the glossy surface, the evolving art industry is headed toward such a chaotic period of restructuring, why should a prospective art buyer continue to utilize an art gallery or dealer in the buying process? The answer is relatively elementary.

Art galleries are still an important contributing element and symbolically—along with museums—the public face of fine art for most people.

Art collecting and buying itself is a progressive system of education and aesthetic refinement. Do not forget the substantial financial input required in cultivating preferences and specialty collecting. Proper advisement is imperative and comes with a price. Just how high consumers will ultimately go to subsidize this education will be a defining point of the Internet's influence. For now, there are substantial reasons why galleries maintain an important role in defining the taste and trends of the industry, and why they will remain a component.

Reputation Building

Artists still track their professional growth by which galleries chose to represent their work. It is an industry-wide acknowledged benchmark of recognition, because the prestigious galleries cultivate their own reputations based on the caliber of professionals they sell and select. Coincidentally, a gallery's reputation is significantly enhanced in the eyes of the artistic community if it is good at selling artwork in volume and at full retail price.

A gallery's role, as seen through many collectors' eyes, is the initial screening process and the collective network of eyes sorting out legitimate talent from mediocrity. The term *talent* is often a gross overstatement, because the judging of art is absolutely subjective and the price of the work is determined more by marketing investment than by quality. Most artists prevailing in and making a living through the gallery sales system are extremely determined and focused individuals.

Showcasing the Potential for Display

A well-managed and designed gallery creates an environment optimizing the aesthetics of any piece of work it is selling.

This showcasing is represented in many forms—the caliber of the polished wood floors, the innovative décor settings, framing, lighting positioning, neutral backdrops, and discreetly placed supplemental promotional literature. A successful gallery knows how to flatter each work of art so a potential buyer can sense how a work can integrate into his or her own design tastes. Such flattery requires significant financial overhead, which ultimately the buyer subsidizes.

Buyers and decorators frequently enter the sanctuary of the art gallery armed with color swatches and paint samples looking for the perfect match for a dining room color scheme. Most artists thankfully never find out their creation was sold because it was the perfect complement to a powder blue flat finish wall paint, the image being incidental.

Understandably, an artist who works diligently on creating relevance from his or her work will be outraged if the sole reason for the purchase is based on color compatibility.

It is often better a buyer and creator not always meet until after the sales transaction is concluded.

Driving Selling (and Reselling) Pricing Upward

Let's be candid. What makes the value of an original artwork appreciate or fall? Like any business, the laws of supply and demand, coupled with the influence of scarcity, drives the market.

Art pricing does not follow an immutable scientific law. No price for a work of art is chiseled in stone, and art really doesn't have a value until someone is willing to buy it for a specific sum of money. Thus, contrary to assumptions, everything in the art world is negotiable unless the seller determines it is not prudent to lower the price on a specific piece (because it is more likely to be sold at full markup without discounting).

This reluctance to bargain is not generally an issue based on principles, but often on contracted agreements. If the net breakdown of a selling price between a dealer and artist is rigid and the profit margin minimal, most dealers will not find it practical to negotiate with buyers. Any pricing discounts are absorbed from the dealer's profit margin (as well as they artist), which may not be mutually acceptable.

If a work of art has an extensive markup with no preexisting conditions for commission distribution, you will likely find a prospective situation for price negotiation. Most art dealers are uncomfortable with this bargaining scenario because of a perception that haggling tends to undermine the dignified traditions of the profession. Yet if you trace the most prolific art collections in the world, not one was purchased by paying full retail price.

Most dealers are open to reasonable offers for the same practical reasons an automobile in the classified ads rarely sells for the published price. Art hanging on a gallery wall unsold does not pay overhead, free up cash flow, or improve the reputation of an artist. Selling is still the straw stirring the cocktail and keeps an operation fluid and humming. The bottom line is, to a qualified and serious buyer, most gallery pricing is negotiable if done in a dignified manner and priced to enable flexibility.

It is imperative an artist's prices rise steadily to improve his or her stock as a selling entity. Higher prices are necessary for a gallery to maintain its necessary profit margins. Artists are traditionally able to upgrade to more prestigiously reputed galleries as the perceived value of their originals appreciates.

Dealer Markup

The average dealer markup on a work sold from a gallery is typically between 50–100 percent. In extreme cases and particularly with emerging artists, the markup may be as high as 200–300 percent (excellent prospects for pricing negotiation). An emerging artist is generally defined as one with a minimal track record of selling, few previous exposure opportunities, and little bargaining power with galleries. Most emerging artists are absolutely thrilled to have gallery exposure and often opportunity comes in the form of lower financial compensation.

More established artists who have demonstrated a consistent ability to sell not only are more apt to secure gallery representation, but negotiate higher commissions for themselves. A top tier of commercially popular artists enjoy further perks including:

- Selecting which lucky prospective galleries (and there are many suitors) have the exclusive geographical representation of their work
- Training gallery personnel to sell their work *their way* as well as choosing the gallery décor scheme
- Requiring minimum gallery selling quotas, automatic re-ordering policies, and permitting no price discounting
- Contractually requiring each selling outlet to allocate a significant budget for local and regional advertising

Franchise Approach to Selling Art

The franchising approach, described in the bullets above, has become a wildly successful formula for some artists. Most impressive is the case of one luminescence painter, whose representative outlets sell exclusively Giclée reprints on canvas. As long as demand remains stimulated and constant, these marketing strategies work.

Within fine art circles, many artists view this particular selling arrangement with a mixture of envy and humor shaded by certain contempt at the ultimate sell out. This notion of selling out is particularly ironic, considering most artists would love being in a position of selling *out* their finished output. I often find such artistic posturing a feeble defense of artistic integrity. Buyers make their purchasing decisions based on a variety of motivations, but rarely on the purported integrity of an artist.

Legitimizing Posterity

Artists are rarely creating work with posterity in mind, since success is often an unforeseen byproduct of the maddening demands of creation. Finished

works ultimately ascending to public viewing are usually the result of numerous attempts and near misses.

Who is to know or confirm what is legitimately from the hand of the artist? Upon their death, most high profile artists' estates are regularly besieged with requests to confirm authenticity of works purchased, and museum curators worldwide have works from master artists regularly challenged.

The financial stakes are potentially enormous. A finished work once confirmed to be the product of a renowned artist transcends simple aesthetics to become an investment vehicle. In matter of high stake art and economics, credited authenticity becomes paramount.

An art dealer should serve as the guardian to prevent this form of abuse, but ethical compromises are nothing unique to this industry. Dealers and/or representatives of an artist should be able to provide a certificate of authenticity for each work they sell, along with detailed condition reports disclosing known defects or damages greatly influencing the value of work. Be very careful to inspect these documents for altered or omitted data. Catching a forgery may often be difficult due to the ease of creating fake templates or editing with word processing equipment.

Additional Functions of Dealers

Dealers who exclusively represent an artist often offer trade-back arrangements, updated appraisal services, and even money back guarantees. Virtual galleries may not feature these services and with no fixed location or nobody to speak directly to for returns, recourse may be limited or nonexistent.

These forms of quality assurance may validate an established retail dealer's markup on a work of art. One way dealers financially protect themselves with their represented artists is to contractually require the artist to sell all work at the identical pricing level as the dealer to prevent undercutting and bypassing. Dealers who have a significant financial investment stake in an artist often require restrictive contracts, paying them a commission on any work of art sold.

Dealers frequently source a requested artist's works for their clients from others, resulting in modified commission arrangements. This modification is also done with artists they represent who have multiple dealer sales outlets. A buyer is rarely aware of the financial subtleties behind each transaction (nor do they care in most cases). One thing is consistently certain: the creative artist rarely walks away with the lion's share of the revenue in any sales transaction involving a dealer.

Locating Dealers Online

Despite an aversion within their ranks toward the Internet as a sales outlet, there are very few art galleries without a Web presence. For a modest investment, from a variety of sources, walk-in retail dealers tend to orient their Web sites toward their specialty. Most sites showcase the gallery's physical location, its artists, professional credentials, upcoming exhibitions, and a liberal sprinkling of images showcasing work by artists they represent. The theme and depths of their respective Web sites typically represent their own attitudes about the Internet as a sales vehicle.

Many galleries have come to realize an aesthetically designed and significantly marketed Web site attracts potential buyer interest globally. Others view their Web presence as a necessary participation but structure their site as a bland sales brochure. A lessening contingent is convinced their market is solely based on personal contact and relationship building. That view is changing, but if it works for a specific dealer, one cannot dispute success.

These conclusions are based on past and present business models serving them successfully. But as in so many other industries offering a precedent, the adage, *adapt or perish* will ultimately stalk the fine arts industry. Many gallery owners may simply retire or close shop before they ever have to acknowledge their denial of the inevitable change within the industry.

Purchasing from Dealers Online

The process of purchasing artwork online offers a few unique advantages that walk-in galleries are unable to match. Many of the online galleries inhabit the two worlds of brick-and-mortar and online sales, thus offering the best of both worlds. This meld may ultimately serve as the benchmark business model of success. The evident advantages of Internet sales between dealer and potential client include:

- *Potential Sales Tax Avoidance*: If clients buy from an out-of-state gallery or use an out-of-state address for shipping and invoice purchases, they avoid paying sales tax, reducing the cost of expenditure 7–9 percent (depending on the state). This current loophole will probably not remain indefinitely, but it serves as a major sales incentive presently.
- *Purchasing Discretion*: Many buyers prefer their anonymity to avoid public scrutiny and maintain the privacy of their collections.
- *Discomfort with Bargaining Process*: Face-to-face negotiating is very uncomfortable for some buyers. Online, it is also possible to negotiate, but at the buyer's pace and schedule, avoiding direct personal contact.

- *Range of Selection:* No longer limted by geographical region, a buyer may purchase work from a wide variety of sources worldwide—from single-staffed to the most recognized and reputed art galleries. Gallery personnel cannot intimidate or engage in condescending behavior or make subjective observations on your potential as a buyer.

Advantages of Some Virtual Galleries

Virtual galleries fill a tremendous need for artist exposure and selling outlets the art gallery community has carefully controlled and stifled in the past. A majority of these sites may well fail or not create enough revenue for their artist participants. However, they certainly have the potential to offer global exposure. That exposure can help artists develop the confidence that is essential if they are to continue to produce commercial sellable artwork.

Internet-savvy artists will exploit as many of these sales outlets as time and expertise permits, and some will ultimately pay dividends in the form of direct sales or selling opportunities.

Security Concerns

Is purchasing from an online exclusive gallery as safe as a brick-and-mortar establishment? Let's put it this way: unless you have direct access to the financial records of any business establishment, you are typically unaware of its *actual* financial health. The same caution you employ in dealing with a brick-and-mortar business should be employed with an online entity. Request references, satisfied customers referrals, professional affiliations, and credentials of the operating management. If these cannot be supplied in a timely manner, why risk conducting business with them?

I would offer the same advice to a buyer in dealing with any existing art gallery, unless you are certain you can walk out of the establishment with the actual work. In numerous instances you cannot, particularly if the painting or sculpture is part of a current exhibition.

How an Internet-Savvy Consumer Base Will Change the Industry

The greatest threat in my view to the existing gallery sales status quo is that in the next generation, the marketplace will be populated by consumers weaned on the Internet, comfortable with online purchases, and time stressed enough to want to avoid the gallery experience (which is an uncomfortable one to many buyers).

In exchange for potentially lower pricing and greater inventory selection, buyers through an Internet virtual gallery or individual artist Web site may relinquish (but not always) some of the benefits traditional galleries offer. These dealer benefits and services may include money-back guarantees, certificates of authenticity, full condition reports, updated appraisals, trade-back arrangements, and personal consultations on the scope and direction of their collection. Are these services worth a 50–200 percent price markup? The answer most likely is contingent on the needs of the buyer.

For a large percentage of future art buyers, this markup level will seem excessive and will necessitate a role modification for traditional dealers. The change may not be immediate, but it will be noticeable over time.

Comparison with Another Online Industry

In my prior, non-art-related professional career that included significant experience in the travel industry, I witnessed how major airlines steadily eliminated their substantial dependence on retail travel agencies (at one time 85 percent of their distribution source) following industry deregulation to sell their product consumer-direct. Airlines accomplished this objective initially through computerized reservation systems and by implementing in-house computer training directly with their largest buyers (corporations).

The advent and integration of the Internet introduced ticketless travel and direct, online booking incentives, and ultimately reduced commissions to travel agencies. All of these strategies were specifically oriented toward re-directing the distribution source of buying airline tickets from middlemen (travel agents) to direct (the airlines).

The net result of their collective efforts has been the virtual elimination of most small- and medium-size travel agencies in cities throughout America by squeezing their revenue source. Air carrier growth and the expansion of the airlines involvement in the ticket distribution system are training a new breed of commercial and leisure flier to look online for the best values and fastest response time.

Is this a business model the fine art industry may ultimately emulate? Due to the less structured nature of the art establishment, I doubt any shift will be this extreme. However, I wouldn't bet on the status quo as we've known it prevailing, either. (For a listing of virtual fine art marketplaces, see the resource list in chapter 10.)

THE CREATIVE *Artist*

Behind every piece of original artwork is ultimately an artist. As a practicing member of this eccentric fraternity, I can assure you my peers are as diverse as their creations . . . many in fact far more interesting personages than creators. As a buyer or collector, if you ultimately intend to buy directly from the creative source, it is important to understand the unique mindset of artists.

The myths about the right-brainedness within the artist community are as rampant as they are exaggerated. Artists may indeed be different, even difficult, and while some may be *shrewd* at marketing, others are essentially clueless. In short, attempting to pinpoint the personality traits of a fine artist is as pointless as trying to summarize any nationality, ethnic group, or gender.

What separates many artists from mainstream nonartists is their compulsion to create and express. Whatever medium a serious artist pursues, most professionals are committed and passionate about their work, even (and sometimes especially) if it defies conventional expression, popular design, opinion, and logic. Most artists create their own conceptual worlds, which their creations validate. In some instances, a society may appreciate and even vaguely understand their personal expression and vision. In rare instances, an artist may be lionized or used as an icon to promote a progressive viewpoint. Sadly in most cases, the creative output of a visual artist fades into obscurity with his or her own mortal demise.

This is not to suggest that all artists are dissatisfied with life or even have a unique perspective to evangelize. The creative conflict is dormant in many fine artisans and their primary motivation is often to create beauty or functionality through their unique skill and craftsmanship. Not all artists are idealists. Some paint or create because they enjoy the labor and are not especially adaptable to traditional means of employment or lifestyle.

What Defines a Professional Artist?

The primary separation between a professional artist and a casual hobbyist who creates artwork is the way in which they perceive their personal commitment to their form of expression.

Most professional artists do not view their work as a casual pastime or amusing manner to pass leisure time between their real profession and other life responsibilities (whatever these may consist of). The tragic reality about the art profession is less than 1 percent of individuals who call themselves artists (and anyone can wear the title) actually financially support themselves exclusively through their creative efforts.

The art world as a business is brutal. It can be enormously taxing emotionally, financially, and spiritually, and promises little if any reward despite one's talent, time commitment, or promotional efforts. The lack of success and recognition are perpetual causes of neuroses for most artists and although we might not change our calling, it would be a welcome assurance to know someday our efforts would be justifiably acknowledged. No such promise will ever be forthcoming.

In addition to the satisfaction every artist gains from facing the creative challenge that stares back from each fresh canvas, pile of steel, or lump of clay, the ultimate reward is an inner one. Our medium evolves by mastering and overcoming creative inertia and making a unique statement, no matter how many predecessors have pursued the same objective. Each painting, sculpture, photographic image, and digital design is the result of a process built on training, experience, and intuition. From the vantage point of an artist, this combination is what distinguishes our work. Artwork is a direct extension of the artist; it exposes an intimate aspect of the artist's personality.

This creative satisfaction, however fleeting, for most of my peers, does not usually fund lifestyles. Creditors, who we must satisfy in the name of shelter, food, education, and leisure activities, are less than understanding of the perspective that financial compensation may not be an artist's primary motivator. However, money will be the primary motivator of an artist's creditors, and that will have a profound influence on an artist's lifestyle.

Despite the romanticized illusion of the starving artist seeking a higher truth, I have never encountered a single situation where poverty has been the stimulus for creating superior art. Instead I've found artists in these conditions so consumed with meeting the daily challenge of survival, they scarcely have time or incentive to create art. Productive artists tend to originate and thrive in a stable middle-class environment, thus debunking romantic myths. Even most artists who have achieved a certain renowned and elevated income status tend to view themselves as middle-class or emphasize their humble, struggling origins.

Purchasing Directly from the Creative Source

With all of these mixed perceptions in mind, purchasing artwork directly from a source such as the creating artist is not generally a straightforward business transaction like refilling your toilet paper inventory or ordering

a fast-food meal. Art galleries are established for the sole motivation of reselling consigned artwork from the creating artist. With regard to direct selling to the public, many artists are ambivalent about the process, since it involves commercializing their creative expression and assuming a role of dispassionate seller. Objectivity is not always assured when marketing something so intimate.

Still, artists pay lifestyle bills like everyone else. Most require both morale-boosts and financial reinforcement as a source of encouragement to maintain a long-term commitment to their work. Buying directly from an artist either through a visit to an open studio, an Internet Web site, or a direct sales exhibition may be a way of negotiating favorable pricing, unearthing the motivation behind a finished work, and/or cultivating a direct rapport with the creator. The process may also become a source of intriguing stories, humanizing the artist, and shedding an interesting light on the acquisition process.

Resources for Locating Artists

Direct access to an artist is the primary advantage to utilizing the Internet as a sourcing vehicle. The three most likely scenarios for locating a specific artist are through:

- An artist's personal Web site
- An artist's participation in a reselling virtual gallery, auction site, business exchange or art collective
- A direct hyperlink to the artist's Web site from an art reference Web site, such as that of another artist, an art gallery, or an art organization.

The best online locating mechanism for locating an artist is through search engines and indexes, employing basic keywords and phrases to locate an artist either by name, region, style, or professional affiliation.

Though creatively inclined, only a small percentage of visual artists tend to be proficient Web site designers. Although many artists have online presences, only a few of them are really good at Web design, so in general, you may not get an accurate impression of what an artist's work is like from viewing it in the Web setting. Over time, this gap in quality will narrow (particularly if artists read this book) and artists' Web sites will be a more accurate mirror of what you can anticipate from their professional output.

For many artists, a quality Internet presence is still not viewed as a professional necessity, so frequently the design and content are determined by a third-party design firm that uses template packaging at a low price from a collective design.

Fear not, the level of artists' Web sites are improving steadily and incorporating structural features such as encrypted payment vehicles, feedback, guestbooks, and dialogue opportunities, image enlargement devices and a host of intricacies common in the e-commerce sector. More artists understand the concept that a Web presence is their unique opportunity to publicize their influences, background, and career chronology. Their Web sites can display an extensive selection of their work not necessarily available through their gallery exposure.

Artistic Productivity

A productive professional artist may create over 100 original artworks in the course of a year's activity. No single gallery can possibly stock this quantity of output on its floor or storage space, meaning unless an artist has multiple selling outlets to handle all of the work (this is *rare*), the artist has a considerable amount of excess inventory. This phrasing does not mean that the excess work is inferior or substandard; merely, it was not the primary choice of the selling outlet(s). Sometimes it simply becomes a casualty of prolific output. An artist's best-finished productions may not be the ones that sell best though traditional channels. Thus, the prospects for a unique discovery increase through direct dealing with the source.

An interesting side note to this commentary on artist productivity concerns Pablo Picasso, arguably the greatest artist of the twentieth century. Picasso was credited with having produced the following in his extended lifetime: 1,885 paintings, 7,089 drawings, 3,222 ceramic works, 17,411 prints (1,723 plates), 1,228 sculptures, and 6,121 lithographs with 453 stones, as well as several rugs and tapestries. Each piece seems to have found a receptive market. Andy Warhol would likely have made a serious run at this level of productivity had he lived beyond middle age.

I know of few artists whose every creative exploit is sold immediately upon completion. One of the realities of being an artist (particularly a prolific artist) is that storage space becomes a professional necessity if you wish to create a stable market value for your work. The dangers in selling everything for immediate cash flow include:

- An inability to accumulate a body of work an artist can control as his or her reputation and pricing levels ascend
- Inconsistency in pricing leading to wildly fluctuating value levels
- A perception that the artist has an indifference toward quality standards
- A tendency to concentrate production efforts exclusively toward a sellable style and compromise artistic growth or innovation

Some Subtleties in Dealing Directly

To understand the process of dealing directly with many artists, it is important to understand the potential differences in the selling process. The process may differ from a straight commercial transaction with a gallery owner. For example, denigrating an object as a negotiating tool to lower pricing may be an acceptable standard or tactic in certain industries. Denigrating an artist's work to his or her face for the purposes of price manipulation is absolutely certain to provoke an angry, personalized reaction from the creator. Most artists not only will refuse to sell that work to you, but any other of their works as well (no matter how financially dependent they are on a completed sale).

The unique (to commercial transactions) attitude many artists nurture regarding their work is a future owner must be worthy and appreciative of the ownership role. This statement is an oversimplification to some degree, because there are also many artists who are emotionally detached from their prior creations and could care less about the ultimate fate of the work as long as the check clears the bank. Most artists, however, tend to have ambivalent feelings concerning this issue and recognize their finished work as an extension of themselves and one to be given the proper respect.

In some instances, the impersonality of an online transaction may remove the potential conflicting personality aspect of the sales process.

Buying Online from an Artist

The process of purchasing artwork online directly from an artist is typically a combination of establishing a dialogue and anticipating an element of compromise in the actual transaction.

Many of the sales security elements available through traditional retail galleries are not available through direct purchase such as:

- Taking the art home on approval for ten to thirty days
- Satisfaction money-back guarantees
- Framing services
- Resale consignment options
- Trade-ins
- Payment installment plans

Some more commercially oriented artists may offer some of these options or all, but they tend to be the exception. Most artists are oriented toward the thinking once a work leaves the studio and the check or credit card charge clears, the work is the buyer's responsibility. This resolute

approach may evolve further as more artists self-market and incorporate a more flexible attitude toward customer service. At present, it is the minority view, and few artists wish to integrate too many options into the selling process, particularly if it involves accepting returned work and refunding previously cashed payments.

A direct buyer should accept these realities as part of the sales process.

Pricing and Negotiation

With regard to pricing, some artists may be limited in their negotiating flexibility based on signed agreements with their dealer(s) or reseller(s). This form of tying agreement precludes negotiation. The posted inventory on a Web site may be unavailable for resale or inaccessible due to current exhibition commitments. Some artists work exclusively on a commission basis and may not have any physical work to sell, merely pictorial examples of their capabilities and previous work.

A larger percentage of artists graduating from art institutions are more Internet savvy and marketing oriented than their predecessors and, often, even their professors. More self-taught artists (myself included) from a variety of professional backgrounds are integrating into the art world, and this shift and evolution is certain to restructure the nature of effectively marketing and selling art.

Just as dealers cultivate return buyers who maintain their longevity, artists may also establish long-term bonds with their financial supporters, creating a mutually loyal relationship beneficial to both parties over the course of their career span. (For a list of artist online portfolios, see the resource list in chapter 10.)

Barter Purchase Opportunities

This form of sales transaction is growing steadily through direct trades with artists and via an extensive consolidation process on the Internet. Bartering products or services is an opportunity to acquire artwork without an extensive cash outlay, and a growing segment of the artist community is broadening its receptiveness to this alternative means, particularly as the selection of tradable inventory and service expands. The online evolution of barter trading has undergone profound consolidation since its inception in the late 1990s (see chapter 14). (For barter services, see the resource list in chapter 10.)

SOURCING *the Sources*

There exist numerous excellent resources for buyers both in publication format and online, oriented toward the intricacies and expectations of the art-buying process. All of these resources offer comparative techniques, qualitative criteria, and insights into assuring the best informed purchasing tactics.

Informed and serious art collectors recognize the value of solid research, investigation, reputation, and value levels of preference specialties they are collecting. Most establish acquisition objectives, budget limitations, and communication outlets from multiple sources to stay abreast of their collecting passions equal in intensity to any artist's productivity. The curatorial resource of preference for future buyers will be the Internet, because no alternative source can ultimately provide a comparable level or diversity of research information. (For online art and media publications, see the resource list in chapter 8.)

COLLECTOR REFERENCE INFORMATION

www.AASD.com.au (Australian Art Sales Digest)
www.AIPAD.com (Association of International Photography Art Dealers)
www.AntiquesWorld.com
www.Art-Almanac.com.au
www.Art-Collecting.com
www.ArtAssets.com
www.ArtBusiness.com
www.Artchive.com
www.ArtCyclopedia.com
www.ArtDaily.com
www.ArtDealers.org (Art Dealers Association of America)
www.ArtFind.co.nz
www.ArtHistoryGuide.com
www.ArtInContext.org
www.ArtistsOnline.biz
www.ArtLex.com
www.ArtLine.com

www.ArtNut.com/intl.html (International Directory of Sculptural Parks)
www.ArtReach.com
www.ArtResources.co.uk
www.ArtResources.com
www.ArtTrak.com
www.ArtUpdate.com
www.AskArt.com
www.BergerFoundation.ch
www.CINOA.org
www.DigitalConsciousness.com
www.Fine-Art.com
www.FolkArt.org
www.GlobalGallery.com
www.Groveart.com
www.iCollector.com
www.Invaluable.com
www.JamesBaird.com
www.LaPada.co.uk
www.LastPlace.com
www.LucidCafe.com
www.ModernAmericanArt.com
www.OldMasters.net
www.PhilaPrintshop.com
www.PostPicasso.com
www.Sculpture.org
www.SLAD.org.uk (Society of London Art Dealers)
www.Studiolo.org
www.TFAOI.com
www.TheArtGallery.com.au
www.TheGalleryChannel.com
www.TwinCitiesFineArt.org
www.Wwar.com (World Wide Arts Resources)

The primary outlets for sourcing artist and galleries offering a specific medium or venue of art on the Internet is through search engines (chapter 4), virtual galleries (chapter 10), online advertisements (chapter 5), and hyperlinks (chapter 8).

Search Engine Sourcing Techniques

The key to understanding how a search engine functions is through the proper utilization of keywords and/or phrases. As there are billions of Web pages and Web sites currently hosted on the Internet with varying content

and millions being submitted daily, the congestion level is enormous and getting worse. Conducting a focused search is a skill requiring refinement, and choosing the best search engine becomes a matter of personal preference. Search engines are only capable of locating a small percentage of hosted Web sites, so it is not unusual for significant information to fall through the cracks.

Search engines are also biased on the information they rank and recover. This bias is often based on their financial considerations in attempting to create a profitable business model. However, the biased influence is not exclusively financially motivated (although it seems to be moving decidedly in that direction). Hyperlinks pointed toward a Web site are another factor very influential in determining ranking popularity.

With these factors in mind, you may need to experiment with several different search engine sites in order to extract the information you are seeking. The more specific your request, the likelier you are to locate your objective. For instance seeking a general term such as *art* versus the more narrowly focused *abstract expressionism* will give you significantly more Web page listings (over 381,000,000), but will be far too general in their content. Plus, who has time to view nearly 400 million web pages, many of them duplicates?[1]

The basic format for conducting a search is as follows: If you type in more than one word in the search box, you are requesting all Web pages (not sites) having EITHER of these words in the document. For example, if you enter: *Surrealist Influence*, you will get back any Web page with the either the words *Surrealist* or *Influence* or both words in the page.

Some tips to narrow the search focus include: Use "+" to require documents contain a specific word. Use "−" to refuse documents containing a specific word. For instance in the above example, suppose you are focused solely on Web sites oriented toward the style of surrealism. You could enter "+Surrealism−Influence" into the search box. Then the search engine will find documents containing only the word *Surrealism*, but not containing the word *Influence*. *Note*: Any Web page having the word *influence*, even if it's about surrealism, will not be returned.

Use "*" for truncation. If for instance you enter *Surrealism* in the search box, you will miss all Web pages having *Surrealistic* or *Surreal* in it, unless they also have the word *Surrealism*. By typing in "Surr*" instead, you will find all Web pages having those first four letters (*Surr*) followed by any other letters. Many search engines also allow you to use "#" for right-hand truncation. An example: #ology will return pages containing the words *Archeology, Biology*, etc.

Google (*www.google.com*), which has become the prominent innovator in search engine technology, runs on a unique combination of advanced hardware and software. The typical search speed can be attributed to the

efficiency of its search algorithm and equally to the thousands of low cost PCs it has networked together to create a lightening fast search engine.

The Google service also features numerous special search services and tools to enhance exactly what a user is seeking. For example:

- Froogle—Used for finding products for sale online
- Google Answers—An open forum where researchers answer questions for a fee
- Google Catalogs—An inventory of mail-order catalogs
- Image Search—A comprehensive image search engine on the Web with nearly a billion images (and expanding)
- Google News—A database of 4,500 continuously updated news sources
- Google Groups—User discussion forums on a variety of subjects [2]

The three largest search engines—Google, Yahoo, and MSN—are by no means the sole outlets for online research. Another form of search device, metasearch engines, troll multiple search engine searches (including the above three) simultaneously. Different search engines use different syntax for limiting and refining their searches.

Additional Capabilities of Search Engines

Finally, some search engines can limit and sort searches by date, language, and even popularity, which may be important element in refining a query for specific information. Once you have located a Web page or site you wish to return to at a later time, bookmark it with your browser through the Favorites Menu.

Search engines, indexes, and meta-engines are only effective if the task they are requested to perform is well defined. Refining your search terminology is critical in locating specific Web pages. Thus, any additional backup keywords (for instance a geographical location where any artist is located) may significantly refine the ensuing results.

Learning to use search engines efficiently is strictly trial and error and in most cases you should be able to locate your desired reference pages within the initial forty listings. Don't be afraid to experiment with various search word and phrase combinations. (For search engines, see the resource list in chapter 4.)

The Imperfect Nature of Sourcing Art Online

If you plan to use the Web as a tool for building your art collection, you will have the choice of looking at both artists' own Web sites and virtual gallery sites, managed by the "gallery" owner.

With respect to artists' Web sites, the visual presentation level will likely be erratic, but they do present an opportunity to establish a direct rapport with the creative source (assuming the artists respond). The level of follow-up service and access to inventory will likewise be dependant on the business organizational skills of the artist.

Virtual galleries, on the other hand, are established as business entities and organized fundamentally as their storefront counterparts. You will find their level of efficiency comparable to these. The ranks of virtual galleries have steadily swelled, however the high profile status for most of the Internet-exclusive, big-budget organizations spawned during the initial Internet boom have thinned. The multiple reasons for their collective failures are a lesson in classical economics.

The Woes of Early Virtual Galleries

In their haste to establish market credibility, many of the early venture capital–funded dot-com art galleries established selling agreements with nearly any established retail gallery willing to ink such a contract. The objectives theoretically were clear for both sides. The virtual mega-galleries could: 1) establish industry credibility based on their liaisons, 2) access consignment art to sell without having to foot the bill for inventory, and 3) through market research, determine which forms of art would actually sell successful online.

For a participating established brick-and-mortar gallery, the objectives were equally concise: 1) gain more industry exposure and potential client base, 2) sell more artwork through noncompeting channels without investing heavily into additional advertising or expensive e-commerce software, and 3) determine if online selling could work on a limited-risk basis.

This marriage of convenience was doomed to fail in nearly all cases from inception for several reasons. First, cultivating a market share in a brand new medium in an industry that is fundamentally based on long-term relationships is virtual impossible. Second, mass-media advertising (most dot-bombs relied on this to gain exposure) is very ineffectual in selling fine art. Third, dividing dealers commissions as a primary source of revenue (employed by most virtual galleries) is not a sound business model to recoup enormous set-up, operating, and promotional costs. Fourth, established artists will rarely make their best work available to unproven Internet sales outlets. This reluctance compromised the quality of the artwork selection offered.

In retrospect, both parties were gambling on an unproven business model without successful precedent. Over time, unfettered by the demands of immediate profitability, some of the larger galleries may have endured and ultimately captured a dominant marketplace share. However, when

competing businesses are collapsing for identical reasons of low sales volumes, investors panic and ultimately pull their financing support. Once the cash flow lifeline was severed, the ensuing liquidation proceedings were the next immediate consequence.

The financial demise and scaling back of many of these larger art-selling virtual galleries has launched a more focused prototype of selling entity, smaller in scale and specialized in nature. Hundreds, even thousands of collective virtual galleries are cultivating unique followings and client bases far removed from the traditional institutionalized art-buying audience.

The Current Guard of Virtual Galleries

Are they successfully selling art? Certainly, yes, and discriminating buyers, using the same standards to gauge their shopping experiences as they would in a retail gallery, will find some excellent values. More importantly, a new generation of more informed art buyer is emerging with the Internet's vast research base at their disposal.

Web sites focusing on exclusively abstract works, regional and national artists, outsider art, and figurative sculpture are finding their unique voice and pricing niche. This decentralized movement has for the most part eluded the radar of most established art galleries, but the scope and depth of their ultimate influence will be profoundly felt. Rather than appealing to a local or regional crowd exclusively, as most retail galleries have for years, their sales base is at once international in scope and a community.

The community concept is cultivated by establishing a dialogue between its participant producers (the artists) and buyers. Chat rooms, blogs, bulletin boards, and informational postings provide such means of dialogue and communication. Pursuing this dialogue is a prudent course of action because buyers' tastes will typically evolve and purchase levels increase as their income levels rise. Most importantly, these Web sites are training the incoming generation of art buyers how to competitively price shop by reducing the ultimate markup. The number one price component of a work of art is the seller markup, so consequently, if it is reduced by consumer awareness and negotiation, more competitive pricing will result. Right now, most art buyers have absolutely no idea what percentage art sellers add as mark-up, so absent of this knowledge, it puts them in an uneducated negotiating position. What most traditional galleries fail to understand about Internet shopping is it is the ultimate price comparison vehicle.

Numerous popular Web sites offer comparison shopping search engines, scaling a range of products and services globally. Can artwork be too far behind as one of the comparison commodities?

COMPARISON SHOPPING SERVICES

www.BestShoppersChoice.com
www.BestWebBuys.com
www.BizRate.com
www.Comparos.com
www.ConsumerWorld.org
www.DealTime.com
www.MySimon.com
www.Nextag.com
www.PlanetOnline.com
www.PriceGrabber.com
www.PriceGuideuk.com
www.PriceSCAN.com
www.Shopping.com
www.Shopzilla.com
www.StreetPrices.com
www.WebMarket.com
www.Winshare.com

INTERNET TRAFFIC RESEARCH

www.Clickz.com
www.Nielsen-NetRatings.com

INVESTMENT *Realities*

As financial rates of return go, fine art is as eccentric an investment as many of its creators. Most artwork created becomes a poor investment from strictly a financial sense.

Art as a Hedge Investment

This simple reality exists: Artists gravitate toward dealers who produce revenue and recognition for them. Dealers gravitate toward artists who sell. Collectors and buyers look for work that speaks to them and that, in many cases, serves as a stable hedge during uncertain financial times. This is the basic financial illusion that the fine arts industry has always cultivated, but the essential economics tend to disagree.

Every study in recent years comparing fine art with other investible securities such as stocks, bonds, mutual funds, and certificates of deposits arrive at the identical conclusion. Financial vehicles regularly and significantly outperform art investment.

The Truth about Dead Artists

Few artists live to accumulate substantial financial rewards within their lifetime for their work, and fewer still have the value of their work appreciate upon or after their death. Sadly, most artists are as neglected in death as they were when actively producing alive. Unless you have a marketing vehicle promoting your artistic output during your lifetime, the prospects for posthumous immortality are as fanciful as any fairy tale.

Before the advent of mass-communications, it was easier to languish as an undiscovered genius. Vincent Van Gogh's single sold painting is testament to that legacy. As a living and productive artist, based on his temperament and instability, Van Gogh would have been an absolute terror for any dealer to represent (save his tormented brother, Theo). Vincent Van Gogh alive would be the poster child for why many art dealers prefer to deal with and specialize in dead artists' estates on a consignment basis.

Because of the extent of mass media exposure today, most artists who achieve extended fame after their death, very likely were already known while they were living.

Contemporary Art as Investment

Somewhere along the way in the mythology of contemporary art, the idea of art as an investment took hold. The collectible object became a symbol of an individual's sophistication and fashion sense. One can certainly gain a reputation for possessing a keen buyer's eye by concentrating on thoroughbred artists (Warhol, Johns, Basquiat, Rauschenberg, etc.) whose collectors' stock has steadily risen with the tide of their auction prices. This form of buying has a precedent of appreciation, so choosing it may have very little to do with personal taste.

A safe assumption for investment return is that recognized and well-publicized art masters of this era (or any notable movement) will continue to appreciate in value, provided an owner can weather the periodic recessions and plateaus of the art world.

Who has the eye to spot the unknown persistent visionaries who, at least until their discoveries by the art world, labor beyond the periphery of recognition and concentrate solely on their obsession? History as it applies toward the fine arts industry is littered with the carcasses of the next big thing, and recognition is one of those intangible mistresses embracing and discarding with equal abandon. The occasional few collectors who seem to possess an eye or the magic touch for spotting future talent generally are wrong nearly as often as they are periodically correct.

A LEGACY PROBLEM WITH CONTEMPORARY ARTWORK

A great deal of contemporary art will only remain in memory as photographic archives. What creates value to an art owner is often a combination of intangibles, but most often consists of a basic, intuitive attraction to a specific work of art. A finished work may appeal to an owner on multiple levels including emotional, sensual, aesthetic, and subconscious. Perhaps an art collector is drawn to the texture of the surface, color patterns, image, size, history, reputation of the artist or dealer . . . all are legitimate motivating factors that influence purchases, but more importantly reaffirm the significance of surrounding our lives with creative objects.

Traits of Compulsive Collectors

No compulsive collector is inclined to brag about the legions of artists whom he or she speculated on and failed to capitalize on financially. This

collector's greatest reward, as with any art buyer, is the pleasure involved in viewing the work, an enriching experience, or, in the case of avid collector, the challenge of the chase.

Thus, is assembling a cohesive collection with the right names and right examples an example of sophistication? Hardly, in my opinion. Rather, it may serve an incentive or basis for individuals pursuing a notion of status or recognition of their aesthetics. It has been observed by many art insiders, obnoxious collectors motivated solely by status tend to acquire loud and flashy art, devoid of subtlety and typically cluttered and overdone. They have difficulty perceiving what is a desirable or important stylistic work because they cannot discriminate between good and bad. Their standards tend to be oriented toward the principle that more and bigger equals good taste.

A consistent trait I've personally observed regarding these prototype buyers, and the galleries that pander to this level of taste, is their absolute conviction that a heightened sense of aesthetics is verified by an excessive retail price. This collective certainty merely confirms even bad taste may be accompanied by a high price tag.

In contrast, industry insiders—familiar with the prevalent market conditions and artists' reputations—advise most top-tiered collections and collectors. Their ultimate purchase selection (whether by gallery or auction house) is typically chosen using sound conclusions based on documented sales trends and the work's provenance. They exhibit personal restraint in their search for pivotal work, employ an ability to negotiate, and commit to seizing unique buying opportunities when the timing is favorable.

Collectors at this level tend to have specific tastes, as well as deeper financial resources, and they work with budget objectives and limitations. In short, many of these collectors exercise the same discipline, dedication, and principles toward collecting as they did in their highly successful business endeavors. Why shouldn't they?

The Internet as a Collector Resource

For the majority of beginning and emerging collectors who will employ the Internet as their art search vehicle, it is unlikely they will own an important or original work from any of the top-tiered contemporary artists initially. A novice collector will be priced out of a buying niche principally inhabited by wealthy or institutional buyers (such as museums or corporate collections). A wealthy novice collector will likely overpay for work acquired, thus receiving an expensive education.

Ironically, collectors with preformed prejudices have an equal or better chance to affordably capture the work of a rising star through an open studio or online Web site if they are willing to make a substantial time and

research commitment. This window of opportunity often closes irrefutably once an artist ascends in the art market, as both reputation and pricing will become inflated.

In our modern society, anyone can use the title "artist." Similarly anyone can use the title "art dealer" and for that matter, the terms "critic" or "art collector." The art industry is as unregulated as any laissez-faire economist could dream. Most attempts at establishing critical standards of quality are embraced by a small circle of elitists and rejected by a large popular chorus. In time, perhaps some parameters will emerge from the chaos, but for now, the measure of recognition seems to be confused with quality as a mark of significance.

Consignment Sales of Artwork

The biggest dilemma with the art-as-investment strategy is that art is not as universally convertible into cash as are coins and jewels. Selling inventory may be very difficult and costly for an individual not intimately immersed in the industry. Whereas real estate commission fees often range between a negotiable 4–6 percent on the gross transaction amount, fine art brokers regularly work on 20–40 percent commission rates on artwork consigned to them to sell by the owner. This commission means a work of art bought at the retail price must appreciate in value approximately 20–40 percent (the consignment commission) during the lifetime of ownership for the seller simply to break even. Talk about pressure for an investment to perform! This process may take years, even decades.

CONSIGNMENT SALES SPECIALISTS

www.Art4Sale.com
www.ArtBank.com
www.ArtCellarExchange.com
www.Artcycle.com
www.ArtMan.net
www.ArtsAlive.com
www.ArtShowPlace.com
www.Barridoff.com
www.DougMeyerFineArt.com
www.FimaFineArt.com
www.Fine-Art.com
www.FineArtC.com (Fine Art Clearinghouse)
www.Gallart.com
www.HamiltonSelway.com
www.Rogallery.com

The temptation for a private collector is to sell the work directly to a private party. With minimal credibility as an art reseller and no base of potential buyer prospects, the seller's prospects for a successful transaction at fair market value is not encouraging. If the seller uses any professional services to facilitate the exchange, financial compensation will be expected and likely cut significantly into any profit margin. Often when investors want to sell their collection, they find out it may be difficult to sell at any price. Desperation-selling always ensures bargains for a prospective buyer. This difficulty is a principal factor why collectors often donate their works to museums. Of course, they also receive recognition and a tax write-off, and they are unburdened of their unsalable works of art.

Does this qualify fine art as a poor investment? Not universally, but when attention to the prospects of making money overshadows the merit of the work, be wary.

Art is not measurably useful. In most instances, you cannot sit on it or utilize it in any practical or functional way. Original paintings are materially composed of canvas and wood frame backings. Their actual material cost is negligible with respect to their selling price. Sculpture may cost more to actually produce, particularly if it is a cast bronze, but assemblage work has minimal or no salvage value based on its components. The fabrication of contemporary art in most instances was never meant to have the longevity as was art created in centuries past. This deficit in construction technique will be a challenge for museum curators and preservers in the future when they attempt to prolong the life of artwork made of temporal components such as thinned enamel house paints, plaster, oxidized steel, and discarded refuse.

What Influences Price Appreciation?

What may seem consistently to drive up the prices for original work by artists are the principles of a unique vision and the limited number of original works. Artists who champion a movement or school of art rarely are the first to embrace a unique style. They are frequently recognized as perfecting the medium best through their unique and original vision. Reputations are often cultivated by artists who not only create the work, but who can also articulate their motivations and ultimate objectives. If that is not their gift, then their paid representatives perform the role.

Within the high end of the art world, the market is very narrow; tight relationships and reputations among buyers and sellers often are the impetus for selling work. It has also given rise to celebrities (renowned rock musicians, for example), who attempt to cross over into the fine art arena.

Celebrities, however, rarely accomplish in fine art what they achieved in their initial field and most serious industry analysis merely dismisses the phenomena as vanity art.

In certain instances (such as with Warhol, Picasso, Haring, Neiman, Max) the celebrity of the artists' lifestyles becomes inseparable from their work. Their broad media exposure transformed them into household names, but from numerous critics' viewpoints, the extreme overexposure compromised the quality of their output. Time will ultimately judge their influence within the industry, because future critics will have escaped the hype.

Dealers and their staffs, art consultants, and publicists are very adept at presenting anecdotes about their artists that both humanize them and stress their unique position in the field. Remember, these stories are less than objective, as the storytellers are motivated by financial incentive.

PROVENANCE

Another value-added component to a specific work of art may be its provenance, normally considered any historical documentation recording ownership, ex-collections, museum exhibitions, and its previous whereabouts. An unusual narrative, documented controversy, or intrigue about a specific work may also qualify as provenance, nearly always increasing the value and desirability of a specific art piece.

In recent decades the importance of this provenance has gone beyond simple marketing motivation as instances of art looted from museums and estates during wartime has prompted the work to ultimately be returned to its proper owners following extensive follow-up research. This state of affairs has also resulted in the creation of online database services, visually posting images and descriptions of stolen or missing artwork. The more a missing work's image and loss notification are circulated, the fewer channels and sales outlets a thief and/or dealer in questionable works has access to.

REGISTRY OF STOLEN AND LOST ARTWORK

www.ArtLoss.com
www.ArtRecovery.com
www.LootedArt.com
www.LostArt.de
www.SazTV.com
www.Trace.co.uk

The Value of Originals, Photograpic Prints, and Reproduction Artwork

Original prints can be sound investments because of the artist's involvement. Photographic reproductions such as posters, limited edition prints—and to some degree, a contemporary technology like Giclées—are not considered traditional investment art. Stating that they aren't traditional is not to say you shouldn't invest in any of these mediums, but doing so for the enjoyment of the work should be the objective rather than any perceived future financial gain.

Reproduction artwork can be considered to be an original because of the artist's direct labor-intensive involvement in the process. The difference is that more than one copy can be produced. The premier form of reproduction art is original prints, two-dimensional works on paper created indirectly. Initially, the image is made on a sub-surface—a block, plate, or stone—and then transferred by inking the sub-surface and printing it onto paper. Thus the prints are not direct creations on a canvas, board, or paper. There are four methods for inking and transferring an image to paper: relief, intaglio, planographic or surface printing, and stencil.

Certain reproductive processes like those used to produce serigraphs involve a degree of handwork, but the handwork is of the publishing company employees, not necessarily the artists themselves. Promotional hype frequently stresses the artist role in overseeing or closely cooperating in the reproductions of their originals, but those actually doing so are a small minority due to the specific technical skill requirements.

Most artist involvement is constituted by little more than verifying that the colors and finished prints accurately reproduce the original work. That involvement itself may be headache enough for a production team. The truth of the matter is that the majority of an artist's participation involves individually signing and numbering the finished product.

Ironically, this area is one where artists' signatures often exceed other entertainment industry figures or professional athletes' autographs in value. The value of an artist's signature validates the finished work and significantly insures a higher selling price than an unsigned reproduction.

THE TRADE VOCABULARY OF ARTSPEAK

No segment of the fine arts industry is more prone to false representation than the area of reproduction art. Like any insulated business enterprise, the art world has a unique trade vocabulary, useful to learn, particularly when investment consequences may be at stake. In theory, the art trade vernacular I term "artspeak" is a standardized system for collectors. More

often, however, it is manipulated into a masquerade of confusing sales jargon, leading unwary buyers into false expectations and speculative gains.

Beware when a reseller casually tosses terms such as "rare" and "investment" around as the focal point of a sales pitch rather than assessing the caliber and quality of the artist or actual work. Artspeak enhances these illusions that reproduction art has a unique collectable niche by integrating terms and phrases into the sales pitch, such as hand signed, consecutively numbered, hand pulled, acid-free paper, no-fade inks, 100 percent rag paper, museum quality, limited edition, subscription edition and my personal favorite, re-marked (the artist or an assistant dabbles a little paint or doodles over the finished print).

GICLÉES PRODUCTION

The newest reproduction technique introduced with the technology age is a marvel called Giclées, continuing to revolutionize the marketplace for both evident and subtle reasons.

What has traditionally frozen out most galleries and artists from producing and marketing reproduction art is the tremendous set-up costs involved in four-color offset printing. These fixed expenses have necessitated large runs of a work of art (to justify the production costs), usually resulting in an oversupply and price deflation of the work.

Current digital technology minimizes the production costs significantly once an image is scanned or photographed with a digital camera into a high-resolution file. With a large format inkjet printer, these images can be reproduced on superior quality paper stock or canvas, replicating the quality of the original work. Millions of minute dots of ink are squirted onto a paper or canvas surface producing tonalities, resulting in high-quality fine art prints. The economic element introduced with this change is the concept of "printing on demand" or more appropriately, whenever you have a sale. The profit margin on these works compared to the production costs can be significant.

This technology, I feel, will radically change the distribution patterns of reproduction art since it becomes affordable for individual artists to self-publish their original works in a price competitive format.

ARE GICLÉES INVESTMENT ART?

The identical investment dilemma exists for Giclées as any other form of reproduction prints. Are they truly investment art? Fine artists who achieve unprecedented success in the medium may lend credibility to the argument, but the inability to establish a reliable consignment market undermines any investment incentive.

Art galleries display, frame, light, and hang reproduction and remarked works identically as originals. Pricing for the mounted, reproduced work of renowned artists rivals the prices of original work of quality and that of established artists of lesser renown. An expensive-appearing mount and frame may seal the illusion, but outside of the art gallery environment, a good framing job adds minimal resale value. The primary duty of a frame is to enhance the actual image by making it a pleasing focal point. A complimentary frame should preserve the integrity of the work, not overwhelm, as is frequently the case with inferior art.

WHY REPRODUCTION ART MAY MAKE SENSE

For many buyers, ownership of an original work by a top-tiered artist is simply financially impossible. Thus, a Giclée or signed reprint of an admired work may bring extreme satisfaction and after all, isn't satisfaction a primary reason to collect art?

Just don't bet your future financial health on it. Most reproduction art (according to nearly every industry resource I've read) will never appreciate significantly. Period. Any advisement to the contrary is misleading and very likely financially motivated by the seller.

Giclée technology will enable artists to distribute more of their images to a wider audience base and provide many with a unique opportunity to become published, a luxury few could previously enjoy. The quality of the work often rivals the original, making them top quality décor to own. I've actually witnessed numerous instances where a Giclée exceeded the original in quality because it cleaned up the rough and uneven textures, giving the finished work a more even appearance.

Scholarship and Research

Hype masquerading as scholarship has fueled the art industry for the past 150 years, that is, for as long as dealers and galleries have been the principal routes to success in the art world. Impressive publications and catalogs litter many artist exhibitions, often being confused with museum and academic publications. This form of vanity press (self-publishing) may build credibility in the minds of prospective buyers.

The Internet is rapidly becoming the primary curatorial resource of the current millennium due to the volume of collective data. Most of this data is biased and the credibility sometimes suspect as precedent has proven a good story or planted rumor can influence a market value dramatically. Profiles and critical analysis published by galleries about their represented artists are assumed to be compromised because the

publisher's financial security is at stake. Galleries are in the business to sell art and cultivate positive reputations, not conduct objective research.

Art scholars, critics, museum curators, and individuals oriented toward academic, scholarly, and historical analysis may be more accurate and less interested in commercial interests. They are also humans with specific tastes, prejudices, and points of view uniquely their own. Their views may fall out of favor as time passes. The critical voice rarely holds sway over posterity. How many twentieth-century art critics can you recall? How many twentieth-century artists?

A NEW ERA IN *Auction Sales*

While the art gallery system has sputtered, coughed, and generally dragged its heels with respect to embracing the Internet, international auction houses have been increasingly active in their attempts to integrate the new technology into the sale of contemporary artwork. Their initial efforts have provided measurable mixed results and significant financial losses, but the auction industry itself is undergoing a profound transformation and reinvention.

Traditional Roles of Auction Houses

Traditionally, galleries and auction houses coexisted within mutually understood parameters until the late 1990s. Art galleries were primary sales outlets for artists consigning fresh work and output (in replenishable quantities). High-end auction houses such as Christie's, Sotheby's, and Butterfields cultivated a secondary market representing owners' consignment and reselling inventory.

Galleries often (and still do) utilized auction houses as an inventory dumping ground and secondary sales outlets for slow-selling works (to alleviate cash flow problems). In the sometimes fierce and psychological battleground of auction proceedings, swollen egos and frenzied bidding often vaulted price levels of minor works to unprecedented heights. Damaged works, which had proved difficult to sell under close gallery scrutiny, often found a receptive marketplace under the gavel. Auction houses habitually sell works as is and though they have been known to pull disputed or questionably sourced inventory from actual auctions, they rarely offer money-back guarantees if a buyer is unsatisfied with a purchase.

Evaluating Consigned Artwork for Auction

An important resource in the auction industry is the published event catalog, which contains detailed inventory descriptions and price estimates. These estimates are merely educated guesses, typically based on the best

available information on recent market prices and precedents of the given artist. Most auction catalogs, however, are printed two to three months prior to the actual event, and upon the publication's distribution, factors that influence pricing may come to light. Trends may rise, fall, diminish, or intensify over a period of time. Thus, price estimates are often exceeded or in a sluggish market, unrealized. They frame a sound starting point for valuation, but like any speculative financial venture, there is always a measure of unpredictability.

Auction house–imposed buyer and seller commissions are what fund these operations. A buyer's premium is often imposed to the final selling price, a percentage commission paid by the ultimate buyer. Auctions expect immediate payment from buyers so their consignors receive their money promptly. Large-scale purchases are often financed by short-term bank loans and on many occasions, dealers or buying syndicates broker their resources to acquire important works they anticipate having strong resale and profit potential. A growing trend in the industry for large purchases has witnessed the auction house itself extending lines of credit.

The Effect of Auction Pricing within the Fine Arts Industry

The high-end auctions are the sector of the art marketplace where record-breaking sales prices tend to inflate expectations within the industry. The actual proceedings are often a mysterious labyrinth of anonymous buyers: shrill bidding to inflate values, and tactical maneuvers an unwary and inexperienced participant can become swept up in, with financially disastrous results. Investment exuberance during an auction should always be tempered by an element of reason and sanity.

In numerous instances, the rising price valuations driven by an auction proceeding have been mistaken as a report on the health of the fine arts industry as a whole. In truth the auction marketplace is more of a speculative exchange of assets like the stock market and not a measure of an artist's stature as a talent. Few artists will ever ascend to such a niche market where their works can be resold on consignment. The minority whose work is sold on the secondary market will rarely gain much from the pricing appreciation since they are no longer in possession of their own work.

How Auction Houses Source Inventory to Sell

A major auction house functions significantly differently from a retail gallery, since its existence is contingent on a higher volume of successful sales transactions. Pricing levels and trends are frequently manipulated by questionable tactics such as pulling work off the market, bid rigging, or

buying in-house if bidding is insufficient. These tactics are sometimes outright illegal when there is collusion between sellers and competitors. The auction houses often tread a fine line between preserving an artist's selling-price reputation and creating a vibrant, open marketplace.

Faced with a diminishing supply of the highest-quality consignment art and an expanding number of individuals pursuing it, many auction houses are becoming more aggressive in sourcing inventory, frequently at the expense of art dealers. Certain auctions houses began the process initially by acquiring estate art directly from the sources instead of merely being the conduit between buyer and seller. For premium and highly profiled works, it is not unusual for an auction house to contact potential bidders directly and enable them to physically see the works as well as keep them on loan in their homes or residences (similar to a gallery's on-approval policies).

Finding Top-End Artwork

Auctions are rarely the scene of the highest-end art bargains, since competing interested buyers usually include museums, corporations, wealthy collectors, and financial speculators. However, due to the sheer glut of transactions conducted by regional to international auction houses, bargains may exist for works that have escaped exposure in the trade industry press.

Fine art, like real estate, is heavily influenced by precedent purchases. Works by major artists are often withheld from the marketplace for years to prevent an oversaturation of inventory and to stimulate pent-up demand for available works.

In the past, auction houses allowed the gallery system to shape emerging trends, reputations, and supply/demand among the ranks of living artists. Each party strayed periodically into the other's terrain, but several factors have forever blurred the distinction between each institution's field of influence.

Auction Houses Expand Their Selling Reach

The Internet enables high-end auction houses to expand their boundaries of territorial sovereignty. When an auction physically occurs in New York, London, Paris, San Francisco, Tokyo, or even Cleveland, bidders may originate from any locality and even participate in the process from their personal computers, portable laptops, or wireless devices. This broadened participation both stimulates the amount and levels of bidding but also freshens up the traditional auction atmosphere. No longer does a bidder have to be physically present or have representation attending the actual event. In fact this revised process removes a certain element of romance and electricity from the traditional proceedings.

No matter, the bottom line is that more bidders create a healthier return and an outlet for dealers and artists alike to market works to a much larger selling base. Traditionally, only high-end artists and works merited the auction block, but that pattern is likely destined for obsolescence.

The Financial Potential of Auction Houses for Artists Selling Direct

Mid- and top-tiered artists can calculate the difference between what they sell for and what they ultimately keep. Many are weighing the difference between an auction house's selling commission of 15–25 percent and the less attractive dealer's 50-percent commission alternative. Some of their works (directly from the artist) have already strayed over to the auction lots and many more certainly will as the practice becomes more commonplace.

AUCTION HOUSES

www.AlderFerAuction.com
www.AllardAuctions.com
www.Altermann.com
www.AntiqueHelper.com
www.AspireAuctions.com
www.AuctionProductions.com
www.AuctionsbytheBay.com
www.AugustinSantaFe.com
www.Baess.com
www.BestOfTheWestAuctions.com
www.BlackwoodAuction.com
www.BocaAuction.com
www.BoosGallery.com
www.BrunkAuctions.com
www.BuffaloBillArtShow.com
www.BunteAuction.com
www.BurchardGalleries.com
www.Butterfields.com
www.CDAArtAuction.com
www.Chait.com
www.CharlieFudge.com
www.CharltonHallAuctions.com
www.Christies.com
www.Clars.com
www.CMRAuction.com
www.CodyOldWest.com

www.CottoneAuctions.com
www.CowboyHallofFame.org
www.DallasAuctionGallery.com
www.Dargate.com
www.DavidDikeFineArt.com
www.DawsonandNye.com
www.DoyleNewYork.com
www.eBay.com
www.Eldreds.com
www.EstateAuctionService.com
www.EstatesUnlimited.com
www.FontaineAuction.com
www.FreemansAuction.com
www.GouldAuctions.com
www.Groganco.com
www.HeritageGalleries.com
www.HighNoon.com
www.iGavel.com
www.IllustrationHouse.com
www.IveySelkirk.com
www.JacksonsAuctionCompany.com
www.JohnMoran.com
www.Jones-Horan.com
www.JuliaAuctions.com
www.KWVAauction.com
www.LeslieHindman.com
www.LittleJohnsAuctionService.com
www.LLauctions.com
www.MapesAuction.com
www.Mastronet.com
www.MatthewsGalleries.com
www.Morris-Whiteside.com
www.MysticFineArtsLtd.com
www.NadeausAuction.com
www.NealAuction.com
www.NewOrleansAuction.com
www.NortheastAuctions.com
www.OGallerie.com
www.OldHatAuctions.com
www.OutercapeArtAuctions.net
www.PAAM.org
www.PacGal.com
www.PhillipsDePury.com

www.PookandPook.com
www.RagoArts.com
www.RoseHillAuctionGallery.com
www.SantaFeArtAuction.com
www.SBAuctioneers.com
www.Shannons.com
www.Skinnerinc.com
www.SloansandKenyon.com
www.Sothebys.com
www.StCharlesGallery.com
www.StephensonsAuction.com
www.StuartHolman.com
www.Susanins.com
www.SwannGalleries.com
www.TheCobbs.com
www.ThomastonAuction.com
www.TreadwayGallery.com
www.Weschlers.com
www.WickliffAuctioneers.com
www.Wright20.com

AUCTION SALES REGISTERS

www.AASD.com.au
www.ArtBusiness.com
www.Art-Sales-Index.com
www.ArtFact.com
www.ArtNet.com
www.ArtPrice.com
www.AskArt.com
www.Heffel.com
www.Invaluable.com

Consumer Market Auctionplace and Person-to-Person Selling

A totally unforeseen phenomenon began in the mid-1990s and has had a great impact on the redefinition of the auction industry. The emergence of direct seller-to-buyer auction sites, pioneered by eBay, has literally burst open the cloistered world of direct auctions. Starting as a modest outlet for selling PEZ collectibles, the person-to-person direct auctions has escalated into a multibillion dollar industry from literally no precedent except newspaper classified advertisements.

When, it comes to Internet success stories, there is arguably not a pure dot-com company in existence rivaling the growth rate, coupled by the profitability, of eBay. Using essentially basic marketing tenets and framing the entire selling concept around developing quasi-trading communities, the eBay phenomena has not just pricked a vein of American pent-up demand, it has sliced an exposed artery.

The low- to mid-range auction market was nearly nonexistent prior to direct Internet auctions, and it has not even come close to its full potential yet. The movement is now global, crossing international borders. Imitators and competitors to eBay have emerged and at present have made a minimal dent in its market share because the company is well managed, innovative, and has an enormous participation base. It's not infallible however and has had minimal to nearly non-existent influence in the luxury goods (big ticket antique/fine arts) industry.

EBay's Failings in the High-end Art Business

The initial high-end, art and antique sales experiment—eBay's Great Collections—was scrapped and redesigned within two years of its introduction. Its replacement was renamed eBay Premiere, a marketing collaboration between several virtual Internet galleries: iCollector.com (*www.icollector.com*), Onview.com (defunct), Guild.com (*www.guild.com*), LatinArte.com (*www. latinarte.com*), and Artnet (*www.artnet.com*) pooling diverse and noncompeting offerings. This cooperative format was scrapped by eBay in January 2002, only to embark on a third failed attempt (ending in 2003) through a joint partnership with Sotheby's (*www.sothebys.com*).

Perhaps from these failed endeavors, eBay will be able to salvage a winning formula for high-end art sales. Presently, its live auction format has become an experimental tie-in with established auction houses, enabling these regular sales to expand their pool of bidders. Its strength remains in exploiting the opportunities available within the lower-priced auction range and in direct person-to-person transactions. (For lists of consumer auction exchanges and online merchant stores, see the resource lists in chapter 12.)

The Quality of Artwork Auctioned through Consumer Exchanges

What caliber of artwork can a buyer anticipate viewing through these low- to mid-market auction exchanges?

The sales ratios for most posted art auction listings have generally been consistently low. Successful auctions typically sell work in the emerging artist, post-art school graduate price range . . . namely low. Most successfully

transacted auctions sales for original artwork have been for under the $200 level (more often below $100), scarcely an incentive for a professional artist to consider such sites a legitimate alternative sales outlet. This scenario will likely change as consumers become more adept in this format and gain confidence in the buying process and the quality of the output. This change will likely take years to evolve although it is much too early to dismiss its prospects.

However, the low-end art market remains the foundation of consumer-directed auctions.

The art of renowned and recognized artists has, on occasion, sold successfully at market price levels, but for the present time, these success stories are in the minority. Some entrepreneurial artists have formed informal collectives such as EBSQ (*www.ebsqart.com*) and IBND.org (*http://ibnd.org*) on major auction sites such as eBay. The collectives enable self-representing artists to share potential buyers, submit theme-based art, and provide each member moral support in a traditionally solitary pursuit. Certain individual artists have cultivated a cult-like following and some claim they have been able to support themselves financially through their auctions by prolific output and perseverance.

Not every fine artist is willing to auction off a day's session in the studio for a pricing structure between 50¢ and $250 (based on the lack of auction reserves), yet the precedent has now been set. More artists will continue to resell in that format their drawings, gestural work, hastily created projects, and inspirations, irrespective of pricing levels. The marketplace will determine value.

The selection of offerings should improve significantly over time with an increase in buyer and seller confidence. The average pricing levels should likewise rise with the expansion and continued acceptance of online encrypted payment programs accommodating credit cards and international money transfers. (For self-representing artist auction sites, see resource list in chapter 10.)

The auction industry is evolving in numerous directions. To varying degrees, each may affect fine art selling distribution. These innovations include reverse consumer and business auctions and B2B (Business-to-Business) exchanges.

chapter 23

INSURANCE, *Appraisals, Shipping, and Leasing*

Relevant and sound guidance on the subject of insurance must be tailored to the unique requirements of the collector. Investing in insurance for your art collection is an important form of protection. As with legal advice, there are numerous subtleties and gray areas in insuring against risk.

Some collectors rely only on their standardized homeowners' policies, which often prove inadequate since they allow for fire and theft, but not necessarily natural disasters or accidental acts committed by family, friends, and visitors. For this reason, if an art collection has amassed a significant asset value, it is prudent to at least consult with a fine art insurance specialist well versed on market values and adequate coverage policies.

Fine art insurance premiums are based on unique variables such as medium, breakage capability, geographical location, material type of home construction, local crime statistics, proximity to the fire department, and efficiency and complexity of your alarm system. Other factors such as market values, reimbursement rates, and the common malady of underinsurance make adequate and sufficient policies a specialist's domain.

ART INSURANCE SPECIALISTS

www.Acordia.com
www.AtlanticMutual.com
www.Axa-Art.com
www.Capax.com
www.Chubb.com
www.Const.co.uk (Constantine)
www.Dewittstern.com
www.FineArtGuy.com (Thomson/Pratt Insurance)

www.HuntingtonTBlock.com
www.Kayegroup.com
www.RKHarrison.co.uk
www.Rockco.com (Rockefeller Risk Advisors)

Keeping Your Recordkeeping Current

Along with periodic reviews of your coverage policy, necessary recordkeeping should include a slide and photographic record of your work(s) and all invoices (particularly the original bill) pertaining to the work(s) insured. Most industry sources suggest keeping a moderate deductible of approximately $1,000 so you can concentrate your coverage on your more valued works.

Appraisals

Added to this recordkeeping, a reputable appraisal should be updated periodically, especially if an area of your collecting becomes particularly volatile. Should you ever make an insurance claim on your collection, it will be one of the first items requested in a settlement. Therefore, you must have work appraised before you can make a claim.

There are numerous dealers specializing in genres of art who are qualified to provide appraisals, as well as specialists who make their livelihood with this profession. Museum recommendations of appraisers are highly desirable and credible. The format is fairly standardized within the fine arts industry. Most appraisal forms are printed on association or dealer letterhead with an address, telephone number, and other locational reference information clearly visible. The appraiser should sign and date the document and make multiple copies for the organization, estate, or individual for whom the appraisal is being conducted and for the appropriate insurance company.

Among the other included information should be the owner of the work, the title of the article, the artist, notation of date and signature (if available), size, medium, condition, description of the subject matter, whether it's framed or unframed, and the value assigned at the time of appraisal.

Most appraisers charge a flat fee for their service and some scale their rate based on a percentage of the value of the work. The appraisal should be based on researching the condition of the work, selling precedent among related artists, style, and the unique provenance of a work. You should work with an appraiser whose career is based on skill and accumulated knowledge, and who is recommended by the industry. Don't choose an appraiser strictly because of location, availablity, or price.

APPRAISAL SPECIALISTS

www.Appraisers.org
www.AppraisersAssoc.org
www.ArtBusiness.com
www.ArtDealerNet.com
www.ArtDealers.org
www.ArtTrader.org
www.ArtTrak.com
www.ArtWorth.net
www.CollectingChannel.com
www.FineArtAppraiser.com
www.SussmanArt.com
www.VWArt.com

Shipping Considerations

Under normal circumstances, it is assumed an art buyer or collector will be responsible for the expense involved in the packaging, crating, and shipping of artwork. This expense is negotiable, but often exceeds cost expectations due to the high degree of care necessary to preserve and protect an art transfer.

For the artist selling or the buyer purchasing a work, no expense should be spared to wrap the contents of the shipping container of choice. The artist or buyer may choose to make a packing service responsible for the actual packing. Due to expense involved with this service, many artists pack and crate their work themselves for delivery. Since there is a time lag between leaving the studio and the delivery at the client's place, it is definitely advisable to insure works while they are in transit.

The insurance rates will depend on the weight, travel distance, nature of the cargo, declared value of the artwork, and mode of transportation. Regretfully, damage, spillage, stainage, breakage, theft, and negligence are unavoidable realities within the shipping business and based on the volume of goods transferred daily, it is miraculous the majority of goods arrive safely and intact. In general, most shippers have successful track records (the reason they remain in business). In cases of fine art delivery, many shipping companies employ the same degree of care (or lack of) as any other consumer or manufactured goods they ship. It is important to determine if your local shipping outlet takes any additional precautions for fragile goods.

For expensive or delicate works, additional care is essential. Substituting general delivery services for art specialists may be cost effective and convenient for getting packages from one place to another. Unfortunately,

the time, headaches, and expense incurred from damaged or broken works rarely justify any savings.

For reproduction art or lower-priced items, general delivery services may work fine, assuming your protective elements are secure. General delivery services such as UPS, FedEx, DHL, Emery, and even the U.S. Postal Service have made package and parcel shipping a relatively straightforward process. Door-to-door shipping often appears to be seamless. But behind the scenes, complex logistical activity takes place. Packages are usually transferred three times, if not more, traveling by a combination of ship, train, plane, and truck. Packages are usually moved to a regional hub to consolidate as much freight as possible and then disseminated to appropriate destinations.

The carrier you choose will make many, if not all, of these routing decisions for you. But it is helpful to be somewhat educated about the various aspects of the shipping process.

Cost Considerations

For instance, freight insurance is not always automatic. Some carriers provide minimal insurance (such as $100 per parcel with UPS) on every shipment, but a minimum is not universally the case. It's worth clarifying the origin point and termination point of the insurance offered to make sure it covers the artwork from door to door.

Most carriers try to make information concerning their shipping rates readily available (providing consumers with direct access to information through sources like the Web). However, additional fees can often creep into a quoted rate. This increase is particularly true with international shipments. Shipments are often shuffled between modes of transportation; some carriers itemize charges for each leg of the journey. Others charge an "all in" rate.

Rates are generally based on weight (either actual or volumetric) per shipment, or per component of the operation, such as per invoice, per container, per box, per hour of labor. Carriers may use a cubic rule to charge shippers for the space their packages occupy. Package volume limits the amount of freight a carrier can hold. For this reason, many carriers will use rates based on a weight or measure basis (whichever is greater).

With these facts in mind, be very conservative when estimating shipping rates, since there will often be unforeseen costs. Most of the general delivery shipping companies have price quotation and tracking components on their Web sites, giving you a basis for estimating the shipping costs. To make your calculations, you will need the zip code where the package will be sent, the package's weight, and its dimensional size. My own experience is these cost estimates differ sometimes from when you actually bring the package to the customer counter.

ART SHIPPING SERVICES

www.ABF.com
www.AffordableFreight.com
www.Airborne-Express.com (Airborne Express)
www.Atelier4.com
www.CargoReservations.com
www.Coast2CoastFineArtServices.com
www.CratersAndFreighters.com
www.Emeryworld.com
www.Fedex.com
www.FineArtShip.com
www.FreightNCrate.com
www.LAPackinginc.com
www.MoMart.co.uk
www.ThePackingShop.co.uk
www.UPS.com (United Parcel Service)
www.USPS.com (United States Postal Service)
www.YouMoveIt.com

Leasing Options

Renting or leasing works of art may be an option through a gallery or artist. Doing so serves two purposes for the artist providing broader exposure and visibility: and generating income from works that haven't sold yet. In many instances, the leasing party will ultimately purchase the work and use some of the leasing payments toward the financing.

Museums across the country have also gotten into this revenue stream by establishing rental and lease galleries as an extension to their operations. Most of these operations are geared toward representing emerging or mid-career artists, and in very rare instances, they may offer pieces from their permanent collection on a limited-time basis. Since many museum storerooms are abundantly stocked and stacked with acquisitions and undisplayed inventory, a short-term loan can serve as positive cashflow for an otherwise dead weight asset.

Many of these transactions are conducted discreetly between the contracting parties, because museums are generally publicly funded and financially accountable to a larger contingency than their immediate board of directors. Rental agreements typically last between one to four months while a leasing agreement may extend up to two years. Some agreements further stipulate that the lessee provides insurance for the entire term of the contract as well as cover the crating and shipping expenses.

For many corporations, leasing art is a valuable tax deduction since normally they can deduct their lease payments as a depreciation expense. This short-term arrangement can also address additional issues such as factoring in the changing tastes of management and employees, the lack of permanence in many company facilities, and perhaps an interest in upgrading the quality of exhibited work as a company's financial fortunes grow.

Many artists welcome the opportunity of added income opportunities and if the work is prominently visible to a large volume of viewers, additional future sales opportunities may arise. An artist's association with a museum, in whatever capacity, is generally a positive résumé reference.

On the downside, if the work is sequestered in a limiting viewing area, displayed improperly or damaged from neglect, the long-term exposure benefits are negligible or nonexistent. Also, the bookkeeping requirements and overseeing timely payments may be a nuisance not adequately compensated by the rental fees and a work being taken off the active selling market for a period of time.

LEASING PROGRAMS

www.ArtBank.ca
www.ArtCapitalGroup.com
www.BiaggiFaure.com
www.LACMA.org
www.PacificArtLeague.org
www.SFMoma.org
www.THINC.org
www.VCCA.com

REEVALUATING THE
Process of Buying Art

If the reader of this work (collector, buyer, artist, critic, or gallery owner) learns only that a new influence is changing the fine arts industry, my principle objective is achieved. As to the nature, level, and depth of this change, every element will be affected differently.

The Changing Art World

Past assumptions about the art will require careful reevaluation.

For starters, the typical art buyer of the future will not match the art buyer demographic profile dealers have used to pre-qualify prospects walking into their galleries in the past.

Numerous future sales transactions may involve a minimal amount of personal contact between the buying and selling parties because of distance and the way in which the sale is conducted. Internet exposure is educating a new breed of art consumer who can and will evaluate digital images, conduct price comparison surveys, and pay electronically from the comfort of home.

It is true that a high-end fine art purchase is not always comparable to a consumer product such as a book, bottle of wine, or computer accessory, but there is substantial space for a middle range. Future collectors and buyers may initiate their collecting pursuits with a Giclée on canvas purchased directly from an artist's Web site or consumer auction site. Later, they may elevate their purchasing levels as their budgets and tastes permit, and gain a greater consumer confidence in buying original art online as the Internet and e-commerce vehicles continue to improve.

Nearly all statistical surveys taken during the past six years regarding Internet usage and purchasing trends validate that the medium is continuing to grow and evolve as a vibrant commercial marketplace.

As the online buying horizons of fine art expand, the marketing capabilities of artists, galleries, auction houses, and consignment resellers expand as well. The greatest growth segment among these groups should ultimately become the artists themselves, who will have greater opportunities to engage

in dialogue and cultivate their unique patronage base. This shift will permanently alter their relationships with traditional selling outlets such as galleries and possibly auction houses.

Direct-selling artists and more informed buyers will not eliminate the need for art galleries. However, the emergence of more efficient direct-sellers, self-publishers, and self-publicists will influence a gallery's role and place in the sales process. Whether gallery owners accept their ultimate fate and adapt will largely depend upon their current attitudes toward using the Internet as a global sales vehicle.

The healthy economics of the industry for now is contingent on art galleries consistently selling artwork created by artists with a demonstrated following. The future source of both an artist's unique following and sales may be derived primarily from an artist's Internet presence. Thus, producer, seller, and buyer are likely to be intertwined through and mutually dependent upon the medium, a marriage of convenience to all parties.

Yet unlike the early, failed Internet "marriages" between virtual and brick-and-mortar galleries, this restructured relationship is constructed on long-term, mutually beneficial principles.

Future Internet Casualties

Future Internet company casualties will continue even after the leveling-off period based on drained finances and poor management. This settling is no different than any other retail business segment devouring most of its entry-level competitors within their first two years. Business failures will be a reality on the pathway toward Internet stability. Just as the computer industry itself survived massive levels of fallout following its consumer market inception in the early 1980s, so too will the Internet endure.

Individuals with an entrepreneurial spirit are waiting in line to roll the dice on their respective visions for this medium.

Worldwide Opportunity

For visual artists, resellers, and the fine arts industry as a whole, the adaptation to the Internet does not promise success or collective improvement, only change.

Whether the Internet will (or has already) become the twenty-first-century equivalent of the nineteenth-century Industrial Revolution, it is certain our culture has been irrefutably changed by the medium. Society's insatiable need for information (where permitted by governmental institutions) has merely been whetted. Any concerted government effort to repress or control information, as history continues to reaffirm and repeat, is doomed to ultimate failure.

Personalization is the foundation for a visual artist who is determined to succeed on the Internet. Our work is our most personal passion. Our respective artistic messages can become diluted in a sterile retail gallery environment. It can likewise be thinned in a cluttered impersonal Web site. Our Web site should be a reflection of who we are and what we are trying to express through our creations.

There are hundreds of technical advancements currently available on the Internet and thousands more in various development stages. The list of innovative possibilities expands daily. The challenge will remain to stay relevant.

Since, at this time, the future of the Internet is unknowable, it is not prudent to hang all of your career hopes on it. Strictly from an artist's perspective, I wouldn't immediately cease the gallery chase nor abandon group competitions. The ills of the industry such as condescending and rude attitudes prevalent among curators, gallery owners, art institutions, and even patrons (particularly when they aren't interested in your work) are not likely to evaporate. Neither are peer jealousies. The Internet is not a cure for poor marketing efforts and likely will not advance mediocre art. It will, however, make artwork more accessible through greater viewer outlets.

Though the ranks of contemporary artists may lack a certain revolutionary zeal, we are participating in a revolution in the art industry. Your creativity and imagination are your best assets. The ultimate satisfaction will be exposing your work to those who traditionally would never have had the opportunity to view it.

WORKS CITED

Chapter 1

1. Marc Spiegler, "Do contemporary dealers still need galleries?" *Art Newspaper* (June 2004), 26–28.
2. Global Internet Index: Average Usage, November 2004, NetRatings, Inc. (*www.nielsen-netratings.com*).
3. Anna Somers-Cocks, "Much ado about minor damage." *Art Newspaper* (January 2002).

Chapter 2

1. Prudential California Realty (*www.williamsmith.com*), Administrative contact: William Smith, Pacific Bay Corporation, Monterey, California. Registered June 1997.
2. "The Pulse of the Market." DomainMart, Inc. (*www.domainmart.com/news/highest_prices.htm*).
3. Quotation by George Bernard Shaw, Source unknown.
4. Global Internet Index: Average Usage, November 2004, NetRatings, Inc. (*www.nielsen-netratings.com*).
5. Babel Fish Translation, AltaVista, Overture Services, Inc. (*http://world.altavista.com*)

Chapter 4

1. "Share your place on the net with us." Google (*www.google.com/intl/en/addurl.html*).
2. "Submitting your site." Google (*www.google.com/intl/en/webmasters/1.html#A2*).
3. "© 2004 Google - Searching 8,058,044,651 web pages." Google (*www.google.com*).
4. Search Engine Market Share, November 2004, NetRatings, Inc. (*www.nielsen-netratings.com*).
5. "PageRank Information." Google (*www.google.com/intl/en/webmasters/4.html#A1*).

6. "Our Search: Google Technology." Google (*www.google.com/technology/index.html*).
7. "Submit Your Site." Yahoo! Inc. (*http://search.yahoo.com/info/submit.html*).
8. "Yahoo Express Program," Yahoo! Inc. (*https://ecom.yahoo.com/dir/express/intro*).

Chapter 5

1. "Company Overview." Overture Services, Inc. (*www.content.overture.com/d/Usm/about/company/vision.jhtml?ref=in*).
2. Keyword Selector Tool. Overture Services, Inc. (*www.content.overture.com/d/Usm/ac/index.jhtml*).
3. Keyword search of terms *art, painting, sculpture,* and *photography,* November 2004. Overture Services, Inc. (*www.content.overture.com/d/Usm/ac/index.jhtml*).
4. Overture-View Bids Tool. November 2004. Overture Services, Inc. (*www.content.overture.com/d/Usm/ac/index.jhtml*).
5. "Compare Your Clicks." Compare Your Clicks! November 2004 (*www.compareyourclicks.com*).

Chapter 7

1. "DoubleClick 2004 Consumer Email Study." October 2004, DoubleClick Inc. (*www.doubleclick.com/us/knowledge_central/research/advertising*).
2. "DoubleClick Fall 2002 Marketing Spending Index." December 2002, DoubleClick Inc. (*www.doubleclick.com/us/knowledge_central/research/advertising*).
3. "In three years, will marketing's effectiveness increase, stay the same or decrease in each of the following media?" Survey to 900 Leading Business Advertisers, April 2004, Forrester Research (*www.forrester.com*).
4. "Using Direct Mail: Loyalty Programs." U.S. Postal Service (*www.usps.com/directmail/dmguide/discoverdm/database7.htm*).
5. "101 Ways to Increase Mail Order Profits." HowtoAdvice.com (*www.howtoadvice.com/IncreaseMailOrder*).

Chapter 8

1. Incoming link search conducted for Web sites *www.art.com, www.fine-art.com,* (*www.absolutearts.com,* and *www.wwar.com* on LinkPopularity.com), December 2004, The PC Edge, Inc. (*www.linkpopularity.com*).

Chapter 9

1. "Join Associates." Amazon.com, Inc. (*www.amazon.com*).
2. "United States: Top 10 Parent Companies Week ending December 13, 2004." December 2004, NetRatings, Inc. (*www.nielsen-netratings.com*).
3. Shawn Collins Consulting, "Affiliate Statistical Report." *Internet Retailer*, (April 2004). (*www.internetretailer.com*).

Chapter 10

1. Robyn Greenspan, "Consumers Lose Themselves Online." Jupitermedia Corporation, Ecommerce-Guide May 23, 2003. (*www.ecommerce-guide.com/news/research/article.php/2211611*)

Chapter 11

1. "*Accounts* and *About* Sections." PayPal (*www.paypal.com*).
2. "*Our Services* Sections." BidPay (*www.bidpay.com/HowItWorks.asp*).

Chapter 12

1. "United States: Top 10 Parent Companies Week ending December 13, 2004." December 2004, NetRatings, Inc. (*www.nielsen-netratings.com*).
2. "Listing of eBay International Exchanges." eBay (*www.ebay.com*).
3. Annelena Lobb, "PEZ=Big Bucks?" CNNMoney.com (*http://money.cnn.com/2002/06/13/pf/q_pez*).
4. "eBay Selling Resources." eBay (*http://sell.ebay.com/sell?ssPageName=h:h:syi:US*).
5. "United States: Top 10 Parent Companies Week ending December 13, 2004." December 2004, NetRatings, Inc. (*www.nielsen-netratings.com*).

Chapter 13

1. "About Nike: Heritage: Origin of the Swoosh." Nike (*www.nike.com*).

Chapter 20

1. "Search for term *art.*" Google. Conducted January 12, 2005.
2. "Google Help Central: Search Help." Google (*www.google.com/help/index.html*).

WEB SITE DIRECTORY

This directory listing is for reference purposes only and should not be interpreted as an endorsement of any of the following Web sites. Due to the transitory nature of many cyber businesses, these service addresses may be subject to change, consolidation, or the sites may simply go out of operation. The number(s) to the right of the listing indicate the page references to where this listing may be discussed in further detail.

ABOUT THE AUTHOR

This California figurative artist has established his working studios in northern California and southern France since becoming a professional artist in 1997. Marques Vickers' work is predominantly oriented toward action female forms, nudes, and full body casts.

Born in 1957, Vickers grew up in Vallejo, California. He is a 1979 graduate of Azusa Pacific University and completed postgraduate work at the University of Bourgogne in Dijon, France. He was the executive director of the Burbank, California Chamber of Commerce from 1979–84 and vice president of sales for AsTRA Tours and Travel of Los Angeles from 1984–86.

An entrepreneur before becoming an artist, he has initiated and managed several business enterprises and is an internationally recognized spokesperson on the growing marketing role the Internet is assuming in the fine arts industry. His numerous self-produced Web sites have received several Golden Web Awards from the International Association of Web Masters and Designers (IAWMD).

His biography has been included in Marquis Publications' *Who's Who in America* since 2003. His work has been exhibited and profiled internationally and is part of several individual and corporate collections and commissions. Figurative artists who have been influential in his artistic evolution include Constantin Brancusi, Alberto Giacometti, Jean Arp, Henry Moore, George Segal, Nathan Oliveira, Concha Benedito, Robert Arneson, and Manuel Neri.

INDEX

Books from Allworth Press

Allworth Press is an imprint of Allworth Communications, Inc. Selected titles are listed below.

The Fine Artist's Guide to Marketing and Self-Promotion, Revised Edition
by Julius Vitali (paperback, 6 × 9, 256 pages, $19.95)

Fine Art Publicity, Second Edition
by Susan Abbott (paperback, 6 × 9, 192 pages, $19.95)

The Fine Artist's Career Guide, Second Edition
by Daniel Grant (paperback, 6 × 9, 320 pages, $19.95)

The Business of Being an Artist, Third Edition
by Daniel Grant (paperback, 6 × 9, 354 pages, $19.95)

Business and Legal Forms for Fine Artists, Third Edition
by Tad Crawford (paperback, includes CD-ROM, 8 1/2 × 11, 128 pages, $19.95)

Legal Guide for the Visual Artist, Fourth Edition
by Tad Crawford (paperback, 8 1/2 × 11, 272 pages, $19.95)

The Artist-Gallery Partnership: A Practical Guide to Consigning Art, Revised Edition
by Tad Crawford and Susan Mellon (paperback, 6 × 9, 216 pages, $16.95)

An Artist's Guide: Making it in New York City
by Daniel Grant (paperback, 6 × 9, 224 pages, $18.95)

The Artist's Quest for Inspiration, Second Edition
by Peggy Hadden (paperback, 6 × 9, 288 pages, $19.95)

The Quotable Artist
by Peggy Hadden (hardcover, 7 1/2 × 7 1/2, 224 pages, $19.95)

How to Grow as an Artist
by Daniel Grant (paperback, 6 × 9, 240 pages, $19.95)

The Artist's Complete Health and Safety Guide, Third Edition
by Monona R aperback, 6 × 9, 416 pages, $24.95)